9.5 THESES ON ART AND CLASS

9.5 THESES ON ART AND CLASS

BEN DAVIS

Haymarket Books
Chicago, Illinois

Published in 2013 by
Haymarket Books
P.O. Box 180165, Chicago, IL 60618
773-583-7884
info@haymarketbooks.org
www.haymarketbooks.org

ISBN: 978-1-60846-268-1

Trade distribution:
In the US through Consortium Book Sales and Distribution, www.cbsd.com
In the UK, Turnaround Publisher Services, www.turnaround-uk.com
In Canada, Publishers Group Canada, www.pgcbooks.ca
In Australia, Palgrave Macmillan, www.palgravemacmillan.com.au
All other countries, Publishers Group Worldwide, www.pgw.com

Special discounts are available for bulk purchases by organizations
and institutions. Please contact Haymarket Books for more information
at 773-583-7884 or info@haymarketbooks.org.

Cover design by Josh On. Cover art is a detail of *Relational Wall* (2009) by
William Powhida. Courtesy of the artist. Collection of Melva Bucksbaum and
Raymond Learsy.

This book was published with the generous support of the Wallace Global
Fund and Lannan Foundation.

Printed in Canada by union labor on recycled paper.

Library of Congress CIP data is available.

3 5 7 9 10 8 6 4

RECYCLED
Paper made from
recycled material
FSC® C103567

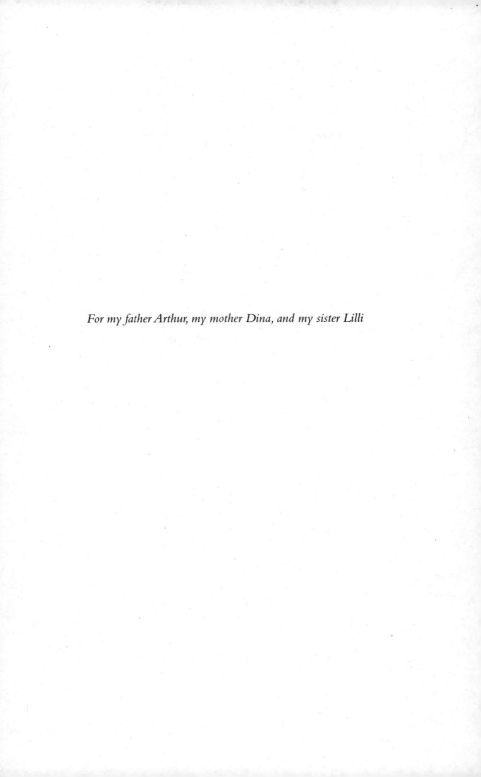

For my father Arthur, my mother Dina, and my sister Lilli

Contents

Introduction

The book you are reading is a collection of essays. Some are entirely new, others substantially reworked versions of pieces I wrote over the last seven or eight years for various art websites, art catalogues, or, in one case, as a pamphlet meant as an intervention into an art show. They respond to a broad array of topics, but also fit together into a carefully curated whole. A few words are in order, then, about the background that has shaped this book.

I moved to New York City in 2004, becoming an art critic full time after stints tutoring criminal justice students and writing about flower shows and poetry slams for a community newspaper in Queens. This was during a period of interesting debates in art—about money, the role of the critic, globalization, and more. The original versions of many of the essays here began as polemics, and they bear the stamp of the time and place they were produced, responding to the concerns that have obsessed the New York art scene during this period (which also explains the somewhat New York–centric focus of the examples).

But another, less evident influence on this book bears mentioning as well. At the same moment that I began to write about art professionally, I also became involved with activism. The years in question were also the years of the massive immigrant rights marches of 2006, dogged antiwar organizing against the wars in Iraq and Afghanistan, the National Equality March and the struggle for same-sex marriage, the successful fight to save Kenneth Foster from the death penalty in Texas and the unsuccessful battle to save Troy Davis from the same fate in Georgia, and the exciting outbreak of the Occupy movement in 2011.

I participated in all these movements and am proud of having done so. Some sense of that experience appears in the following pages, but probably not enough to do justice to how much my involvement in such events influenced my thought. It was the experience of taking part in actual social movements—aggravating, difficult, humbling, inelegant, but ultimately

worthwhile—that helped to put the sometimes too self-important claims of art in perspective. As a consequence, I believe that activism has made my art criticism stronger, even where I was not directly writing about politics.

I have a vivid memory of first meeting serious Marxist activists (as opposed to the academic Marxists, post-Marxists, and postmodernists with whom I had studied) and being asked what interested me politically. I explained that I was trying to develop a theory of how Kierkegaard's theory of the aesthetic aspect of seduction stood as a critique of the Hegelian master-slave dialectic, through a reading of pick-up tips from *Maxim* magazine. I can only imagine what a kook they thought I was—but I'm glad they had patience with me.

Terry Eagleton writes about the distinctive combination of pessimism and optimism that characterizes Marx's thought—Marx is more pessimistic than most about the past, which he sees as a progression of forms of exploitation, but more optimistic about the future, which he sees as possibly much more equal and democratic.[1] This is a fine temperament for an art critic to absorb: I am probably more critical than most about the progressive pretensions of various aesthetic theories and art history's tendency to romanticize the accomplishments of artists. On the other hand, I do not default to a wholesale dismissal of visual art; in fact, I think art has an important role to play in our lives—potentially a much more important role indeed.

Experience has shown that mentioning "Marxism" is liable to provoke all kinds of puzzled reactions and hostile misinterpretations. What does this most abused of philosophies mean to me? This brief introduction is not the place to engage in depth with all the many debates about this subject, some of which are taken up in the course of my essays. However, I will say that the core of Marx's thought seems to me to be his critique of capitalism and complementary focus on the revolutionary power of the working class, combined with a belief that a substantially more equal and just world is desirable and possible. These tenets seem to me to be more relevant today than ever, given that a particularly virulent form of capitalism has pervaded the world on an ever-more-intensive level in the last forty years and is doing a fine job of herding humanity toward a cliff.

I sometimes like to catalogue how many times, within purportedly serious works of art history or theory, I run into offhanded references to how the horrors of the Soviet Union prove that the ideas of Marxism are fundamentally flawed, with this insight inevitably leading to the sad and stupid assertion that all dreams of a substantially better future are futile. Yet there is a robust history of left-wing Marxist critiques of the former Soviet Union, most notably from Leon Trotsky, who believed that Stalin's "socialism in one country" had degenerated into a bureaucratic caricature of the ideals of workers'

power. Trotsky is hardly an obscure figure—he was in fact one of the leaders of Russia's socialist revolution.

Given how widespread the interest in alternative currents of Marxist thought has been in both the academy and the more high-minded art magazines—from the Frankfurt School to Situationism to various forms of post-Althusserian philosophy—it is telling that the Trotskyist tradition, with its activist emphasis, is so little discussed. This absence is particularly inexcusable given that Trotsky had a great deal to say about artistic matters, in ways that refute many of the persistent stereotypes about the Marxist approach to art.

Explicitly or implicitly, the exploration of how an activist-oriented, progressive Marxist approach clarifies our understanding of artistic questions is the thread that ties together this book. Thus, in chapter 1 I attempt a sustained theorization of how the Marxist idea of class affects the way we think about the labor of visual art. The text is a dilation of my pamphlet *9.5 Theses on Art and Class*, which has become one of my most widely read and debated texts despite having never been officially published, and which stands here as chapter 2.

Chapters 3 through 5 take up art's relation to politics. In my opinion, the guidance that Marxism gives on this question is exactly the opposite of the caricature that has Marxist critics reducing art to its value in making a political argument. In fact, I try to show how various mainstream art theories are much more reductive, relying on nebulous idealist abstractions about both art and politics and collapsing both fields together into an unsatisfactory portmanteau.

Chapters 6 through 10 turn to the context within which contemporary art is made and discussed, focusing, as any good Marxist analysis should, on the material structures that shape our ideas. In these essays I attempt to show how transformations in the economy and society at large have affected the institutions of visual art and the ways in which these institutions in turn constrain and determine what art we see and how it is valued.

Chapters 11 through 14 address various debates within art theory. My focus here is on how abstract and apparently intractable theoretical problems—about art's relation to mass culture, the "crisis of criticism," the fate of conceptual art or postmodernism—cypher political questions and how a grounding familiarity with serious Marxist thought helps clear them away.

Finally, my two conclusions attempt to turn to the aforementioned optimistic side of Marxist thought. Chapter 15 reflects on how one might engage constructively with the professional "art world" in the present while escaping its biases. Chapter 16 tries to go beyond a critique of art in the present, to sketch what positive contributions political struggle might have to offer visual art.

For whom, finally, have I written this book? I have two audiences in mind. One consists of artists, writers, and other art lovers. The world of contemporary

art may be distinguished, from the outside, by its glamour and sophistication, but those who engage with it up close will find, to their sorrow, that it is unceasingly petty, full of unexamined exploitation and willful social ignorance. Year after year, it chews up and spits out idealistic people, leaving them disgusted and heartsick. And yet I firmly believe that the encounter between idealistic notions about what art can be and the far-from-ideal realities of art in the present can be a profoundly politicizing experience. For those navigating this terrain, I hope that this book is a useful tool.

Second, I have in mind a political audience looking, from the outside, for some kind of sympathetic guide to the strange flora and fauna of contemporary art. I have *occasionally* heard activists whose political wisdom far exceeds mine offer blanket dismissals of contemporary or even modern art as being wholly inauthentic. Given the field's overwhelming association with the titans of the One Percent, this may be understandable. I hope that the essays assembled here can help do justice to the complexity of their subject. Contemporary art's sometimes baffling character may be partly due to its decadence, but it is also partly due to how visual art has preserved middle-class values of independence and creative autonomy more than other spheres and has thereby held out hope for constructing an alternative culture in our capitalist world. Or—a third option—art's strange forms of expression might just be something like the garbled sound that comes when you need to say something but haven't quite figured out how to say it yet. As my own experience attests, sometimes it is worth being patient as well as critical.

I do not know if I have always been successful in writing in a voice that speaks to both audiences. But if this book plays even a small role in bringing them closer together, then it has done its work.

Brooklyn, New York
March 2013

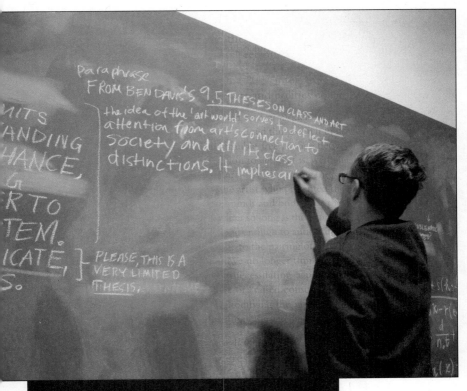

Art and Class

Artist William Powhida during "#class" show at Winkleman Gallery. Photo by John W. Beaman

ONE
Art and Class

It was an article in the *New York Times* in December 2009—art fair season in Miami—that touched off the chain of thoughts that led me to assemble my ideas on art and class in a systematic way. Damien Cave's profile of Brooklyn artist William Powhida tracked him as he moved around the aisles of Art Basel Miami Beach, the annual stew of art commerce and excess in balmy Florida, recording Powhida's reactions to the spectacle as he went. It struck me as a strangely poignant snapshot of that particular troubled moment in art history, describing an artist trapped somewhere between longing and disgust. "A lot of us go back and forth about wanting to destroy this model, and wanting to support it," Powhida said.[1]

If people cared what he had to say, it was because of *How the New Museum Committed Suicide with Banality*, an outraged and off-the-wall drawing produced for the cover of the *Brooklyn Rail* earlier that year. Powhida had used this platform to vent his anger at the New Museum for agreeing to host a show of the personal art collection of titanically wealthy Greek businessman Dakis Joannou. Rather than being curated by a member of the institution's staff, the show was to be assembled by Jeff Koons, an American artist known for shiny neo-pop objects who also happened to have been the best man at Joannou's wedding. The widespread perception was that the New Museum, which had begun life as a lively alternative institution, had sold its birthright for a mess of pottage.

In his drawing, Powhida weighed in like an Internet-age Daumier: the curators, collectors, artists, and art dealers associated with the New Museum were caricatured, their incestuous interpersonal connections mapped out and set alongside quotes from pundits who had weighed in on the matter and commentary from Powhida himself. *How the New Museum Committed Suicide with Banality* became something of a touchstone, pushing Powhida into the role of social commentator within the New York art scene. The slew of moralizing denunciations about the Joannou show took me a bit by surprise—

the influence of the wealthy on art was, after all, not particularly new, as American as Solomon R. Guggenheim and J. Paul Getty. I found the outrage inspired by the New Museum show salutary but trivial. In 2009, there were bigger problems in the world.

The minor revelation in Cave's profile was the glimpse it gave into the background that informed Powhida's art-world satires (for the occasion of that year's Art Basel Miami Beach, he created a drawing called *Art Basel Miami Beach Hooverville*, depicting the art fair as a teeming Depression-era shantytown). "Mr. Powhida is not comfortable in this world," wrote Cave. "He was reared in upstate New York by a single mother who paid the bills with a government job, and he has earned his own living for the past decade as an art teacher in some of the toughest public high schools in Brooklyn. He said his artwork brought in only about $50,000 over the past three years, and that he was still repaying his undergraduate loans from Syracuse University."[2] Those fleeting biographical details hit home for me what should have been an obvious point: Powhida's satire of art's institutional politics drew its outrage from experiences rooted outside that sphere, even if this outrage was channeled into something that felt, to me, fairly inside baseball; to understand the cathartic snark of the work, you had to grasp something about the situation of the contemporary artist, about the promises an art career held out and failed to deliver.

In an article summing up the controversy, I suggested that Powhida curate a response to *Skin Fruit*—the vaguely leering title of the Koons-curated New Museum spectacle—and in the spring of 2010, the gallerist Ed Winkleman invited Powhida and another artist, Jennifer Dalton, to curate just such a response show at his small outpost on the westernmost reaches of Chelsea. They conceived of it as a kind of freewheeling workshop or brainstorming session, with anyone who wanted to take part in the discussion about money's impact on art invited to do so. It was called "#class."

Scanning the proposed contributions to the event's program in advance, I was struck by how many of them seemed to be jokes or simply off topic (for example, a debate between artists and dealers staged as a game of Battleship, or a performance for which everyone entering the gallery was photographed as if they were a celebrity). It seemed to me that artists were struggling—and failing—to find a language with which to engage with the topic of artists' economic position. I wrote the short pamphlet *9.5 Theses on Art and Class* over the course of a weekend as my contribution to the show. During the opening, I passed out copies and taped the text to Winkleman's front door. A few weeks later, I returned to participate in a discussion of the text with Powhida and Dalton, which attracted an eager though eclectic crowd (including one clownish commentator from the conservative *New*

Criterion magazine, who suggested that the problem with contemporary art was that government art subsidies were too lavish). Yet, as with most debates about art and politics or art and the economy, the conversation felt strangely centerless, as if we were all searching for a common framework upon which to draw.

Years later, the feeling that the game is rigged, which gave birth to the New Museum controversy, has only sharpened. The air of decadence has become so claustrophobic that even pundits not particularly known for their radicalism find it intolerable. In mid-2012, Sarah Thornton, author of a breezy bestselling piece of sociology, *Seven Days in the Art World*, and art beat reporter for the *Economist*, penned an extraordinary text entitled "Top 10 Reasons NOT to Write about the Art Market," announcing that she was abandoning coverage of the market altogether. Her list of reasons included, "The most interesting stories are libelous" and "oligarchs and dictators are not cool."[3] Dave Hickey, a critic once known for his rollicking critique of anti-market sanctimony, also announced that he wanted out, mainly because he was disgusted by the dominance of the superrich. "Art editors and critics—people like me—have become a courtier class," he remarked. "All we do is wander around the palace and advise very rich people. It's not worth my time."[4]

Even Charles Saatchi—the advertising mogul at least partly responsible for the rise of both neoliberal doyenne Margaret Thatcher (through his "Labour Isn't Working" campaign) and art-market darling Damien Hirst (through his art collecting)—recoiled in horror from what the art scene had become. "Being an art buyer these days is comprehensively and indisputably vulgar," he wrote. "It is the sport of the Eurotrashy, Hedge-fundy Hamptonites; of trendy oligarchs and oiligarchs; and of art dealers with masturbatory levels of self-regard."[5] Responding to these tantrums, the radical critic Julian Stallabrass attacked Hickey and Saatchi only for seeming to hold out the possibility that contemporary art might be anything more exalted: "If works of art are vulgar and empty, why should people be any more upset by that than by, say, garish packaging on supermarket shelves?" Stallabrass actually seemed to suggest that critics abandon writing about fine art altogether and focus instead on what people were sharing on Facebook.[6]

He can do that if he likes, but I think he may be throwing the baby out with the bathwater. For my part, I'm not quite ready to give up on the entire world of art all at once. Since I nevertheless accept the dire state of the situation, what this debate proves to me is that if you are going to have any way to interact with contemporary art positively, you need some theory that is more nuanced than that on offer. In my head, I keep coming back to that discussion at Winkleman Gallery—we are *still* struggling to find a language with which to engage with the topic of artists' economic position. And the theory of the

classed nature of artistic labor from my *Theses*, I continue to hope, is the missing piece that might provide the resources for a more constructive critique.

"A Rehash of Marxist Ideology"

Of course, complaints about art and money are not new. Long before the New Museum dustup, anxiety about the art market's impact on contemporary art had been gathering steam, as had the sense that the theory to understand it was lacking. "We don't have a way to talk about the market," the critic Jerry Saltz wrote in the *Village Voice* in 2006. "There is no effective 'Theory of the Market' that isn't just a rehash of Marxist ideology. There's no new philosophy to help us address the problem of the way the market is affecting the production and presentation of art, although people are trying."[7]

The swipe at "Marxist ideology" made me cringe—but I had to sympathize with where Saltz was coming from. For people not embedded in contemporary art, who have only the outside picture of auctions and galas, it is difficult to explain how deep-rooted is the belief in art-making's inherent righteousness and radicalism among the cognoscenti. For decades, various strains of Marxist-inspired cultural theory have been, if not the mainstream, then somewhere in the region of the mainstream for art criticism, touted not just by wild-eyed outsiders but by establishment tastemakers. In general, these have left behind a sour aftertaste on account of their self-righteous political abstraction on the one hand and their seeming inability to give account of the pleasures of art-making on the other.

Some of these excesses are inherited from the critical theory pioneered by the so-called Frankfurt School. Theodor Adorno and Max Horkheimer famously elaborated the idea of the "culture industry," painting a bleak picture of the psychic consequences of the commodification of aesthetics by capitalism in Hollywood (the objects of their condemnation in *Dialectic of Enlightenment* include Orson Welles and Mickey Rooney, which seems quaint now).[8] For Adorno, repulsion toward popular culture was the flip side of an anguished passion for the more difficult efflorescences of modern art, which he argued—drawing on the rhetoric of Marxist dialectics—held out hope for some kind of experience that wasn't subordinated to the instrumentalized logic of capitalism: "A successful work of art is not one which resolves objective contradictions in a spurious harmony, but one which expresses the idea of harmony negatively by embodying the contradictions pure and uncompromised, in its innermost structure."[9]

Where does class fit in here? Even for Martin Jay, one of the Frankfurt School's more enthusiastic chroniclers, the theories of Adorno and the school around him "expressed a growing loss of confidence, which Marxists had

traditionally felt, in the revolutionary potential of the proletariat."[10] In effect, in Adorno's aesthetic theory an engagement with the working class's struggle against capital was displaced onto an investment in the artist's struggle with the baleful effects of commodification. For later artists and writers, this template provided a way to give outsized social importance to debates about modern and postmodern art that would otherwise have seemed technical and obscure. The result was a widely influential form of cultural criticism that claimed the mantle of Marxist radicalism but lacked any interest in the most vital concern of Marxism: class struggle.

Adorno was writing in the shadow of World War II, against the backdrop of murderous states waging total warfare, marshaling their populations via intensive propaganda. His views were shaped by this experience, as well as by his exposure during his sojourn in the United States to its seemingly monolithic consumer culture, with workers in his view bought off and sated by mindless entertainment. This historical context definitively colored his perspective on culture under capitalism. It is also a thing of the past. Since the 1970s, both the economy and its relation to the state have been decisively transformed, as neoliberalism pulverized old certainties about the social contract. You would, therefore, expect some kind of reevaluation of Marxism's take on culture and its relation to capitalism. And so there has been.

If the proletariat fades into the background for Adorno, a prominent recent type of Marxist-inflected art criticism has taken a different tack, actually identifying contemporary artists with the proletariat tout court. Artists may not be laborers in the traditional sense, but (so the argument goes) creativity itself has now become a dominant form of "immaterial labor" in our postindustrial economy, as the stable world of factory labor has been replaced by the more mercurial realities of a service economy. Michael Hardt, for instance, has argued flat out that "some of the qualities of artistic production . . . are becoming hegemonic and transforming other labor processes."[11] The economy is now based around manufacturing knowledge and experiences, which in turn makes it creative through and through.

Instead of artists being proletarianized, Hardt and his co-thinkers in effect hold that the entire proletariat has been aestheticized: "[artists] increasingly share labour conditions with a wide array of workers in the biopolitical economy."[12] Bizarrely, the struggles of visual artists are collapsed together with the experiences of a whole motley range of other types of intellectual and service workers—scientists, financial analysts, nurses, and Walmart greeters are mentioned in the same breath—and accorded more or less equal political potential. Any sense of what makes the specific form of labor performed by contemporary artists unique is lost in the miasma of a nebulously conceived postindustrial economy based on "immaterial labor."

Neither of these seems a particularly promising way of approaching the relationship of art to the economy. But the point here should be that these are examples of botched uses of Marxist analysis, not the real deal. "Marxism," after all, is a plastic term. It has meant many different things to many different people—from the revolutionary romanticism of Arts and Crafts guru William Morris to the bowdlerized, totalitarian ideologies associated with Stalin and Mao and the soggy, apolitical abstractions taught in the halls of academia. Setting such false interpretations aside and returning to the underexplored Marxist idea of class still promises to do what no new "Theory of the Market" does.

"The Basic Reason that Classes Exist in the First Place"

Mainstream discussion of class starts and ends with the idea that one's class is synonymous with how much money one has. To say that someone is "working class" is to say that they come from a humble background. A mainstream publication like the *Economist* has employed a technical definition of "middle class" that encompasses anyone whose income is one-third disposable.[13] Many sociologists talk of class as a cultural question, as if the difference between being middle class and working class were a matter of education or social background.

Such ways of looking at the question have their merits—income and culture are, of course, very important. However, as Michael Zweig notes in his book *The Working Class Majority*, they fail to get at the heart of the matter. "The working class does have different income, status, and lifestyles from those of the middle class and capitalist class," Zweig writes. "But if we leave the matter there, we miss the basic reason that classes exist in the first place."[14]

Defining class purely as a matter of income or wealth results in several obvious difficulties. A goal of workers organizing together in a union, for instance, is for them to raise their standard of living. If class were simply a matter of how much money you took home at the end of the week, then it would seem that the more successful the working class was at organizing to get a bigger share of the products of its labor, then the more it would actually cease to be the working class. Viewing class struggle strictly through the lens of wealth versus poverty also seriously narrows our understanding of the stakes: the dignity of working conditions, guarantees of steady employment, the right to grievance, and the intensity of the working day are all classic concerns of working-class struggle—and all of them are about more than the number on a paycheck.

At the same time, certain members of society who would intuitively seem to fit our definition of "middle class," upon consideration, turn out to be not necessarily better off than their working-class kin. Think of small business

owners. Family shops or restaurants often have the proprietor or her family members doing a large portion of the work themselves, pushing themselves to work long hours for little compensation besides the reward of keeping the enterprise going. Peasant farmers, one of the enduring examples of the petite bourgeoisie, are often dirt poor.

What, then, is a more productive way to think about class? The paradoxes listed above resolve themselves if you accept that class position relates not to how much one happens to be paid but to the *kind of labor* one does and how this labor relates to the economy. The working class is distinguished from the middle class not by how its members have more modest houses or watch different TV shows but by the level of authority they have over the conditions of their own work. Working-class people, in this definition, share a special characteristic: they have to sell their labor power as an abstract thing in order to earn a wage. As for the middle class, here is Zweig's rough definition: "It includes professional people, small business owners, and managers and supervisors who have authority over others at work. . . . Instead of seeing them as people with middling income, we will see them as people with middling authority."[15] (I'm using Zweig because of the clarity of his explanation, but actually this is a fundamental aspect of how Marxists see the world.)[16]

What, then, distinguishes middle-class business owners from out-and-out capitalists? While popular outrage justly dwells on the lavish bonuses of bankers and the lifestyles of the megarich, the factor that makes a capitalist a capitalist is also not a question of wealth or income—if a CEO proclaims that he is going to work for one dollar a year, that does not suddenly mean that he has been thrown into the working class; he has obviously not sacrificed his authority. Greed is part of what greases the wheels of the capitalist system, but there are people who are simply ideological evangelists for the good of the free market (this is, in fact, the classical meaning of "liberalism").

Zweig explains the difference between middle-class business owners and capitalists as relating to whether or not the owner works alongside her employees.[17] I think, however, that we can be even more precise. Marx defines the capitalist as being one who acts as "capital personified," as the agent who carries out capitalism's logic. In volume 1 of *Capital*, he makes a surprising remark: the ideal image of the capitalist is not the lavish-spending libertine, but the "miser," that is, someone who hoards profits for future investment rather than spending them on himself.[18]

Marx's formula for capital is M-C-M′, by which he meant that a quantity of money (M) becomes capital when it is invested in the production of a commodity (C), which is then sold again for more money (M′), in order to begin the cycle again on an expanded level. Ultimately, he remarks, in its purest form the capitalist mindset is represented by the formula M-M′. The

specific form of business involved (the C, the form of commodity involved in the process) ceases to seem important; all that matters is that investments return profits so that the cycle can be started once more.[19] A capitalist, therefore, is not just someone who has a say in how a business is run, but someone whose motivation is to run a business for the sake of profit.

That may sound quite general, but in fact it represents a mindset very different than that of the average small business owner. As a 2011 Brookings Institution study puts it, "most small businesses have little desire to grow big or to innovate in any observable way." Instead, the authors write, surveys indicate that such people as "skilled craftsmen, lawyers, real estate agents, doctors, small shopkeepers, and restaurateurs" are motivated more by "nonpecuniary" factors such as "being one's own boss, having flexibility of hours, etc."[20] Consequently, a fairly clear line of demarcation exists between middle-class and capitalist mentalities: middle-class agents are focused on their own needs or simply maintaining their autonomy; capitalist business people act in the name of profit, as "capital personified."

As an example, Zweig mentions the family doctor, a traditional representative of the middle class. Organized around private practices, doctors have had a great deal of independence and freedom. But as more and more doctors work for large health-care conglomerates, their position has changed, dragging the medical profession toward the working class. Conversely, if a doctor's personal practice grows to the point where she is more concerned with administering the labor of others and maximizing the profit of the whole enterprise in the name of competition, then she has ceased to function as a middle-class agent and become a full-on representative of capital.

As Zweig writes, "classes are not simply boxes or static categories into which we pigeonhole people." They are by their nature "a bit messy"—and indeed the particular class composition of any given professional sphere is dynamic and in constant evolution.[21]

"A Different Order of Freedom"

How does this schema apply to the visual arts sphere? More than most other creative spheres—or most contemporary "industries," period—the production of visual art is tied to the middle-class form of labor. In fact, I'd put this point in a stronger way still: the contemporary artist is the representative of middle-class creative labor par excellence.

Artists function as their own creative franchises, and are expected to have their own creative signatures or styles. Uniqueness and independence of mind are selling points when it comes to art—values that are antithetical to what is expected of ordinary workers, who must take direction and are

treated as ever more disposable (evidence is scant that the neoliberal economy, whatever its claims to celebrate creativity, has freed the average worker from these pressures). People decide to become artists—and continue to identify as artists, despite the limited prospects for success—for exactly the kind of "nonpecuniary" benefits that animate the other middle-class professionals the Brookings Institution paper mentions: the opportunity to make money doing something in which they are personally invested; freedom from the grind of an office job or more regimented forms of work; the belief that they have found a "calling" that is uniquely their own.[22]

In 2011, the National Endowment for the Arts (NEA) identified 2.1 million "artists" living in the United States.[23] However, of this total, considerably fewer than one in ten were "fine artists."[24] About 10 percent of these so-called creative laborers worked in architecture and about 17 percent in the performing arts. By far the largest portion of creative laborers—close to 40 percent—were classified as "designers" of various kinds ("graphic, commercial, and industrial designers, fashion designers, floral designers, interior designers, merchandise displayers, and set and exhibit designers").

Consequently, most of the workers in the "creative economy" of the United States are not artists in the sense we are familiar with from the visual arts sphere, creating unique art objects to be sold through galleries or seen in museums. Their working conditions are quite distinct. Industrial designers working for manufacturers or merchandise displayers working for department stores do indeed use creativity in their jobs. However, all but a lucky few superstars have no personal claim on the products of their creativity and must produce according to very specific corporate mandates. Designer Norman Potter's attempt to draw a distinction between the procedures of art and design is still illustrative here:

> Some of [the] procedures [of design] will be familiar to painters and sculptors, and certainly to filmmakers; but for them the work will have a more inward character in its origins. Thus a painter's first responsibility is to the truth of his own vision, even though that vision may (or maybe always does) change as his work proceeds. He may be involved with contractual responsibilities, but not to the same extent as is a designer, whose decisions will be crucially affected by them. The designer works with and for other people: ultimately this may be true of the fine-artist, but in the actual working procedure a designer's formative decisions have a different order of freedom.[25]

The two modes of thinking that Potter lays out may blur together at a thousand points—as Zweig says, the issue is "a bit messy." But the distinction is not a mere intellectual construction; it rests on something real. The opposition between art and design here is above all a difference between two different class-based notions of creative labor.

"You Do Realize What You're Doing to Your People, Right?"

As anyone who has ever turned on a TV during a political election cycle knows, the mythical middle class plays a role in American discourse completely out of proportion with the realities of life in the United States of America. One definition of the American Dream is, of course, owning your own business and becoming an entrepreneur. Yet such rhetoric obscures the reality of the economic situation.

"By every measure of small-business employment, the United States has among the world's smallest small-business sectors (as a proportion of total national employment)," one recent study concludes.[26] More people in the United States work for large enterprises than for small firms. Politicians' ritualistic invocation of the magical "middle class" is both a way of acknowledging the realities of the mass of working people by addressing "the little guy" and of deflecting attention from these very realities by eliding the working class.

Something similar happens when we talk about the "creative industries" in the way that the NEA does, lumping together visual art, which is created relatively autonomously, with the work produced by workers hired by large corporations and media companies. The term "artist" has connotations of freedom and personal satisfaction that can be used to obscure real relationships of exploitation when it is overgeneralized to apply to any type of labor that is deemed remotely creative. (An infamous example comes from the early days of Hollywood, when executives consciously encouraged actors, cinematographers, directors, and writers to identify their work "as skilled artistry rather than labor" in an effort to stave off a wave of unionization hitting their industry.[27])

Yet it remains crucial to stress that the difference between these modes of creative labor is not simply a matter of how we choose to define what we do; it is connected to how different types of labor *actually* operate. To illustrate this point, let's look at a few case studies, comparing the issues faced by different kinds of creative laborers.

Visual artists have a level of independence that other creative workers don't. This fact does not mean that they live in some paradise free of exploitation, however. In recent years, the New York group Working Artists in the Greater Economy (W.A.G.E.) has drawn attention to how artists are often expected to create work for free for their own museum exhibitions, thus making professional success a kind of poisoned chalice, entailing escalating expenses without the guarantee of any solid reward.

A 1973 letter from the experimental filmmaker Hollis Frampton to Museum of Modern Art (MoMA) curator Donald Richie has served W.A.G.E. as a kind of manifesto on artists' historical struggle to be paid for their work.

Having been offered a retrospective of his films but told that it would be "all for love and honor" and that "no money is included at all," Frampton listed the numerous people with whom he had worked or with whom he would work in the process of creating and showing his art—from the film manufacturer and processing lab personnel to projectionists and security guards—and asked why they should be paid for their work while he was not:

> I, in my singular person, by making this work, have already generated wealth for scores of people. Multiply that by as many other working artists as you can think of. Ask yourself whether my lab, for instance, would print my work for "love and honor." If I asked them, and they took my questions seriously, I should expect to have it explained to me, ever so gently, that human beings expect compensation for their work. The reason is simply that it enables them to continue doing what they do.
>
> But it seems that, while all these others are to be paid for their part in a show that could not have taken place without me, nonetheless, I, the artist, am not to be paid.
>
> And in fact it seems that there is no way to pay an artist for his work as an artist. I have taught, lectured, written, worked as a technician . . . and for all these collateral activities, I have been paid, have been compensated for my work. But as an artist I have been paid only on the rarest of occasions.[28]

Such concerns are not just a matter of pride. Frampton cites the case of legendary avant-garde filmmaker Maya Deren, who died at age forty-four in circumstances of extreme need despite having been celebrated for her pathbreaking contributions to cinema. In her final years, she was literally reduced to begging for money to complete her work. "I leave it to your surmise whether her life might have been prolonged by a few bucks."[29]

The issues of compensation that Frampton outlines remain today. In 2012, W.A.G.E. released a survey of close to one thousand New York artists, showing that "the majority (58.4 percent) of respondents did not receive any form of payment, compensation, or reimbursement for their participation [in shows at museums or nonprofits], including the coverage of any expenses."[30] According to the group, small organizations were about 10 percent more likely to pay a fee than larger ones—enough of a difference to suggest that the lack of compensation was not purely a matter of budgetary constraints but also of an institutional culture where the opportunity to show work is expected to be reward enough.[31]

A state of affairs that simultaneously celebrates art and devalues it is bound to provoke some angst. Returning to the orienting example of Frampton's letter, however, it bears mentioning that there *is* a difference between his labor as an artist and the labor of the other workers he mentions as benefiting from his work. In fact, the difference is encoded in the nature of the dispute

itself: MoMA's security guards and projectionists cannot decide whether or not they want to perform their roles, at least not if they want to keep their jobs; Frampton, on the other hand, retains the autonomy to say no, and can therefore bargain for better terms (whether or not he is in a position to win them). This is partly because, as he himself stated, he dedicated himself independently to creating the work in question ("the irreducible point is that I have made the work, have commissioned it of myself, under no obligation of any sort to please anyone"[32]), which therefore exists and belongs to him whether or not a museum chooses to show it. Stripped of the specifically artistic rhetoric, therefore, Frampton's position appears to be less that of a worker demanding a wage and more that of someone who owns property and hopes to rent it out. Indeed, it was a rental fee for his films, along with compensation for any expenses to him incurred doing the show, that Frampton ultimately demanded in his letter.

Perhaps it goes without saying that matters are hardly better when one descends into the more directly commercial world of galleries, though few of the stories about artists' disputes with their representation ever see the light of day. In 2011, however, the artist Dana Melamed filed a complaint against her New York gallery, Priska C. Juschka Fine Art. Among other things, Melamed claimed that the gallery had sold close to $150,000 in art at Art Basel Miami Beach in 2009 but had given her only $10,000 (contractually she was owed half); that the gallery had sold a number of her works at a discount without her permission; and that when she tried to recover her works from the gallery, in the words of the complaint, the "Defendants did not return Plaintiff's art works to her but threatened to remove Plaintiff's art work from the State of New York and to dispose it 'on the street.'" Ultimately, the case was settled in Melamed's favor in 2012.

"It's very common, and that's the problem," she said later, when interviewed about the suit. "From what I hear from other artists, it's very rare that they get paid on time."[33] This humiliating state of affairs is the reality of life even as a modestly successful artist, and the incident was widely taken as a cautionary tale about how artists need more legal protections.[34]

For the purposes of our comparison, though, some points about the specific character of Melamed's dispute are worth emphasizing. First of all, the issue did not arise at the point of the production of the artworks in question but rather from how they were circulated and sold. Second, the relationship between artist and gallery owner is explicitly conceived of, and even codified in law, as being akin to that between two business owners, with Melamed, as a producer, entering into a consignment agreement with the gallery to provide her with a service: marketing the work and brokering sales. Unlike in the case of a worker hired to produce an object for an employer, who can then sell the

resulting product for whatever he deems necessary to turn a profit, Melamed's grievance rests on a visual artist's putative right to continue to have a say over the products of her labor, even when they are out of her hands.

The issue of visual artists' rights over their works, even after sale, has been of historical importance, from the struggles over intellectual property that ignited the Art Workers' Coalition in New York in the late 1960s[35] to contemporary debates over whether artists deserve "resale royalties" for works sold on the secondary market.[36] Yet—and here is the important point, since we are talking about art and class—this kind of intimate connection with the products of one's labor is *exactly* what working-class people are denied by definition as a result of the quid pro quo that forms the central dynamic of a capitalist economy: trading your labor power for a wage. In fact, Marx's description of working-class "alienation" reads as a direct reversal of the characteristics ascribed to artistic labor (that is, that it may be pursued for personal satisfaction as well as monetary reward, or that it reflects some personal vision or investment): "The worker . . . is only himself when he does not work, and in his work he feels outside himself. He feels at home when he is not working, and when he is working he does not feel at home."[37]

Having looked at issues faced by visual artists, now let us consider some examples of disputes from another realm of the "creative economy" to see what the properly "alienated" form of creative labor looks like.

The production of software is one of the key examples offered by postindustrial theorists to prove that we have entered a new economy based on "immaterial labor"[38]; video gaming has grown to be the single largest arm of the entertainment world, surpassing the Hollywood giants that gave Adorno nightmares.[39] Countless numbers of talented computer engineers are drawn into the orbit of the video game industry because of the cachet of working in a dynamic and creative field. In 2004, an anguished blog post by the anonymous fiancée of one engineer at Electronic Arts (EA)—a company that has become a Fortune 500 behemoth in part by cannibalizing scores of independent game studios—described labor conditions where seven-day workweeks had gone from being an exception, used during "crunch" periods when completing a game, to mandatory, with no comp time, sick days, or overtime being offered. Management hid behind an exemption to California labor law for skilled "specialty" workers; complaints about physical and mental exhaustion by programmers were met with the refrain, "If they don't like it, they can work someplace else." The anonymous "EA Spouse" concluded her blog post:

> If I could get EA CEO Larry Probst on the phone, there are a few things I would ask him. "What's your salary?" would be merely a point of curiosity. The main thing I want to know is, Larry: you do realize what you're doing to your people, right? And you do realize that they ARE people, with physical limits, emotional

lives, and families, right? Voices and talents and senses of humor and all that? That when you keep our husbands and wives and children in the office for ninety hours a week, sending them home exhausted and numb and frustrated with their lives, it's not just them you're hurting, but everyone around them, everyone who loves them? When you make your profit calculations and your cost analyses, you know that a great measure of that cost is being paid in raw human dignity, right?

Right?[40]

The post touched off widespread outrage in the developer community and led to several successful class-action lawsuits. In one, EA programmer Leander Hasty (revealed to be the significant other of Erin Hoffman, also known as the "EA Spouse") stated that while they are classified as skilled laborers, he and his fellow programmers "do not perform work that is original or creative and have no management responsibilities and are seldom allowed to use their own judgment." In essence, for these computer programmers, the new creative economy had come to look very much like an old-fashioned Fordist assembly line, as one industry watcher put it.[41]

Another case: In 2012, a new push began to unionize the several hundred visual effects and animation artists at Sony Imageworks. A union drive had overwhelmingly been voted down almost a decade before, but in the interim benefits for the non-union animators had drastically eroded, even as the department became more central to Sony's operations, churning out multiple blockbusters. "No one seemed to want to admit that those benefits could all be taken away at a moment's notice," the animators attempting to organize their workplace told one industry website, "and they all eventually were."[42] Company policy appeared to be to dodge, as much as possible, the burden of offering any serious retirement or health benefits, consigning workers to permanent freelance status.

When a website dedicated to female professionals wrote a particularly sycophantic profile of Sony executive Michelle Raimo Kouyate, stressing how she maintained great work-life balance ("don't even try to tell Michelle that her rich home life—part of which unfolds at her family's vacation home in West Africa—needs come at the expense of her career"[43]), an anonymous Imageworks employee offered an angry rejoinder on the union's blog: "How do I care for my family without health insurance, sick days or vacation days while working mandatory twelve hour days, six days a week for months on end? Is the value of my children or even myself less than others?" For the author, the answer to ending this sorry state of affairs was the answer that working-class people have always turned to: "I think we can work towards all of these goals, by organizing."[44]

EA computer programmers and Sony animators may not fit our stereotypical definition of what the "working class" looks like. Many differences

separate the kind of labor they do from the textile workers of Marx's day or the autoworkers of the 1930s. But their struggles have much more in common with these classical images of the "alienated" working class than they do with those of the contemporary artists represented in the W.A.G.E. survey. Both groups are subjected to plenty of indignity and injustice—but this doesn't mean that the issues they face are the same, any more than apples and oranges are the same because they are both fruit.

"Cut Up into Two Persons"

"I think what's confusing," said Jennifer Dalton during that long-ago discussion of my *Theses* at Winkleman Gallery, "is that you say that artists are middle class, but we *feel* working class. We feel replaceable."

The issue of class has moral overtones. If politicians endlessly pay homage to the "middle class" as a way of painting a magical picture of the American economy as an even playing field where we can all potentially realize ourselves, struggling artists may claim the idea of themselves as "working class" partly as a way of putting a name on their own embattled condition and piercing stereotypes that all artists are well-to-do dandies. As the example of Melamed shows, even successful artists routinely have to fight in order to claim what should be theirs. Even more importantly, inasmuch as the vast majority of contemporary artists do not actually make a living through their art but get by through a variety of other jobs, they are in actual fact members of the working class.

The theory that contemporary art is characteristically middle class may sound dismissive, as if it were a way of saying that artists' grievances aren't as significant as those faced by "real" workers. This is far from the case. It might be important to remember, therefore, that the reason Marxists look to the working class is not *moral*. Marx and Engels's attachment to the working class was definitely not just a modified version of the biblical promise that "the meek shall inherit the Earth" or that "the last shall be first."

Rather, it was their contention that the working class was exploited, but also uniquely positioned to be a revolutionary agent in a capitalist society. Capitalists had become the dominant class; capitalism had created a vastly productive, interconnected world economy (albeit one that ran on truly shortsighted logic and inequality); and the working class had a special relationship to maintaining this system. That is, workers collectively do the work that makes this sprawling system function and it therefore needs them on an ongoing basis, day in and day out. This fact gives them special power. Among other things, it gives them a unique weapon, the strike, which no other group can claim. By simply uniting and making a collective decision *not* to work, the working class can wield tremendous power.

It has become fashionable among aesthetic theorists invested in "immaterial labor" as a new capitalist norm to assume that Marx and Engels's faith in the proletariat was misplaced. It used to be that pundits would argue that workers in the United States were too comfortable, too bought off by capitalism. These days, it is more common to argue the reverse, that the working class under conditions of globalization and neoliberalism has become too unstable, too decomposed to ever have hope of political solidarity or united action. Marxism, we are told, is applicable only to old-fashioned factory workers—a condition of labor in nineteenth-century Europe that no longer holds under contemporary technological capitalism. Adam Turl has neatly summed up the host of distortions that underlie these various theories:

> What most post-industrial concepts have in common . . . is that they narrowly identify the working class as industrial workers, rather than the class of wage workers as a whole, which also includes white-collar workers, service workers, transportation workers, and so on. They also mistakenly associate the relative decline in the number of industrial workers with their declining social weight in the economy, when rising productivity in industry actually increases the potential power of industrial workers even if their relative numbers might diminish. Finally, post-industrial theory tends to conflate the decline in labor parties, trade unions, and other forms of traditional working-class organizations—the product of several decades of neoliberal attacks—with structural changes that they argue render the class less powerful, or even powerless.
>
> The Marxist concept of the working class is far more dynamic. While employers utilize structural shifts—deregulation, industrial decline in one region, and so on—to weaken working-class organization and lower labor costs, these changes are not permanent barriers to working-class struggle. On the contrary, they guarantee that the working class will be compelled to resist. The revival of such resistance is a political and organizational question rather than a structural one. Marxism locates within capitalism—driven to accumulate capital through the expropriation of surplus value—the class whose labor turns the wheels of production, however shaped, and therefore possesses the power to transform it. The working class, though its structure has changed dramatically over time, still possesses the centrality and power attributed to it by Karl Marx and Frederick Engels when they wrote the *Communist Manifesto*.[45]

In other words, economic and political theories that dwell on an insurmountable new "postindustrial" condition suffer from a faulty theory of class, no less than the aesthetic theories we looked at earlier. Yet nothing in this theory says that other classes or social groups don't have real grievances or participate in social struggle. The unemployed, students, and others can and do play decisive political roles. What the Marxist emphasis on the working class *does* indicate is the pragmatic reality that, in a capitalist world, the working class has a form of social power and a key role to play that these other

groups don't, and that politics rooted in these other groups will have an in-built limit in the absence of a connection with an organized working class because systematic change requires some systematic way to challenge power. As the *Manifesto* states (rather sternly) of the middle class:

> The lower middle class, the small manufacturer, the shopkeeper, the artisan, the peasant, all these fight against the bourgeoisie, to save from extinction their existence as fractions of the middle class. They are therefore not revolutionary, but conservative. Nay more, they are reactionary, for they try to roll back the wheel of history. If by chance they are revolutionary, they are so only in view of their impending transfer into the proletariat, they thus defend not their present, but their future interests, they desert their own standpoint to place themselves at that of the proletariat.[46]

For middle-class agents to become effectively political involves them decisively breaking with the biases associated with their own class, because in a society where the relationship between capitalist and worker is the most important one, the middle class occupies a vacillating center position. Marx himself writes, in *Theories of Surplus Value*, that a member of the petite bourgeoisie "is cut up into two persons. . . . As owner of the means of production he is a capitalist; as a labourer he is his own wage-labourer."[47] Among professional artists or those who aspire to be professional artists, it is this characteristically middle-class split that explains the seemingly paradoxical political temperament that observers often find, with artists pulled between egalitarianism and meritocracy, caught between what they have to gain from class struggle and what they have to lose.[48] Lucy Lippard captures this contradiction beautifully in "The Pink Glass Swan," her classic essay about artists and class:

> Looking at and "appreciating" art in [the twentieth century] has been understood as an instrument (or at best a result) of upward social mobility, in which owning art is the ultimate step. Making art is at the bottom of the scale. This is the only legitimate reason to see artists as so many artists see themselves—as "workers." At the same time, artists/makers tend to feel misunderstood and, as creators, innately superior to the buyers/owners. The innermost circle of the art-world class system thereby replaces the rulers with the creators, and the contemporary artist in the big city (read New York) is a schizophrenic creature. S/he is persistently working "up" to be accepted, not only by other artists, but also by the hierarchy that exhibits, writes about, and buys her/his work. At the same time s/he is often ideologically working "down" in an attempt to identify with the workers outside of the art context and to overthrow the rulers in the name of art.[49]

Among other things, such an internally divided temperament accounts for the historical difficulty in organizing artists into any sort of coherent political formation. Visual artists, in fact, are not unlike the peasants Marx memorably described in *The Eighteenth Brumaire of Louis Bonaparte* as being

"formed by the simple addition of homologous magnitudes, much as pota-
toes in a sack form a sack of potatoes."[50] Peasants' lives were rooted in the
form of small property; their collective interests didn't fuse into anything
greater but merely formed an aggregation of individual units, making them
politically weak though numerically vast.

Contemporary artists—highly educated, concentrated in urban centers
where they often interact professionally, and moreover thrown back into the
working class because of the capricious nature of the art market—are gen-
erally much more naturally radical than the peasantry that formed the back-
bone of reaction in France. Their conditions are similar, however, in that *as
artists* their collective labor doesn't really add up to anything larger and is
not related to any larger institution that they could take control of collec-
tively. Artists merely form a collection of individualities, of individual fran-
chises jostling to distinguish themselves from one another.

The upshot is that visual artists' middle-class position is not merely a limit
on their relation to larger social struggle but also on their ability to organize
to transform *their own* conditions. Attempts to organize artists to address in-
equality have generally run aground on a simple but crucial issue: what in-
stitution is there to which they could relate in order to make collective
demands? What power do they have besides moral authority? As Carl Andre,
once an advocate of identifying radical art with blue-collar labor, said in
1979 when asked to join in a global "artist strike" against the system, "From
whom would artists be withholding their art if they did go on strike? Alas,
from no one but themselves."[51]

Still, this reality doesn't mean that artists' protests cannot have a real and
vital impact. In some ways, you could even say that the very unattached nature
of artistic struggle gives it a certain mercurial power that can help serve as a
detonator for wider change. To return to the example of the Art Workers' Coali-
tion, after forming in the late sixties to take on a wide range of issues affecting
artists—from MoMA's silence on the war in Vietnam to the museum's "black-
mail" of painters into donating work to its collection[52]—it collapsed after a
few short years, undone by its wildly eclectic nature and endless squabbling.
However, in the meantime, its highly visible pickets and outspoken protests at
MoMA played a role in inspiring the museum's workers to unionize.[53]

Consequences and Contradictions

At the end of this long journey, what has been gained by clarifying the
class dynamics of contemporary artistic labor?

Among other things, clearly mapping the relation of art and class helps to
sharpen our understanding of what continues to make visual art unique and

therefore aids our understanding of what makes it interesting. Whatever the twists and turns of art-making in its "post-conceptual," "post-studio," "relational" era, visual art still remains rooted in a notion of labor that puts it at a right angle to the way work is experienced in much of the rest of our capitalist world. Visual art still holds the allure of being basically a middle-class field, where personal agency and professional ambition overlap. Such an admission saves you to some degree from the Manichean position of seeing art as either commercial and corrupt or noncommercial and pure (á la Stallabrass).

But there's something else. A clear idea of class can also give a sense of the real stakes of art, providing a much-needed dose of realism. Even the best art theory can make fantastically overblown claims (Adorno's notion of art as consciousness's last tortured stand against capitalism or Hardt's idea of art as a model for postindustrial "immaterial labor" in general). Art theory, in other words, suffers from an overinflated sense of its own importance. In a society overwhelmingly dominated by corporations and wage labor, accepting that visual art is middle class in nature also means beginning to see the natural limits of what you can promise for it as a critic or expect of it as an artist. That gives you a more realistic starting point for action.

I wrote earlier that the theory of class might provide the missing center of the debate about art. But in some ways, I confess, I think of it as decentering. Very intelligent people used to believe fervently that the heavens revolved around the Earth, a model inherited from a superannuated past and maintained by adding greater and greater layers of useless intellectual refinement as new phenomena were observed. For artists and critics, accepting the middle-class definition of artistic labor might be something like the shift away from the geocentric cosmology. It might allow them to cut through casuistic arguments and provide a much more reliable model for understanding the motion of the "art world" as it sails through the cultural firmament.

What is lost may be the mystified but comforting sense of self-importance that comes with believing that you are at the center of the universe. What is gained in return, however, will be a more scientific understanding of the forces that actually govern that universe—and that is worth the trade.

TWO

9.5 Theses on Art and Class

1.0 Class is an issue of fundamental importance for art.

1.1 Inasmuch as art is part of and not independent of society, and society is marked by class divisions, these will also affect the functioning and character of the sphere of the visual arts.

1.2 Since different classes have different interests and "art" is affected by these different interests, art has different values depending on from which class standpoint it is approached.

1.3 Understanding art means understanding class relations outside the sphere of the visual arts and how they affect that sphere as well as understanding class relations within the sphere of the visual arts itself.

1.4 In general, the idea of the "art world" serves as a way to deflect consideration of both these sets of relations.

1.5 The notion of an "art world" implies a sphere that is separate or set aside from the issues of the non-art world (and so separates it from class issues outside that sphere).

1.6 The notion of an "art world" also visualizes the sphere of the visual arts not as a set of conflicting interests, but as a confluence of professionals with a common interest: "art" (and so denies class relations within that sphere).

1.7 Anxiety about class in the sphere of the visual arts manifests in critiques of the "art market"; however, a critique of the art market is not the same as a critique of class in the sphere of the visual arts. Class is an issue that is more fundamental and determinate than the market.

1.8 The "art market" is approached differently by different classes; discussing the art market in the absence of understanding class interests serves to obscure the actual forces determining art's situation.

1.9 Since class is a fundamental issue for art, art can't have any clear idea of its own nature unless it has a clear idea of the interests of different classes.

2.0 Today, the ruling class, which is capitalist, dominates the sphere of the visual arts.

2.1 It is part of the definition of a ruling class that it controls the material resources of society.

2.2 The ruling ideologies of society, which serve to reproduce this material situation, also represent the interests of the ruling class.

2.3 The dominant values given to art, therefore, will be ones that serve the interests of the current ruling class.

2.4 Concretely, within the sphere of the contemporary visual arts, the agents whose interests determine the dominant values of art are: large corporations, including auction houses and corporate collectors; art investors, private collectors, and patrons; and trustees and administrators of large cultural institutions and universities.

2.5 One role for art, therefore, is as a luxury good, whose superior craftsmanship or intellectual prestige indicates superior social status.

2.6 Another role for art is to serve as financial instrument or tradable repository of value.

2.7 Another role for art is as a sign of "giving back" to the community, to whitewash ill-gotten gains.

2.8 Another role for art is as a symbolic escape valve for radical impulses, to serve as a place to isolate and contain social energy that runs counter to the dominant ideology.

2.9 A final role for art is the self-replication of ruling-class ideology about art itself—the dominant values given to art serve not only to enact ruling-class values directly but also to subjugate, within the sphere of the arts, other possible values of art.

3.0 Though ruling-class ideology is ultimately dominant within the sphere of the arts, the predominant character of this sphere is middle class.

3.1 "Middle class" in this context does not indicate income level. It indicates a mode of relating to labor and the means of production. "Middle class" here indicates having an individual, self-directed relationship to production rather than administering and maximizing the profit produced by the labor of others (capitalist class) or selling one's labor power (working class).

3.2 The position of the professional artist is characteristically middle class in relation to labor: the dream of being an artist is the dream of making a living off the products of one's own mental or physical labor while being fully able to control and identify with that labor.

3.3 A distinctive characteristic of the visual arts sphere, therefore, is that it is a sphere in which ruling-class ideology dominates, and yet it is allowed to have an unusually middle-class character (in fact, it is by definition middle class—the "art world" is defined as the sphere that trades in individual products of creativity rather than mass-produced creativity).

3.4 In part, the middle-class character of the visual arts relates to 2.5–2.8 above. From a ruling-class perspective, it is beneficial to promote the example of middle-class creative labor for a variety of reasons.

3.5 Nevertheless, the middle-class perspective on the value and role of art is not identical to the ruling-class one; artists have their own way of relating to their labor and consequently their own value for "art."

3.6 The middle-class value of art is double-sided: on the one hand, "art" is identified as a profession, as a desirable means of support.

3.7 On the other hand, "art" is identified as self-expression, as a manifestation of creative individuality (whether that is expressed through a specific style of craftsmanship or as an original intellectual program; art-theory debates about the importance of the hand of the artist or "studio" versus "post-studio" production displace this more fundamental and structural sense in which the sphere of the visual arts preserves individuality).

3.8 Two permanent contradictions therefore dominate the sphere of the visual arts. The first contradiction is between the fact that the visual arts are dominated by ruling-class values but defined by their middle-class character.

3.9 The second contradiction is internal to the middle-class definition of "art" itself, which is split between notions of art as profession and as vocation and therefore comes into contradiction with itself at every moment where what an artist wants to express runs into opposition with the demands of making a living (in a situation where a minority dominates most of society's resources, this is often).

4.0 The sphere of the visual arts has weak relations with the working class.

4.1 The working class here is defined as consisting of those laborers who are compelled to sell their labor power as a commodity to make a living and therefore have no individual stake in their labor.

4.2 There are many links to the working class in the visual arts: gallery workers, anonymous fabricators of artistic components, nonprofessional museum workers, and so on. Most artists are themselves employed outside the "art world"—the dream of having fully realized middle-class status remains aspirational for most people who identify as "artists."

4.3 Still, the form of labor at the heart of the sphere of the visual arts, the

production of artworks, remains middle class—far more so than most other so-called creative industries.

4.4 One consequence of this predominantly middle-class character is the visual arts' approach to dealing with the social and economic contradictions that it faces. An individualized relation to labor means that middle-class agents tend to conceive of their ability to achieve their political objectives in individualistic terms, with their social power deriving from intellectual capacity, personality, or rhetoric (it is this reality that is behind the displacement of the discussion about art's contradictions onto considerations of the "market"—a construct in which free individuals enter into economic relations with one another—rather than considerations of "class," a concept that implies fundamental, opposing interests that go beyond the individual).

4.5 On the other hand, because being a member of the working class involves being treated as an abstract, interchangeable source of labor, the working class's ability to achieve its objectives depends much more on its ability to organize collectively. This is a form of resistance that is difficult to achieve within the sphere of the arts (all talk of an "artists' strike" remains satirical outside a situation like that of the 1930s government art support in the United States, where artists are employed as a bloc).

4.6 Because the ruling structure of society is capitalist—that is, the exploitation of wage labor to maximize profit—the working-class position is actually closer to the core of society's functioning than that of the middle class; middle-class workers, by the very nature of their semi-independence, have only the ability to shut down their own production, whereas an organized working class can directly affect the ruling class's interests.

4.7 The specific nature of the working class suggests its own relation to the concept of "art," distinct from either capitalist or middle-class notions.

4.8 On the one hand, one working-class value of art is determined by the reality of "creative industries," in which creative laborers are employed who have a working-class relation to the products of their expression; that is, they produce creative products not as an expression of their individuality but simply as a task. Viewed from this angle, "art" is demystified—it is not a uniquely exalted form of expression but simply one more human process that is the subject of labor.

4.9 On the other hand, inasmuch as working-class labor is controlled from above, the ideal of "art" might also represent a form of labor that is opposed to the demands of work, as freely determined expression, whether private or political. Viewed from this angle, art is deprofession-

alized and in this sense is actually more "free" than the middle-class ideal of personal-expression-as-career.

5.0 The idea of "art" has a basic and general human sense on which no specific profession or class has a monopoly.

5.1 "Art," conceived of as creative expression in general, can be seen as representing a function as basic as exercise or dialogue and a need only slightly less fundamental than eating or sex ("slightly less fundamental" because the question of creative expression comes after simple survival—you must first secure food before you can think of cuisine).

5.2 Conceived of in this way, every human activity has an artistic component, an aspect under which it can be viewed as "creative."

5.3 However, in any given historical situation, some forms of creative labor are valued over others; some types of labor are considered more exalted, others less so.

5.4 Which of the various forms of labor are considered truly "artistic" on their own is governed by the present ruling class [2.2], which presides over the dominant relations of production and by this means has influence over both the character of non-artistic "labor" and the value of "art," as well as the intersections between them.

5.5 However, the general artistic impulse does not simply vanish in the face of its specific historical determinations; insofar as a basic sense of art as creative expression exists, humans also have a certain day-to-day creative investment in their labor, since all labor is the creative transformation of matter or life.

5.6 On the other hand, insofar as the general impulse toward creativity is cramped and thwarted by the demands of a specific historical setup, there exists the impulse to escape these and express freely outside of them.

5.7 Because "art," in the sense of general creative expression, is a basic impulse, no class has a monopoly on it; however, the organic worldviews of different classes can be closer or farther from expressing the possibilities of its general realization.

5.8 Both ruling- and middle-class worldviews preclude the idea of "art" as general human expression: the ruling class because it defines the value of art according to the interests of a narrow minority; the middle class because its interest involves defining creativity as professional self-expression, which therefore restricts it to creative experts.

5.9 The working-class perspective, then, can be seen to reflect the most organic contemporary conception of generalized creative expression (even

if circumstances don't always allow this conception to be developed or expressed)—"art," in this light, is at once a subject of labor just like any other [4.8] and opposed to the alienation of the present-day labor process [4.9]. It is therefore implicitly free of any professional determination and common to all (though this aspect, in the present ideological setup, is often channeled into middle-class creative aspirations—which can itself be seen as one of uses of the "art world" for the ruling class [2.8 and, following from this, 2.9]).

6.0 Because art is part of society [1.1] and because no single profession has a monopoly on creative expression [5.0], the values given to art within the sphere of the contemporary visual arts will also be determined in relation to how "creativity" is manifested in other spheres of contemporary society.

6.1 "Art" in common parlance has a double meaning: It designates creative activity in general and represents work that circulates within the specific tradition and set of institutions of the visual arts; thus, something can be "art" (that is, creative) but not "Art" (that is, not fit within the visual arts sphere), or something can be "Art" (that is, can be easily classifiable within the sphere of the visual arts) but not be "art" (that is, not be particularly creative).

6.2 Contemporary visual art therefore has a paradoxical character: It is a specific creative discipline that arrogates to itself the status of representing "creativity" in general (when someone says that he is professionally an "artist," he is often both trying to indicate that he works within a certain set of traditions and institutions and implying that his labor has a certain especially creative character).

6.3 This overlap stems from the middle-class character of the contemporary visual arts—the middle-class perspective being precisely the one in which one's investment in creativity in general overlaps with one's professional identity.

6.4 However, equally paradoxically, contemporary visual art, as opposed to every other type of creative labor (music, film, acting, graphic design, cake decoration) has no specific medium—that is, no specific form of labor—attached to it; when you say that you are an "artist," you imply nothing about the specific character of your work (contemporary art, in this way, is a kind of reductio ad absurdum of the idea of creative individuality).

6.5 This lack of definition is in inverse proportion to the extreme hyper-definition of labor in a variety of other contemporary creative industries—

video games, film, and television all involve creative labor employed on a massive, impersonal, and very specialized level.

6.6 Because capitalist relations of production are the dominant relations of production and these other "creative industries" are more fully organized around capitalist production, they also have a more central importance to contemporary society—they are at the center of innovation, investment, and public attention on a level with which the sphere of the visual arts cannot by itself compete.

6.7 Nevertheless, while it cannot compete with these industries, contemporary art takes on its significance in relation to them—while they represent creativity tailored to capitalist specifications, the sphere of the visual arts generates its cachet precisely as the sphere in which individual quality and intellectual independence are preserved (in much the same way that politicians avoid talking about the working class by talking endlessly about the importance of the middle class, an exaggerated intellectual significance is given to the importance of the middle-class "art world" to escape the reality of the extent to which contemporary creativity is dominated by impersonal industry).

6.8 The visual arts, in relation to visual culture or culture in general, thus finds itself with few stable paths. It can attempt to merge with these other, fully capitalist creative spheres, but only as a junior partner—it does so at the cost of giving up its reason for existing as a separate, privileged sphere at all, which is that it represents autonomous creativity not directed by the pure profit motive.

6.9 On the other hand, contemporary visual art also faces a dilemma if it does not engage with other, more dominant creative industries; in that case, its audience becomes narrowed to only the very rich and those who have the privilege to have been educated in its traditions, which makes clear the narrow horizon, and, consequently, lack of freedom within which this supposedly free form of expression maneuvers.

7.0 Art criticism, to be relevant, should be based on an analysis of the actual situation of art and the different values at play, which are related to different classes [this point simply draws the conclusion, for criticism, of 1.9].

7.1 Art criticism is itself a middle-class discipline, based on norms of individual intellectual expression; since relevant art criticism involves analysis of the actual class situation of art, it involves transcending purely subjective, individual, professional opinion.

7.2 However, transcending purely "subjective" criticism does not imply the false "objectivity" of art criticism that imposes a philosophical or polit-

ical program on art; this sort of scholastic criticism equally implies a middle-class perspective (often one based in the academy), insofar as it advances a purely abstract, intellectual program and fails to address the actual social situation of the visual arts (for example, simply insisting that art "be political" without seriously analyzing for whom or to what ends "political art" is directed actually reinforces the framework of individualistic, professional expression).

7.3 Acknowledging that contemporary art has a middle-class character is not the same as denouncing the sphere of the visual arts for "petit-bourgeois decadence"; one must judge art in terms of the contradictory values given to it by competing class interests, which in part means recognizing the sphere of the visual arts as a significant repository of legitimate hopes for self-expression. Insofar as contemporary society thwarts or distorts self-expression, the urge to follow one's own creative path can itself be a political impulse.

7.4 However, the middle-class character of the visual arts does mean that this sphere is faced with certain dilemmas [see, for instance, 3.8, 3.9, 6.8, 6.9] that cannot be resolved within that sphere itself as it is currently constituted [4.5, 4.6]; a realistic and effective critical worldview starts from this standpoint.

7.5 Artistic quality is not something that can be judged independently of questions of class and the present balance of class forces because different classes have different values for art that imply different criteria of success [see theses 2, 3, 4].

7.6 Insofar as different class influences are at play in the visual arts, an artwork is never reducible to one meaning; quite often, artworks amount to compromises, attempting to resolve a number of different influences into a single artistic formula (a work might, for instance, be executed in a style that is attractive to art collectors, but also attempt to put an original professional signature on it and at the same time express some type of sincere political solidarity).

7.7 To state that every contemporary work of art will by definition be a product of contemporary society and thus bear the marks of the contradictions of its actual material situation does not imply that all art can be reduced to the same problem. Effective art criticism implies having a dynamic analysis of how specific aesthetic values are related to the present balance of forces and making a judgment with regard to what factors are playing the most crucial role at any given moment with any given work.

7.8 There is an aspect of taste that implies nothing political and is simply

the product of personal experience and history (that is, there is no contradiction if two people have the same political analysis of the world but different aesthetic preferences). But such judgments are of secondary importance here. "I liked this" is a legitimate opinion, but it is not criticism that is serious, interesting, or useful.

7.9 Art criticism is not political because it imposes a political framework on contemporary art but because accurately representing art's real situation implies understanding the dilemmas of middle-class creative labor in a capitalist world [see 3.8, 3.9] and, therefore, implies a political critique of that setup.

8.0 The relative strength of different values of art within the sphere of the visual arts is the product of a specific balance of class forces; there can be more or less progressive situations for contemporary art, even in a capitalist world, depending on the strengths of these different classes and what demands they are able to advance.

8.1 These demands, to be effective, should be organically connected to actual struggle—they cannot be an abstract program cooked up by a few and imposed as a program for art without any connection to actual movements within that sphere. Nevertheless, some provisional suggestions can be advanced, flowing from the analysis in the preceding theses. All of the following ideas have some support and expression, currently— the trick is to extend such initiatives to the point where they become more than purely symbolic gestures [thus fitting the criteria of 2.8] and are strong enough to shift the dominant values of art.

8.2 Above all, private capital has disproportionate influence on the visual arts; therefore, increased public funding for arts institutions can have the effect of reducing the intensity of the contradiction facing the visual arts.

8.3 Such institutions should be democratically accountable to the communities they serve, so as not to replicate the effect of top-down influence on art through bureaucratic directives; currently existing institutions should be made more democratic; institutions should pay the artists they exhibit, rather than exploiting artists' professional aspirations by extracting free work from them.

8.4 Art's current definition as a luxury good, or as the primary concern of a specific professional sphere, limits its full significance. Programs should be launched and supported that offer venues for artistic activity that are not necessarily aimed at the rich or already initiated.

8.5 Research and critical projects should be funded that investigate, explore, and support, on a large scale, alternative definitions and sites for creativ-

ity; "art" is not always produced by or for the market, a fact that should be a fundamental starting point (this involves transcending the "critique of the art market" paradigm, which assumes that the problem is simply making the market more democratic).

8.6 Contemporary art suffers from a narrow audience. Access to art education is largely (and increasingly) determined by income level and privilege; art education should be defended and made universal (this point itself involves a critique of the notion that art is a luxury).

8.7 There is no reason why the immense quantity of artistic talent that currently exists, unable to find purchase within the cramped confines of the professional "art world," could not be put to work generalizing art education, thereby providing itself with a future audience.

8.8 This kind of common identity could form the basis for organizing artists as something more than individual agents, each working on a separate project; it therefore would also lay the foundation for a more organically political character for contemporary art.

8.9 Creative expression needs to be redefined. It should not be thought of as a privilege but as a basic human need. Because creative expression is a basic human need, it should be treated as a right to which everyone is entitled.

9.0 The sphere of the visual arts is an important symbolic site of struggle; however, because of its middle-class character, it has relatively little effective social power [4.5].

9.1 Achieving the reform objectives of thesis 8, therefore, entails that the sphere of the visual arts transcend itself and purely "art-world" concerns; such reforms will be best achieved by linking up with struggles outside of the sphere of the visual arts (for instance, linking the fight for art to the fight for education [8.6]).

9.2 Whatever these specific struggles are, it is an organized working class that is best placed to challenge dominant ruling-class relations [4.6], which is the precondition for challenging dominant ruling-class values of art and improving the situation of art.

9.3 The dual working-class values for "art" [4.8, 4.9]—as the subject of normal labor and as free expression in surplus of the demands of day-to-day labor—seem to imply a contradiction; this contradiction, however, is based on the current economic setup, in which a ruling-class minority dictates the conditions of work.

9.4 Such a contradiction is transcended in a situation in which laborers dem-

ocratically control the character of their own labor, and, consequently, the terms of their own leisure; it is only such a state of affairs that offers the potential for the maximum flourishing of human artistic potential.

9.5 It is toward such a perspective, which involves changing the material basis of society, that those who care about art should turn. In the absence of such a perspective in the sphere of the visual arts, its representatives will turn in circles, responding to the same problems without ever arriving at a solution. Art's situation will remain fraught and contradictory; its full potential will remain unrealized.

Art and Politics

Trevor Paglen, *N5177C at Gold Coast Terminal, Las Vegas, NV, Distance ~ 1 mile*
C-Print, 40 x 50 inches, 2007. Courtesy of the artist.

THREE

What Good Is Political Art in Times Like These?

It is one thing to argue about the relationship between art and politics when social movements are at a low tide, when political struggle is episodic or mainly defensive—as it has been for the last three decades or so. But it is quite another to take up the question when there are movements in the streets, when political struggle is back on the agenda. Who knows what the future may hold, but one can at least seize the moment to look at the question again, letting new events shake up old certainties.

I wrote the first version of this essay during the explosion of revolutionary energy in early 2011. A mass uprising had just toppled a dictator in Tunisia. In Egypt, the hated thirty-year reign of Hosni Mubarak had just been overthrown, and Tahrir Square was poised to enter popular mythology as a symbol of the heroism of ordinary people standing up for themselves. The civil wars in Libya and Syria were still in the future, as were the ongoing struggles in Egypt that followed the fall of the tyrant.

In Wisconsin, the lessons of Tahrir were not lost on US workers. Faced with a right-wing attack on the rights of public-sector workers, protesters carrying signs that read "Fight Like an Egyptian" or that branded their governor "Scott 'Hosni' Walker" flooded the capitol building in Madison and occupied it. In retrospect, the occupation in Madison—which went down in defeat—set the stage for the Occupy Wall Street movement that erupted in the fall, also inspired by the sit-ins in Tahrir. Its forms multiplied themselves across the world, holding the center of discussion for months and transforming the discussion of inequality. For the three decades I have lived, it was the most consequential chain of political events I had witnessed.

If it seems trivial to think about aesthetic affairs amid such epoch-shaping political events, that is indeed part of my point. As images of Tahrir Square filled the airwaves around the world, I found myself writing to artists in Egypt for an article about how they were responding to the uprising. An Egyptian painter wrote back, chiding me via email and questioning the terms of the inquiry. "It's not about artists now," she wrote. "It's about all Egyptians." She was right.

41

Of course, many artists lent their passions to the struggle in Egypt. The occupation of Tahrir Square itself had a creative dimension that went beyond the participation of professional artists, at some moments taking on the aspect of the "carnival of the oppressed" about which students of revolutionary literature have read, with quickly conceived street theater and plucky graffiti helping to maintain spirits or simply expressing participants' newfound sense of self-confidence. But professional artists were indisputably a part of the drama. Participating in the streets, some even gave their lives in the fight to bring down the dictator, as was the case with thirty-two-year-old sound artist Ahmed Bassiouny, who was felled by Egyptian security forces in the early days of the uprising and became one of the martyrs of the struggle. (His work—both his art and video he had taken of the protests—represented Egypt at the 2011 Venice Biennale.)

The crucial thing about that Egyptian artist's emailed objection for me, however, was the way it clearly laid out the stakes of the rift between art and politics, a rift that becomes all the more stark during moments of high political drama. Amid the fury and urgency of revolt, the most important questions are not artistic ones. This may seem obvious. But it is light-years away from how the perennial subject of "political art" has been approached in the visual arts in the recent past.

Art-making can take place within political movements, certainly. But an overemphasis on the creation of individual, signature forms—a professional requirement—can just as often make it a distraction from the needs of an actual movement, which are after all collective, welding together tastes of all kinds. The art-historical celebration of the touchstones of "political art" often has altogether too little to say about the complexities of the political questions in which artists were involved and, therefore, becomes a kind of static hero worship.

Let's begin by taking a look at three of these touchstones to see what they tell us about just how art has related to politics in practice.

- Vladimir Tatlin's *Monument to the Third International* has entered the history books as the classic symbol of the optimistic spirit of the early Russian Revolution. Never realized, the proposal for a spiraling tower was meant to be a triumphant three hundred feet taller than the Eiffel Tower, every inch of it imbued with industrial-esoteric symbolism. The spiral represented Marxist dialectical materialism; the tilt of the tower mirrored that of the Earth and was to aim the structure at the North Star; the massive buildings cradled within its scaffolding were meant to reflect the forms of the primary Platonic shapes—square, circle (cylinder), and triangle.

 Tatlin himself coined the Russian Constructivists' motivating motto, "Art Into Life," a slogan meant to indicate art's new and progressive en-

gagement with practical problems to match the revolutionary moment. It is notable, then, that the poetic, megalomaniacal *Monument to the Third International* was completely impossible to realize and could definitely not be put "into life." In fact, the years when he was engaged in propagandizing for it, between 1918 and 1921, coincided closely with the savagery of the Russian civil war, when Russian industry was wiped out, millions of lives were sucked into the fratricidal vortex, and desperate shortages of basic foodstuffs afflicted city and countryside alike. The Third International, the organization for which the tower was proposed as a headquarters, was a coordinating committee of world Communist Parties meant to spread the revolution internationally—an urgent and immediate task, since the Bolsheviks were keenly aware that without a like-minded workers' revolution in Germany, they could not sustain their own tenuous social gains.

While *Monument to the Third International* reflects the amazing optimism inspired by the revolution in some sectors of the Russian intelligentsia, it equally reflects the isolation of their art from the practical problems of the moment (which is exactly how revolutionary leader Leon Trotsky spoke of it in his *Literature and Revolution*.[1]) As for Tatlin himself, though he served in the revolutionary socialist government as director of public monuments, he seems to have been as inspired by the mystical numerology of poet Velimir Khlebnikov (who believed that the secret to the universe was the number 317) as he was by Marx and Engels.

- Pablo Picasso's *Guernica* almost certainly takes the prize as the most iconic work of political art of the twentieth century, its imagery synonymous with the antiwar movement and perennially reborn on placards at protests everywhere. The frieze-sized painting was imagined as a response to one of the inaugural atrocities of modern warfare, the 1937 air raid by German bombers in support of the fascist general Franco against the culturally important Basque hamlet of Guernica. This calculated slaughter of a civilian population was intended to cow the Spanish Republicans and made an indelible impression on the Spanish artist, then living in France. At the time of the massacre, Picasso—already the world's most famous painter—had been asked by the Republican government to make a piece in support of the cause for the World's Fair in Paris. The bombing gave him his subject.

The result was, indeed, a propaganda coup for the Republicans. After its appearance at the fair, partisans sought to leverage the fame of *Guernica* by touring it to England to raise support for the cause in 1938. Its display at the Whitechapel Gallery, which is supposed to have drawn some fifteen thousand curious visitors, provoked the following scene, one of the more moving footnotes in modernist history: "The most remarkable addition to the *Guernica* exhibit was the serried ranks of worker men's boots that were

left like ex-votos at the painting's base: the price of admission was a pair of boots, in a fit state to be sent to the Spanish front, a generous gesture that considering Barcelona's imminent fall now seemed increasingly futile."[2]

All this makes *Guernica* an indubitably heroic example of political art— but what still has to be reckoned with is the much-remarked-upon fact that the content of the painting seems to have remarkably little in it that is specific to the bombardment of the town of Guernica itself. Picasso had developed the motifs and even specific passages of the work in previous, apolitical works. The miasma of screaming figures, while admirably evocative of the anguish of war, contains not a single reference to the terrors of modern warfare—a bare lightbulb is the only suggestion of the present day at all. *Guernica*, therefore, is above all a vivid example of how, in the relationship of art and politics, the political movement of which an artwork is part determines its overriding power, trajectory, and meaning. (For his part, the still-basically-apolitical Picasso would join the French Communist Party after the war, in blissful ignorance of Moscow's role in undercutting the cause of the Spanish Revolution during the civil war.)

- Hélio Oiticica, grandson of an anarchist professor and son of one of Brazil's first experimental photographers, has the unique distinction of having sparked an entire political-cultural movement. Affiliated with the Neo-Concretist group, he came of creative age amid the very specific conjunction of forces of Brazil in the 1960s. A dictatorship had seized power in 1964 and set itself the task of capitalist modernization. In Latin America, such developmentalist philosophies found a cultural parallel with elites' fascination with the streamlined forms of European modernism. Brasília, the purpose-built modernist capital, had opened at the beginning of the decade, a powerful symbol of this fusion. Radicalizing against this backdrop, Oiticica set himself the task of articulating a defiantly indigenous form of avant-garde art, looking to meld European aesthetic traditions with a romanticized vision of the popular participatory spectacle of Brazil's Carnival.

 The result was a prescient series of projects that made a virtue of participation: artworks that were meant to be worn (his cape-like *Parangolés*), handled (his box-like *Bólides*), or walked through (his proto-environmental artworks, known as *Penetráveis*). Such interactive art struck "against everything that is oppressive, socially and individually— all the fixed and decadent forms of government, of reigning social structures," he declared.[3] In 1967, he showed his landmark installation *Tropicália* in the "New Brazilian Objectivity" show at Rio's Museum of Modern Art, a labyrinth-like environment that invited viewers to explore "a tropical scene with plants, parrots, sand, pebbles" (in his own

words),[4] semi-ironic totems of Brazilian identity. In most other contexts, Oiticica's political claims for his art would be absurd hyperbole. In late-sixties Brazil, against the background of worldwide youth rebellion, they landed like a match on dry tinder. Much to the artist's own surprise,[5] his messianic project for a popular/avant-garde fusion of Brazilian culture actually came to be when a radical pop singer, Caetano Veloso, adopted the name of his artwork "Tropicália" for one of his anthems. In a few momentous months, the term blossomed into a brand name for an entire countercultural movement.

Lest there by any doubt about Tropicália's anti-establishment aura in its moment, after the increasingly paranoid Brazilian dictatorship issued its infamous Fifth Institutional Directive in 1968, consolidating power and sanctioning censorship, it immediately moved to jail the movement's musical leaders, Veloso and Gilberto Gil. Oiticica, for his part, went into exile. Yet the powers-that-were were also too canny to simply repress a style with so much mass cachet; they simply insisted that Tropicália's representatives eschew the radical sentiments associated with its inaugural moment. ("There is no more hope in organizing people around a common ideal," a resigned Veloso was compelled to say in 1972.[6]) As it made its way into official culture, Tropicália morphed into what Oiticica viewed as a de-fanged, commercialized simulation, and from exile he spilled much ink trying to defend the original critical potential of his cultural movement.[7] And so the final irony is that a man whose entire project was promoting interactivity and merging the avant-garde with popular art ended up decrying how his most celebrated creation was used almost as soon as it truly became popular art.

What can be generalized from such examples? Each at least illustrates an artist trying to work through how a very esoteric program might relate to the popular struggles of the day. The results have had lasting significance—in fact, in each case, the works in question have contributed decisively to our images of the struggles of which they were a part, and are known to people who have neither interest nor knowledge of the steel shortages in Russia during the civil war, the dilemmas of the United Front in revolutionary Spain, or the hardening of military rule under the Costa e Silva dictatorship. Our political iconography would be poorer without them. Yet the record also shows that it would be too much to consider any of these men political visionaries; their art has been an eccentric component part of political struggle, carried along by its larger machinations. This doesn't mean they aren't to be greatly celebrated; just that some sense of proportion is required in doing so.

In more recent decades, as the global tide of social protest that marked the 1960s receded, there have been fewer examples of vibrant mass movements

for art to plug into. At the same time, art theory was one of the places within the university where some of the radical energy of the sixties found some continued life (to be a feminist, a queer theorist, or even a Marxist of some kind are relatively mainstream positions within cultural theory, and musings on such subjects are common enough in art magazines like *Frieze* and *Artforum*). One of the paradoxical results of this isolation within the academy is that, while the idea that art has some political role attached to it still has robust support among many art professionals, the conversation about what it means to be a "political artist" has become completely compacted into the question of artistic practice itself. The question of what, if any, relation artists might have to activism has receded into the background.

"Political art"—of a certain stripe, at least—was even a sort of mainstream in the recent past, though by the end of the 1990s its evident lack of attachment to a real political public had managed to elicit a kind of public backlash. *New Yorker* art critic Peter Schjeldahl coined the term "festivalism" to describe the kind of facile, posturing radical art made for international art biennials and museum shows—academically infused conceptual or environmental works of great liberal pathos and self-righteousness directed toward an uncertain audience (as Schjeldahl defined his term: "Installation art . . . used to nurture a quasi-political hostility to 'commodity capitalism'").[8] More recently, such attitudinizing has become less fashionable as "festivalism" has become displaced by the "conceptual bling" favored by the ascendant culture of art fairs, where edgy baubles reign—but for those enmeshed in the debate about art, it remains important as the symbolic other pole to market-based aesthetics, soaking up a great deal of the energy of politically curious artists.

For me, one of the clearer examples of the paradoxes of this type of political art came in 2006, when the Danish art troupe Wooloo Productions staged a project called *AsylumNYC* at the generally progressive White Box space in New York City. The piece was meant to draw attention to the plight of immigrants and the cruelties of US immigration policy through a faux reality competition in which Wooloo invited a group of foreign-born artists to live in the gallery, while attempting to construct art installations using only materials they could convince visitors to bring to them. The "winner" would get a rarely granted O-1 visa granting them "creative asylum."

The sensationalism and mock cruelty of this weeklong stunt ("It's sort of a gladiators' arena in a sophisticated setting," one of the contestants told the *New York Times*[9]) was justified by the need to generate a media spectacle that would call attention to the issue of immigration—a justification that was considerably undercut in that the show happened to coincide with the mas-

sive May Day marches of 2006 in the United States, in which literally millions of undocumented workers flooded the streets of Los Angeles, Chicago, and New York City in a stand against the shameful Sensenbrenner Bill, which would have criminalized the undocumented to an unprecedented degree. Set against the historic May Day supermarches, this art project looked completely gratuitous or even distracting because of its deliberately provocative moral ambiguity.[10]

A much more prominent example might be the work of Swiss installation artist Thomas Hirshhorn, who has staged numerous projects that purport to be some kind of righteous experiment in artistic consciousness-raising. In 2006, at the Gladstone Gallery in New York, he created a bracing installation featuring fashion mannequins riddled with nails, festooned with gory, graphic images of casualties from the war in Iraq. The title of this spectacle, *Superficial Engagement*, was connected to a rather messianic theory about how Hirshhorn's art praxis represents a needed model of intervention. As the press release explained it:

> The events of the world, both the violence and glamour, cannot be cast aside; the imagery that stares back from the news reflects and creates the collective view of the world. This form of "superficial engagement," as the artist dubs it, keeps the argument on the surface, not giving room to pundits or politicians to equivocate. As he puts it in his own formulation of the show, "To go deeply into something, I first must begin with the surface. The truth of things, its own logic, is reflected on the surface." The current climate of constant war and oppression worldwide particularly provokes Hirschhorn's critical inquiry, as he considers his art and his political activism to be inseparable.[11]

Superficial Engagement was particularly illuminating because its motivating theory pushed the contradictions of festivalism to its limits. It confronted the viewer with brutal images of the ongoing war in a visceral way to force a reaction, and thereby seemed to acknowledge the problem posed by the lack of clear positions and general esoteric character of most political art, which allows critics to praise it as radical without taking any real position of practical consequence. But of course the idea that forcing viewers to confront the facts of brutality somehow prevents pundits and politicians from equivocating was (and is) simply wrong. As Susan Sontag put it: "In fact, there are many uses of the innumerable opportunities a modern life supplies for regarding—at a distance, through the medium of photography—other people's pain. Photographs of an atrocity may give rise to opposing responses. A call for peace. A cry for revenge. Or simply the bemused awareness, continually restocked by photographic information, that terrible things happen."[12]

In fact, Hirshhorn's own take on the vital questions then being debated about the war (should the United States withdraw from Iraq?) was not at all

clear from *Superficial Engagement*—despite how the theory of "superficial engagement" itself seemed to be an elaborate way of saying that Hirshhorn felt that he, as an artist with political convictions, should make work that approached the condition of propaganda. In the end, it was as if he was more comfortable in creating a theory about what he should do than doing it.

Maybe this type of tortured attempt to occupy some ideal political-aesthetic space has merit in a period where there are few political movements in evidence; the intellectual hothouse of art is a place where radical ideas can be kept alive in some kind of coded form (although in 2006 there was, in fact, an antiwar movement, just as there was an immigrant rights movement). But the truth may as well be admitted outright: there is no elegant fit between art and politics, no ideal meld of the two. What is needed for effective political activism relates to the demands of a living political movement, which may or may not call for something that is particularly aesthetically refined, just as what "works" best aesthetically in the context of a gallery or museum is not usually a slogan or a placard. This lack of fit is an ugly condition for professional artists—but it will remain with us as long as we live in a world that is as ugly as this one.

"The work of 'political artists' usually harms no one, and I would defend their right to make it; what I cannot support is their self-serving assumption that it 'somehow' has a political effect in the real world," the artist Victor Burgin said in a 2007 interview. "In a university art department, I would prefer as my colleague the artist who makes watercolours of sunsets but stands up to the administration to the colleague who makes radical political noises in the gallery but colludes in imposing educationally disastrous government policies on the department."[13] Expanding things beyond the university milieu, I think this is a fine way to frame the question of art and politics today.

What do these reflections mean, practically? They definitely do not mean "Don't make political art." I hope that we will have much more politically inspired art—and inspired political art—in the near future. What they do mean, though, is that with new and important struggles all around, we should once and for all ditch the bad art-theory habit of looking for a "political aesthetic," of judging an artwork's righteousness in philosophical or formal terms, divorced from its significance to what is happening in the world. Not even the most committed art practice can, on its own, be a substitute for the simple act of being politically involved as an organizer and activist. Perhaps in this context one's talents as an artist might find a place, or perhaps an experience of this kind of activity might be processed, later, into something of enduring creative significance—but the need to engage comes first. This is a lesson I take from the Egyptian artists and their struggle.

In a 2008 contribution to the journal *October*'s issue on artistic responses to the war in Iraq, Martha Rosler—who has made her share of "political

art" and is probably considered an exemplary "political artist"—addressed the question of what artists could and should do. Her final word: "organize, organize, organize."[14] This was the correct starting point then and it is definitely the correct starting point now.

FOUR

Collective Delusions

The recent financial crisis has posed, in the starkest possible way, the question of what alternative models for politics might be viable in the present. Improbably, this seems to mean that art theory—which usually distinguishes itself as rarified, abstract, and removed from coherence altogether—has taken on a new practical importance as a guide for action. People are back in the streets, occupying public space, building temporary oppositional communities, and actively rooting around for models of organization. And art, at least according to the vaporous abstractions of theory, still holds out the potential to be an alternative of some kind.

In one of its forms, this outlook has meant a new emphasis on the idea of art as collective labor. The dominant way of presenting art identifies it with a few branded stars. Radical theory, on the other hand, emphasizes creativity as something that belongs to all. Moreover, even when art seems to issue from the hand or mind of an individual "genius," this person is building on the contributions of the past and is supported by a whole network of forces: uncredited assistants who do a good part of the labor; governments and institutions that provide financial support and infrastructure; teachers, colleagues, and friends who contribute feedback and advice. Maybe artists don't seem like workers in any classical sense. But—so the argument goes—this fact may just mean that artistic labor, which is not straitjacketed by the realities of the factory or the office, might be able to better express a wholesome human solidarity. Given a radical enough push, artistic labor might provide the model for a form of activism that is meaningfully novel.

These kinds of arguments tend to bear the mark of art theory's ghettoization in academia, based as they are on a casual and intellectually glib dismissal of the "traditional" working class, seen as too fragmented and uninspiring to have any effective political agency (as if the task of politics wasn't precisely to organize and inspire!). That doesn't mean, however, that they don't get a hearing. Thus, in the protean constellation of groups that came out of the

Occupy movement in 2011 and 2012, inspired by anarchist thinker David Graeber's insistence that "communism" is not a form of social organization but a present-day reality expressed in routine moments of generosity,[1] you might hear artists making hopeful reference to the so-called communization thesis—in fact just a repackaging of a very old idea of building alternative communities in the present as an alternative to the Marxist focus on building organizations to challenge the state.[2]

In an essay in the book *Communization and Its Discontents*, Anthony Iles and Marina Vishmidt make the connection between "communization" theory and art explicit:

> It is possible to draw a link between the critique of labor as a ground for human emancipation (communism) in the communization account and the critique of labor found in critical aesthetics, from Schiller onwards, which proposes a genuinely human community bonded together by play rather than production; collective self-determination as a work of art. The idea of an immediate appropriation of the world, of determinate negation of what is, in some ways evokes an aesthetic rather than a political view of the content of revolution.[3]

Just what exactly this "aesthetic revolution" might look like or how artists working together might serve as a model for activism is left largely to the imagination.

It might, therefore, be useful to look into the political claims made in recent theory for specific historical avant-garde movements a little more closely, to see if collective art practice can indeed offer some wisdom to activists today. The best resource on recent collectives is the slender tome *Collectivism After Modernism: The Art of Social Imagination After 1945*, introduced and edited by Blake Stimson and Gregory Sholette. In its pages, you will find stirring accounts of all types of art collectives—from Japan's Hi-Red Center and Cuba's Arte Calle to the Union of the Committees of Soldiers' Mothers in Russia and Art & Language in the United Kingdom.

Coming from very different cultures, reacting against very different forces, these groups represent an extremely mixed bag and can hardly be expected to share much in the way of an aesthetic, let alone an ideology. And yet, if there is a consistent thread that runs through the various essays in this book, it is the attempt—very much in line with the theoretical tendency mentioned above—to pump the idea of collective artistic labor up with all the dignity of a full-blown alternative politics. Stimson and Sholette could hardly be more explicit about the political ambitions of their book, introducing it with this (fairly goofy) pastiche of Marx and Engels's famous line about socialism: "There is a specter haunting capitalism's globalization, the specter of a new collectivism."[4] This type of sentiment, in one form or another, forms the un-

derlying basis for a number of the essays in *Collectivism After Modernism*, despite their diverse subject matter.

Thus, in an article summing up the achievements of postwar European formations CoBrA, the International Movement for an Imaginist Bauhaus, and the Letterist and Situationist Internationals, Jelena Stojanović explains their innovations as flowing from their discovery of the political value of collectivism: "They strongly believed that international collectives provided, inadvertently perhaps yet uniquely, the underpinning for both the aesthetical and the political avant-garde, and that the very existence of collectivism profoundly challenged any form of specialization, spatialization, or demarcation."[5] In his essay on the dynamics at work in alternative media collectives like Paper Tiger TV, art activist Jesse Drew explains the promise of collective activity along similar lines: "Contemporary art production is intimately connected to the art market, and thus financial considerations often take precedence over many aesthetic concerns," he writes. "Thus, the question of ownership and authorship becomes crucial within this context if an art product is to have value. Collective art production is often antithetical to authorship and ownership, or is at least ambiguous."[6] And radical curator Okwui Enwezor, surveying a range of art collectives in the African context, similarly makes the case for the collective impulse as a kind of gut-level anticapitalism, pronouncing that "the idea of ensemble or collective work for the visual artists under capitalism is anathema to the traditional ideal of the artist as author whose work purportedly exhibits the mark of her unique artistry."[7]

As a purely historical observation, of course, it is indisputable that art collectives have often coalesced for political reasons. In an individualistic world, banding together can itself have a potent polemical aspect to it (as with Critical Art Ensemble, a group whose form echoes that of an anonymous think tank). It can also be a way of abandoning ego in favor of promoting a cause (as with Gran Fury, the artistic cell of the gay rights activist group ACT-UP [AIDS Coalition to Unleash Power], which did heroic work to confront the AIDS crisis) or provide the freedom to state uncomfortable truths that might well leave individuals exposed to being targeted (as with the Guerrilla Girls, known for biting graphics exposing gender inequality in the arts). A question only occurs when the virtues of collectivism are taken not merely as a *description* of how some people work within certain circumstances, with certain goals and certain constraints, but as a *template* for committed political art in general, thereby becoming the object of a false political investment.

You'd never say that joining a band had any intrinsic political virtue—it's just one of many ways of making music, as characteristic of ragtag outsiders as it is of prefabricated pop ensembles—but when it comes to the visual arts, suddenly "collectivity" is assigned some type of untamed philosophical significance

all its own.[8] From the evidence of the quotes above, it appears that part of the attraction comes from the extremely eccentric economic context of the visual arts: The system of art stardom apparently makes the trope of anonymous team-work seem wildly radical—despite how, outside the boutique sphere of the visual arts, *most* creative labor in a capitalist society is performed by anonymous professionals, often working in teams.

If the idea of collective art nevertheless has an intuitively political ring to it, then this is in part because the idea of the "collective" itself has such a rich political history. Most obviously—as Stimson and Sholette's introduction above demonstrates—it resonates with the idea of socialism from the *Communist Manifesto*. Capitalism, Marx and Engels argued, brought the world together and created great wealth. But it also despoiled the earth and alienated humanity from itself, reducing workers to cogs in a machine, their labor and living conditions determined by market forces about which they had little say. The solution, Marx and Engels thought, was to expropriate the expropriators: for the people who did the work to take charge of the means of production and run society democratically in their own collective interests. Such a political revolution would put an end to the contradiction of a world in which, more than ever before, humanity's destiny was bound together—the *Manifesto* is a clear prophecy of globalization—and yet, at the same time, most of the benefits went to a tiny few.

This righteous vision would have a dramatic allure for artists as well as for political radicals. In fact, in the history of modern art, literary theorist Martin Puchner has argued that it was the great impact of the *Communist Manifesto* that created the template that various modernist avant-gardes picked up on with their own manifestos. The Futurists, Dadaists, Surrealists, and so on mimicked revolutionary cells, issued calls to action, denounced the ills of society as they saw them, and gained a sense of relevance for what were some pretty esoteric practices through the association.

Puchner sees an insoluble tension between the claims made by the two different avant-gardes, aesthetic and political: "The history of these competing manifestos is . . . a history of struggle about the relation between art and politics."[9] Stimson and Sholette, for their part, see less tension and more coincidence between the aims of art and politics in the early twentieth century, reading, for instance, Surrealist strategies of collective authorship (the "exquisite corpse") or the quixotic quest for universal geometry in Mondrian as implicitly progressive attempts to find a "collective voice." This, in turn, leads the authors of *Collectivism After Modernism* to make some exalted claims for the significance of modernist art:

> Modernist collectivism, as we have it here, was the first real effort to develop a
> sustained alternative to commodified social life by cultural means, and it was

full of the spirited and sometimes foolish ambition of youth. Modernist artists understood the collectivization of their professional roles, functions, and identities to be the expression of and, at best, a realization of the promise and/or pitfalls of social, political, and technological progress.[10]

(In a similar way, in their essay on the political potential of aesthetic play, Iles and Vishmidt claim: "The project of the dissolution of art into life—expressed variously in surrealism, the situationists, Dadaism, constructivism, productivism, futurism, conceptual and performance art—has drawn life into art's orbit but also bound art closely to the potential transformation of general social life."[11])

Of course, it is an undeniable fact that many modernist artists were inspired by socialism or other forms of radicalism—perhaps not surprisingly, given the turbulent political times they were living through, spanning world war and the promise of revolution. The 1920 Dada exhibition proffered such slogans as "Dada is fighting on the side of the revolutionary proletariat,"[12] while at the other end of the aesthetic spectrum, Bauhaus master László Moholy-Nagy famously declared that "constructivism is the socialism of vision."[13] We can be proud today about the degree to which the heroes of modern art saw their aesthetic breakthroughs as being propelled by their affinities with the radical left (though this commitment was far from universal: see the fascist sympathies of the Futurists). Yet the very diversity of the aesthetic innovations claimed for radical politics puts into question the degree to which any such specific connection was logical, as opposed to being a rhetorical flourish meant to justify difficult aesthetics in hard times. Vladimir Tatlin, who even served in Russia's revolutionary government, would write that "what happened in '17 in a social sense [the October Revolution] had been carried out in our fine craft in 1914, when 'material, volume, and construction' were established as a principle."[14] But this explanation of the social value of Tatlin's experiments was an ex post facto justification, issued only in 1920. In 1914 he was pro-war, like most of the Russian avant-garde but unlike the antiwar Bolsheviks.[15]

Stimson and Sholette do intimate that there might be a problem in lining up the two fields of artistic and political practice, even provisionally. The aim of the likes of Malevich, Mondrian, Magritte, and Modigliani, they claim, was "never anything else than this or that form of trickle-down communism" (another rather absurd formulation). "Its aim was always to generate the glorious—ecstatic, even—indistinguishability of the proletarian procession." Yet, they caution, "this does not mean ... that the rarefied practice of petty bourgeois artists was the same as that done in factories or soviets, or in collectivized farms, or even in proletarian processions."[16] Still, even to maintain, as they do, that a similar "aim" informed these two worlds is claiming too much, unless the idea of "collectivization" is to become so

general as to be basically meaningless. The implication that avant-garde experiments were the province of "petit-bourgeois artists" needs to be thought through very clearly.

Marx and Engels developed their notions of revolutionary communism against (at least) two competing ideologies that bear on the question. First, they distinguished their ideas from "utopian socialism." The utopians, Marx and Engels note in their *Manifesto*, were reformers who genuinely saw that society could be more just and more rationally organized. However, the utopians conceived of their job not as participating in collective political struggle but in drawing up attractive and imaginative plans for harmonious future communities. Consequently, they ended up seeing the agent of change not in the masses themselves, but in the minority who could dream up a plan and in the rich and powerful people who would fund and enable them to realize their egalitarian fantasies.

Simultaneously, Marx and Engels's socialism has always been rival to another political tradition, anarchism, sometimes also known as "libertarian communism," since the crux of the dispute lies in differing attitudes toward the state and authority. Marx and Engels insisted that the road to a more egalitarian society passed through seizing the resources of the state; that achieved, the groundwork could be laid for a truly collective community through the redistribution of wealth. Anarchist contemporaries like Mikhail Bakunin, however, saw all forms of the state, no matter how democratic, as inherently compromising, and thus rejected any positive role for it, even a transitional one.[17] Various possible conclusions can be drawn from this foundational point of anarchist thinking,[18] but one of them is that, since nothing is to be gained from taking power, the center of political engagement shifts from movement-building to creating an alternative, liberated lifestyle in the here and now, in the form of communes, squats, or affinity groups.

For the present discussion, what is important is that these two distinctions—between socialism and utopianism and between socialism and anarchism—are also the basis for disagreements about the possible relationships between artistic practice and political activism. As Hal Draper points out in his classic pamphlet *The Two Souls of Socialism*, for thousands of years there had been figures fighting for "collective" ownership of one kind or another; they had simply believed that it would best be imposed from above, by a benevolent dictator or heroic minority. Marx's theoretical innovation was to argue that collectivism was meaningless without collective political agency—working-class democracy—and that therefore the masses must be the real agent of social change. "This intersection, this synthesis, was the great contribution of Marx," Draper writes. "In comparison, the whole content of his *Capital* is secondary."[19]

But this simple theoretical point also makes a mockery of Stimson and Sholette's claim that modernists' feints at "collective" forms of art were somehow the artistic parallel of the workers' movement. However radically intended, investments in the political value of "collective" tropes suggest a detour into the forms of politics that Marx opposed. For artists, the conclusion of Marx's insight must be that, in the present at least, the relation between experimental art and radical politics is going to be an awkward one, since the agent of the former is a small coterie of intellectuals, while the agent of the latter is the working class itself, in its millions; there can therefore be *no one style* that corresponds to the movement. Activists dedicated to the self-emancipation of the working class have a political program; they do not—and cannot—have a corresponding artistic program. On the other hand, both utopians and anarchists ultimately locate politics with an enlightened minority, either with visionaries who impose a plan from above or with the autonomous community of likeminded people. Consequently, a much more natural "fit" exists between these political forms and the forms of avant-garde art practice.

Stimson and Sholette argue that artists' relation to collectivism underwent a change in the postwar period (hence the title of their book, *Collectivism After Modernism*). For modernists who believed in the progressive power of good design or universal geometry, they observe, one task was "to envision a radically new society, often in terms that resembled a monumental social design problem."[20] For artists investigating collective artistic strategies in the Cold War period, such schemes seemed discredited: "The old modernist collectivism was indissolubly linked with a bigger ism, a bigger ideal that had failed—communism—and it had little choice but to distance itself."[21] Art movements like Constructivism, De Stijl, and the Bauhaus were contemporaries with an authentically socialist revolution in Russia, and conceived of their visions of social rejuvenation through a generalized aesthetic program as in some ways at least in dialogue with the rethinking of social life inspired by the revolution in Russia. (Though Russian revolutionary Leon Trotsky, for one, would insist that proposing a program for "revolutionary" art in the absence of achieved social transformation was putting the cart before the horse—as he quipped, "The traditional identification of poet and prophet is acceptable only in the sense that the poet is about as slow in reflecting his epoch as the prophet."[22]) All that was promising about the Russian Revolution, however, was ground out of it under Stalin by the end of the 1920s. The bureaucratic police state that resulted—notably hostile to experimental art—could easily be used to confirm the anarchist charge that the state was inherently corrupting.

Consequently, as artists politicized during the Cold War period, utopian, top-down schemes had lost a lot of their luster, and what Stimson and Sholette's "collectivism after modernism" in its various forms involved was the quest to

discover what artists could do after the road of healing society through such methods was barred to them. What exactly the various postwar international formations expounded upon in *Collectivism After Modernism* truly have in common is unclear and probably not worth trying to figure out. For the book's editors these represent merely a transitional stage or "pivot point" that ushers in their real obsession,[23] which is what they describe as a dawning new form of idealistic contemporary collective creativity, based on building "temporary autonomous zones" and "fleeting communal forms and communal work."[24]

Stimson and Sholette pitch this latter program for artistic praxis as a return to "Marx's self-realization of human nature constituted by taking charge of social being here and now . . . engaging with social life as production, engaging with social life as the medium of expression."[25] Yet the truth is, as we have seen, the crux of Marx and Engels's critique of anarchism is exactly that social life *cannot* be taken charge of in the "here and now"—to be fully meaningful, collective social life requires political revolution, which only subsequently creates the space for authentically collective experience, a process that won't be short-circuited by any intellectual means.[26] Thus, when Stimson and Sholette speak about the postwar transition from one form of artistic collectivism to another, the change in emphasis they detect is not a transition from a dated form of artistic radicalism to real Marxist artistic radicalism, as they would have it, but a transition from one false way of avoiding the real Marxist challenge to another. The "modernist" style of artistic collectivism they describe ("to envision a radically new society . . . in terms that resembled a monumental social design problem") leans more toward the utopian politics that Marx and Engels critiqued; the promises of contemporary artistic collectivism (inspired by "temporary autonomous zones" and "fleeting communal forms and communal work") has more of a kinship with the anarchism against which they also tirelessly set themselves.

Of course, one cannot doubt that communal artistic experiments can inspire activists and artists alike and that this is a good thing. Our task as observers should be to assess what the strengths and weaknesses of such experiments are and to avoid making claims for them that are beyond their power to deliver. It is staggering to see the degree to which critics take artistic posturing at face value, failing to locate any contradictions in these practices at all—as if making political claims for art didn't entail the burden of serious political assessment.

Thus, the group of radicalized French artists known as the Situationists is often presented as the prototypical example of a movement that denied any distinction between art and politics, to radical ends. Emerging in 1957, the so-called Situationist International consisted of a coterie of bohemians—never more than seventy, and never more than a handful at any one time—around hard-drinking intellectual Guy Debord. Situationist theory is now

probably most associated with Debord's 1967 book *The Society of the Spectacle*, a set of dour anticapitalist theses that proposed that every aspect of life had become alienated. In art, their main innovation was to argue that earlier anti-art movements like Dadaism and Surrealism had failed because the gestures of isolated individuals couldn't hope on their own to bring down the institutions of art that would later co-opt them. What followed from this insight, the Situationists believed, was that the goals of "anti-art" required a total revolutionary transformation of society in order to be realized. How this was to be achieved in practice for them wasn't totally clear, though their uncompromising position did lead them to excommunicate any artist among them who gained mainstream attention. As late as 1967, they were proposing that hijacking billboards and publishing "situationist comics" would be their main form of political intervention, while most of their energy was spent publishing shrill essays in their own avant-garde journal attacking anyone they thought didn't live up to their level of commitment.[27] Still, the extravagantly virulent rhetoric of the Situationist International caught the imagination of some groups of students in Germany and France, and became one of the influences on the student uprising of May 1968 in Paris—an association to which this art movement owes its continued cachet today.

But the question should be not just whether they influenced events, but how. Did Situationism's strange and unstable hybrid of art and politics offer an effective strategy? One can read pages of theoretical writing on the movement and yet encounter no real reckoning with its members' lunatic sectarianism, their inability to sustain substantial public support beyond a small coterie of students and dandies, or the factional struggles that caused the Situationist International to fly apart completely by 1972—all of which, arguably, flow directly from the reality that they were more concerned with intellectual abstractions than with serious political organizing. As one glowing theoretical account of the Situationists puts it with clueless enthusiasm, the movement's leader Guy Debord "was in search, not of the organic intellectuals of the working class, but of what one might call the alcoholic intellectuals of the non-working classes."[28] Debord's dandyish political slogan "Never Work," which he developed during his bohemian days, seems custom-ordered to make the Situationists seem out of touch with workers—even though the political program toward which his group swung during the proto-revolutionary crisis of 1968 was to demand the formation of "workers' councils" in the factories.

The poetic Situationist graffiti of May '68 may be what certain commentators like to remember fondly about the events, but in a mass upheaval, graffiti hardly amounts to a strategy. In both their writings and their slogans, the Situationists spent more time denouncing the filmmaker Jean-Luc Godard than they did the authoritarianism of Charles de Gaulle. As to the practical realities

of their collective organizational form, there was always what art historian Simon Ford calls a "lack of fit" between Situationism's "anti-hierarchical organizational programme (described as a 'Conspiracy of Equals') and its actual organizational self-limitation (i.e., it was exclusive and hierarchical and dominated by one man, Debord)."[29] With minimal numbers of adherents, hostility to any serious structure, and a tendency to denounce one another at the drop of a hat, the Situationists were quickly marginalized and were unable to exert any serious influence on events. Serious political people cannot take them as role models unless irrelevance is their goal.

In his essay in *Collectivism After Modernism*, critic Brian Holmes explicitly constructs a lineage running from the Situationists through Britain's punk culture of alternative record labels and DIY zines ("punk as productivism"), to the carnivalesque street parties of the various late-nineties antiglobalization protests and the forms of anarchic cultural intervention loosely inspired by them.[30] He celebrates the dissolve of politics into artistic spectacle:

> The political struggle is directly artistic; it is a struggle for the aesthetics of everyday life. The pressure of hyperindividualism, or what I have called "the flexible personality," is undoubtedly what has given rise to the widespread desire to construct collective situations, beyond what was traditionally known as the art world. The indeterminacy of the results, the impossibility of knowing whether we are dealing with artists or activists, with aesthetic experimentation or political organizing, is part of what is being sought in these activities.[31]

It is always inspiring to see what levels of creativity and humor can be brought forth by truly popular political movements. Yet Holmes notably ducks any serious criticism of this type of aestheticized approach to organizing. Certainly the playful aspect of a "global street party" adds an appealing element of fun to anticapitalist politics. But is this element, in itself, enough to sustain an expanding movement that seriously challenges a deep-rooted, highly organized global capitalist system? Or does the overemphasis on the Dionysian and disorganized aspect of politics also represent a potential weakness?

Holmes calls his model of activism "do-it-yourself geopolitics." Stephen Duncombe has offered a particularly acute critique of the underground culture of zine and DIY culture that might aid in developing a real analysis of the political stakes here. The latent political orientation of the DIY underground, Duncombe writes, was mostly anarchist, spurning anything so systematic as organized politics in favor of an aesthetic of visceral personal rebellion, expressed through homemade personal publications and networks of below-the-radar information sharing. This stubborn rejection was a source of much of its strength, in Duncombe's affectionate account, giving zine-makers a sense of ownership over their message, an antidote to alienation. And yet this under-

ground's willful lack of organization and centralization and mono-focus on culture itself as a form of resistance also represented a nagging weakness:

> [The DIY underground] has no effective way to repel its own co-optation by parasitic marketers, no way to reach out to the unconverted, no way to mediate between the annihilation of purity and the danger of selling out, and finally no way to combat the political and economic machine that is the cause of the alienation it protests. By looking for cultural and individual solutions to what are essentially structural and societal problems, and locked into the contradiction of being wed to the society it hates, the underground inevitably fails.[32]

This anarchist subculture brought these contradictions into the streets during the antiglobalization movement. Politics needs pageantry, certainly—but there has to be quite a bit more than pageantry for a movement to be any sort of real challenge to the powers that be. The notion of politics as street theater—building "temporary autonomous zones" as a "space-time effectuation of latent possibilities," as Holmes enthusiastically explains it—is also a perfect recipe for displacing the goal of struggle from enduring material change that could benefit large numbers of people to a spectacle that is purely for the amusement of those who take part.[33] As for the antiglobalization movement, it largely disintegrated after September 11, when questions of the state returned with a vengeance and it became clear that the "directly artistic" nature of the struggle did not obviate the necessity of actual, sustained, nonartistic political infrastructure.

These are lessons for artists that should be thoroughly studied before trying to reapply such strategies to the still-developing struggles of the present. The attempt to reframe political questions as artistic ones is, perhaps, a permanent temptation of artist-led political organizations, and maybe the lesson that art serves politics best when it avoids trying to *become* politics is one that each generation has to relearn for itself. No clever reframing of the terms or pat formula will allow one to escape the reality that the relationship between art and politics is a difficult one; a certain degree of anguish is the price one pays for looking at the question honestly.

How Political Are Aesthetic Politics?

A few years ago, during the height of the agitation against the occupation of Iraq in New York, I ran into an artist at an antiwar demonstration. Marching down Broadway, we struck up a promising conversation about the state of the world, about US imperialism, about the importance of building the movement. Like a good activist, I collected his number, calling him back a few days later to invite him to an upcoming organizing meeting. I was dismayed when he brushed me off, saying that he was focusing his energy on his work in the studio; his painting, he told me, was his contribution to making the world a more peaceful place.

It is hardly a revelation that art-making can serve as an alternative, spiritual form of social engagement and can therefore be as much of a competitor to activism as a natural companion. To hear the case stated so baldly, however, was somewhat disheartening. Yet at least the fallacy of my acquaintance's reasoning was fairly clear. A slightly more refined way of muddying the waters— less popular with people you meet at protests, perhaps, but more popular with the kind of academic tastemakers who still set the agenda for fine art—takes the form of what I call "aesthetic politics." In this mode of thinking, it is not just that artistic practice serves as a stand-in for activist engagement; art itself serves as a *model* for political activism, an alternative political ideal. Every few weeks, it seems, some critic or commentator unveils some version of this idea, presenting it as if it were the most revolutionary discovery since Marcel Duchamp put a toilet on a plinth.

It's not hard to see why such speculations might have considerable seductive power for the professional art pundit. Not only does the political investment in aesthetic virtues seem to hold out an attractive alternative to the three deadly p's of political art—propaganda, posters, and puppets—but it also grants new urgency to the embattled study of art itself. Art becomes not just a pleasant pastime but a form of superior social wisdom. And art criticism, correspondingly, loses the stigma of superfluity, achieving the status of righteous ideological intervention.

The problem with this position is that it falls apart on contact with anything that resembles political reality.

1.

For those looking for an introduction to "aesthetic politics," Karen Beckman's analysis of the photographic practice of radical-geographer-turned-photographer Trevor Paglen provides a particularly fine demonstration piece.[1] The political subject matter of Paglen's "Limit Telephotography" series of photos is undeniable. He set out to document CIA "extraordinary renditions," personally venturing into remote desert locations and even, in one striking instance, to Afghanistan in his quest to capture the dark doings that are hidden from the US public. To achieve this feat, Paglen was obliged to work using a telephoto lens at extreme distances, giving the images of sinister planes camped on tarmacs a distorted, murky look. They are consequently both disturbing pieces of documentation and images that have an undeniable aesthetic aspect (the artist himself has compared them to Impressionist paintings).

In her assessment of Paglen's project, Beckman homed in on the disquietingly seductive quality of the images, the woozy, indistinct, almost-abstract property that has allowed them to be shown in art galleries and museums. Setting their aestheticized character off against the clearly politically motivated nature of his practice, she then offered up what could stand as a canonical formulation of "aesthetic politics": Paglen's project, Beckman wrote, transcended mere documentation of atrocities, illustrating instead "what activism would look like if it were founded on ambiguity, incomplete understanding, doubt, and obscurity, rather than slogans, unity, loyalty, and coherence."[2]

Paglen's unique body of work undoubtedly provides an interesting test case when it comes to the question of politics and art. In a review of the same series of photographs that Beckman addressed, I once referred to the works as "negative political art," by which I meant that in foregrounding their own aestheticized character, they called attention to the uneasy, unstable relation between artistic and political activism.[3] Beckman, for her part, turned aestheticization into a political virtue in itself—instead of pointing to a problem, the works solved a problem for her. "Paglen's photographs," she wrote, "allow us to begin better to glimpse . . . what the aesthetics of photography can offer the sphere of ethics and politics *beyond* evidence, in a moment where ambiguity and otherness constitute two of the targets of the war on terror."[4]

The close reader of this line will note how its logic functions by smearing together concerns from art theory—the celebration of multiple narratives and sliding signifiers—with topical political concerns in order to produce the basis

for its critical validation of Paglen. The rhetoric of the war on terror was—and is—indeed frighteningly Manichean, pitting a freedom-loving West against a freedom-hating Other. But to say that its targets are "ambiguity and otherness," as if ambiguity was on the right side while clear-cut political speech was always totalitarian, is intellectually lazy. The very nature of Paglen's project of investigating "black sites," which has sometimes involved travels to dangerous and out-of-the-way places, implies some awareness of how the government functions as much by keeping its real operations ambiguously out of sight as by demanding that people unquestioningly swallow its propaganda.[5] Power functions as much, in this case, by fomenting multiple narratives as by denying them—as Paglen himself has noted elsewhere, pop-culture conspiracy theories about Area 51 have been very useful for characterizing anyone interested in the government's secret operations as a kook.[6]

What, then, were the pitfalls of "evidence" for Beckman such that she saw the need to call for an ethics and politics that functions "beyond evidence" (a proposition that sounds suspiciously religious)? Her larger thought was that the way photographic proof of government crimes like those that took place in Abu Ghraib was wielded by activists during the movement against the war in Iraq somehow mirrored the crude way that the government used "evidence" to support its own claims. If protestors make claims to certainty, she fretted, they are buying into a mode of thinking that somehow gives magical, totemic power to images as unmediated representations of truth, which will then demobilize them: "[Paglen's] work constitutes an intervention both into the Bush administration's use of photography and video and into parallel assumptions that other images could simply counter those of the administration, speaking for themselves in unambiguous ways."[7]

Yet what historical examples Beckman could have had in mind remained unclear. In the specific case to which she was referring—the rhetorical terrain of the war on terror during the George W. Bush administration—the antiwar movement did not prove itself to be particularly demobilized by a belief in the unambiguous power of images. The 2003 invasion of Iraq was preceded by the largest coordinated demonstrations in human history, despite an unrelenting pro-war push in the mainstream media, citing all kinds of evidence of weapons of mass destruction and so on, photographic and otherwise. Such momentum didn't sustain itself on this scale, but that had much more to do with a lack of sustained political organization—that is, unity, loyalty, and coherence, the very virtues Beckman dismissed—than with the fact that activists were holding out for "other images [that] could simply counter those of the administration."

Such recourse to "aesthetic politics" was hardly unique in this period. The influential art theory journal *October*'s book-length special issue on art's

response to the war in Iraq in 2008 asked, in the face of the then-ongoing US occupation, why more artists and artworks hadn't achieved the popular impact of Vietnam-era protest art. Rather than assuming that the pervasive abstraction of contemporary art-theory musings might have something to do with their lack of relevance to the antiwar movement, all too many of the various *October* contributors opted to double down on the abstraction.[8] Curator Christopher Bedford, for instance, offered the example of Julia Meltzer and David Thorne's art film *We Will Live to See These Things*—a beautiful, nonlinear, meditative look at life in Syria—as a model of vital artistic rebellion specifically because "its observational neutrality—studiously achieved—is, in effect, a form of passive resistance that very quietly but incessantly proffers a documentary model that rejects the use of images as divisive, propagandistic weapons."[9]

The important thing in this instance for me was that, just as in the case of Beckman, when you dug into it, behind Bedford's embrace of "aesthetic politics" lurked an outlandish explanation for the origins of the war in Iraq (inherited from the neo-Situationist writings of the Retort collective),[10] essentially transforming it into one big cultural studies question. The Iraq War was waged as revenge for 9/11, Bedford tells us, and was "a literally genocidal search for righteous images of military retaliation iconic (and reproducible) enough to counter the looming shadow presence of the towers."[11] Actual political motives—about the geopolitical importance of oil and the United States' long-term interests in the Middle East—were deemed less important than some kind of nebulous thesis about the society of the spectacle.

The lesson in both Beckman's and Bedford's cases, it seems to me, is that "aesthetic politics" is not just the wrong answer to the right question. The question that it thinks it is answering—the political vision upon which it is based—is wrong at the root, removed from any serious and sober analysis of the forces that affect the world. Only once one has defined the problems facing the world in suitably abstract terms (as dogmatic "certainty" versus wise skepticism or as the overbearing influence of the "spectacle") is the way cleared for the subtleties of aesthetics to appear as an answer. But one can, in fact, take an approach that is self-aware about how images are used, and what their limits are, without going to the other extreme of worshiping artistic ambiguity.

Returning to the key example of Trevor Paglen, it is worth noting that this artist's own understanding of his practice is emphatically *not* in line with Beckman's reading of it as a demonstration of how "the very possibility of effective political intervention depends on our developing alternative models of activism, in part through an engagement with the aesthetic."[12] Paglen has lectured on his experiences tracking down "black sites," published a book on their political geography,[13] and, finally, allowed his "Salt Pit" image to be

cited as evidence in the Center for Constitutional Rights's attempt to expose the US government's complicity in the "extraordinary rendition" of Majid Khan—all very old models of "effective political intervention" indeed.

2.

An example that makes the stakes of the argument still clearer to me came at the 2011 Venice Biennale. The world's highest-profile international art event is mainly, these days, an excuse for cavorting jet-setters to clog the sinking city, but the biennale still also serves as a modest showcase for competitive cultural display on the model of World's Fairs, with different countries putting their best feet forward via curated national pavilions. (In a notable, if slightly overstated, assignment of ideological significance to the festivities, curator Francesco Bonami once declared that when the Bruce Nauman pavilion representing the United States won the Golden Lion for Best Pavilion in 2009, it was a "sign that the Obama effect has lifted the ban that during the Bush era made the US pavilion 'unfit' for the award.")[14]

The mildly surprising selection to represent the United States for 2011 was the art duo Jennifer Allora and Guillermo Calzadilla, known for installations, videos, and performances that put a political spin on the Duchampian tradition of the "altered readymade." Their "Gloria" project for Venice tackled its context head-on, involving a series of theatrical installations framed as satires of US power, incorporating performances by real-life Olympic athletes in an effort to draw comparisons between the artistic display of nationalism and other forms of cultural display. In their most talked-about and most visible intervention, Allora and Calzadilla presented a fifty-two-ton army tank turned upside down in the gardens in front of the pavilion with an Olympic runner stationed atop it, essentially using it as an exercise treadmill. In another installation, Olympic gymnasts were pictured in videos on the island of Vieques, Puerto Rico, their contortions staged at various sites significant to the struggle against US military occupation of the island (the anticolonial struggle of Puerto Rico being a longstanding interest of the artists).

The meaning of the sundry works was given a textbook "aesthetic politics" spin. "I would say that it is critical about American militarism," Calzadilla said of the intentions behind "Gloria." "But there's a difference between a critique and being critical." He emphasized that the works in the pavilion "don't have a specific meaning, they don't have a specific agenda. They're not trying to convince anyone of anything. It's art. We are artists, we are not politicians. The objects can have many readings."[15] Allora outlined their overall approach along similar lines: "It's not ever any direct, didactic political message. We're not interested in that notion of politics. Politics to us would

be essentially this idea of questioning—what is the nature of these relationships that exist today, and how do they fit together, and how can they be untied and organized in new ways? Which essentially is a formal question."[16]

The artists expressed some wonderment that their proposal, with its satirical digs at the United States, had been approved by the State Department for Venice. ("We were 100 percent ourselves, and they, for whatever reason, decided this is the direction they wanted to go with this Biennale—strangely enough."[17]) For its part, however, the State Department was very clear about what it saw as the virtues of "Gloria": "So often we go to our international partners and say, 'Hey we want this from you on trade policy,' or, 'We want you to stand with us in Afghanistan,'" one official explained to NPR. "And we often are not very popular when it comes to our regular foreign policies. So it's very important also to cultivate that softer image—what the Obama administration has called 'smart power.'"[18]

Even a glancing familiarity with Italian Marxist Antonio Gramsci's theory of hegemony could have saved some confusion here. According to Gramsci, modern capitalist states rule via combining direct force with efforts to gain ideological legitimacy, consciously permitting subordinated interests to have some regulated representation. "Gloria" offered a textbook example of this principle at work in the sphere of art: what was from Allora and Calzadilla's point of view a critique of militarism was from the government's point of view a buttress of US militarism, making the superpower seem like a champion of tolerance at a time when it was bleeding credibility into the rocks of Afghanistan.

Importantly, Gramsci's theory does not suggest that all political gestures simply become dissolved into meaningless symbolic theater; there is a balance of forces that is being preserved, and for the "fundamental group"—the ruling class—the whole game consists of finding ways to let opposed interests have some expression, thereby making them feel that they have some stake in preserving the system and obscuring the ugly reality of power, but without in any way threatening the deeper realities of its rule.[19] Since Allora and Calzadilla's "Gloria" drew explicit comparisons to the Olympic Games as an ideological display, one might recall the famous 1968 Mexico City Olympics, when victorious US runners Tommie Smith and John Carlos raised their fists in the Black Power salute, undermining US credibility at a crucial moment. This is an example of a symbolic gesture that definitely fell outside of hegemonic totalization.

In the case of the 2011 Venice Biennale spectacle, the artists' commitment to "aesthetic politics" was exactly what made their work useful as a support of the hegemonic narrative of benevolent US power, giving vent to a progressive political sentiment in such a way as to disperse any actual political

force it might have had. The "formal" nature of Allora and Calzadilla's critique rendered their anticolonialism in a form that was palatable enough to get the official stamp of approval.

3.

Within contemporary academic circles, the king of "aesthetic politics" is French philosopher Jacques Rancière, who lends a certain Continental authority to the theme (*The Politics of the Aesthetic* is, in fact, the name of the introduction to his works in English). In a 2007 interview in *Artforum*, Rancière succinctly explains the way he sees art and politics collapsing into one:

> In the time of politically engaged art, when critical models were clearly agreed upon, we took art and politics as two well-defined things, each in its own corner. But at the same time, we presupposed a trouble-free passage between an artistic mode of presentation and the determination to act; that is, we believed that the "raised consciousness" engendered by art—by the strangeness of an artistic form—would provoke political action. The artist who presented the hidden contradictions of capitalism would mobilize minds and bodies for the struggle. The deduction was unsound, but that didn't matter so long as the explanatory schemata and the actual social movements were strong enough to anticipate its effects. That is no longer the case today. And the passage to the pairing of "aesthetics and politics" is a way of taking this into account: We no longer think of art as one independent sphere and politics as another, necessitating a privileged mediation between the two—a "critical awakening" or "raised consciousness." Instead, an artistic intervention can be political by modifying the visible, the ways of perceiving it and expressing it, of experiencing it as tolerable or intolerable.[20]

When you decode this passage, what Rancière is saying is this: At some undefined point in the past, we overestimated art's political role as a "consciousness-raising" tool; but the fact that art could change the world was an illusion, a dogmatic theory that seemed credible only because of the existence of powerful "actual social movements," which presumably were the key ingredient in the actual world-changing. But then, in a weird pivot, Rancière concludes that the key contemporary question is not to help build "actual social movements," but rather to redefine politics itself in such a way that it completely sidesteps any non-artistic question at all ("an artistic intervention can be political by modifying the visible").

Without specific examples, it is admittedly difficult to judge the stakes of Rancière's intellectual program, so it is worth now directing attention to a body of work to which he refers approvingly in the same interview, a portfolio of photos by the late French New Wave filmmaker Chris Marker. "Staring Back," as Marker's series is called, consists of black-and-white images extracted from

the breadth of his own film oeuvre, rendered with a distorted, pixelated character that gives them a distanced feeling, as if you are looking at the originals through water. As Marker was mainly a documentarian, the stills have a concrete historical background as documents of the events through which he lived.

The origin of this project is complex, but worth tracing in detail to show the stakes here. In the catalogue to the touring version of this show, curator Bill Horrigan noted that the "seed" of the exhibition was a series of stills from recent protest footage, which Marker picked out while he was assembling his wry 2004 documentary *The Case of the Grinning Cat*, a film that charted the appearance of a particular piece of surreal street art—a grinning yellow cat— against the background of the political turbulence of antifascist and student protests in Paris in the early 2000s.[21] From there, Marker branched out to create a montage of images of protests culled from throughout his own work. When it was shown at the Peter Blum Gallery in New York, the series of protest stills from "Staring Back" filled several walls, arranged chronologically as if to form a personal narrative of Marker's engagement with politics.

For his part, Rancière values Marker for how he perceives of his work as poetically defying its status as factual political documentation. "It's not a technique for identifying individuals," he claims, referring to Marker's habit of reframing images from his documentary works. "It's a tactic for blurring identities. The ambition here isn't to locate individuals but to blur roles, to extricate characters from their documentary identity in order to give them a fictional or legendary cast."[22] For the philosopher, Marker's refashioning of his own oeuvre resists the partisan, propagandizing style of representing protest, asking us instead to reimagine the images as fantastical events, unchained from their specific historical dimensions, open to multiple interpretations, and thereby resisting the dominant way of imagining the possible.

You have to admit that Rancière's description touches on an important dimension of Marker's operation. The protest sequence from the "Staring Back" exhibition began with pictures from a 1961 demonstration against the French occupation of Algeria, followed by images that are recognizably drawn from *The Sixth Side of the Pentagon*, Marker's righteous 1967 documentary about the march on the Pentagon, a high point in the era's antiwar opposition. Following the Pentagon demonstration images, the series offers some picturesque frames of May '68 in Paris—and then the images, though still in murky black and white, jump forward to the new millennium, and we are amid the protests depicted in *The Case of the Grinning Cat* that inspired the project in the first place.

Importantly, however, a marked difference between the way the two eras are depicted becomes evident. In the sixties photos, a motif is cops, looming over the protagonists or coming at them, and hence the sense of power being confronted. In the post-2001 images, a single policeman is represented, and

his back is turned to the camera. In the newer images, Marker's lens lingers instead on grizzled old leftists and, especially, attractive young women lit up by political ardor. Both the sixties and the more contemporary images are often blurred or obscured, in classic Marker fashion. But in the earlier ones, the blurring represents being engaged in the action; in the latter, it seems to represent distraction, interacting with the protest as a passing spectacle.

If you go back and watch Marker's documentary *The Sixth Side of the Pentagon*—a searing, artful piece of agitprop that very much conveys a spirit of sixties idealism—what stands out is the conclusion, in which the film's voiceover asserts of the student protestors who have spent the night in jail that the one certain thing for them is that "they had changed forever." Compare this idealistic sentiment to a wall text Marker inserted into the Blum exhibition beside the May '68 photos. He quotes Abbie Hoffman: "We were young, we were reckless, arrogant, silly, headstrong—and we were right." Then, clearly reflecting on the Middle Eastern conflicts that were calling people into the streets as he was making his new film, Marker added his own commentary: "Yet he [Hoffman] also said, 'We ended the idea that you can send a million soldiers ten thousand miles away to fight a war that people do not support.' How could he figure that one day those very people could support, at least for a while, the wrong war?"

What is the point of this lengthy analysis? When you step back and consider the "Staring Back" project overall, you do indeed find that its specific intention is to reframe Marker's own previous, more politically directed work, or as Rancière would put it, "to extricate characters from their documentary identity." But what is the *political* status of this operation? Rancière implies that it represents a kind of semiotic liberation. Yet looking at Marker's project carefully, it becomes clear that the aesthetic "opening up" of his earlier images of militant protest—the reemphasis on the earlier images' decontextualized aesthetic dimension—flows from a loss of faith in the vitality of political activism, and a retreat into aesthetics precisely as a separate sphere.

"My main reason to be here has nothing to do with the intricacies of world politics," Marker narrates in *The Case of the Grinning Cat*, explaining his compulsion to film the various demonstrations. The reason he showed up, he tells us, was to hunt for a detail in the crowd that had taken on an unexplained private significance for him and become a kind of Surrealist symbol taken up by the youthful Parisian protesters themselves—the cartoon image of a grinning cat by the graffiti artist M. Chat. As a poetic notion, the attention to this ornamental aspect of the protests has a certain pathos. As a strategy for social change, is it thin gruel. The demonstrators Marker captured on film carrying signs that proclaimed "Make Cats, Not War" and sporting grinning cat masks are no better or worse than the Yippies Marker filmed in 1967 in *The Sixth*

Side of the Pentagon who sought to end the Vietnam War by chanting "Out, demons, out" and levitating the Pentagon. At the end of the day, Marker's own "aesthetic politics" explicitly flow from world-weariness and withdrawal, rather than offering a cogent answer to the questions of the moment.[23]

It is not out of the question that some formal tic might take on political significance, of course. But the political value of any artist's aesthetic choice is never a priori and must always be tied to an assessment of how the choice interacts with the forces at play in a live political situation. Inasmuch as the proponents of the various brands of "aesthetic politics" do this, their assessment of the world is in general simply wrong; often based on some naïve assumption that all power functions by repressing multiple meanings. As a critical trope, "aesthetic politics" is more of an excuse not to be engaged in the difficult, ugly business of nonartistic political activism than it is a way of contributing to it.

It may be worth concluding by saying that I use the Chris Marker show because I *like* Chris Marker—I love his work, actually. "Staring Back" specifically had a haunted, valedictory loveliness that was undeniable. It is in part because I love it that it is worth doing justice to what it actually is.

Disentangling what is aesthetically affecting from what is politically effective is one of the vital tasks of criticism. Muddling the two can only do a disservice to both.

Art and
Its Audiences

Brainstormers performing *Point* outside of PS1 Contemporary Art Center, 2005. Photo by Eddie Chu.

SIX

Art and Inequality

Dramatic changes are reshaping what it means to work in the visual arts sphere, yet the sense one gets, as various art pundits and commentators try to make sense of the situation, is of explorers making their way through an altered landscape with an old map. The mélange of theories long popular with art critics, from a highly abstract post-Marxism to poststructuralist theories that treat art as pure discourse or philosophical potentiality, don't exactly provide the vehicle for sober assessment. In some ways, the best analysis being done is by the financial hustlers looking to capitalize on the art boom—though it probably goes without saying that their sanguine perspective has to be taken with a grain of salt.

In her recent book *High Price: Art Between the Market and Celebrity Culture*, Isabelle Graw tries to delineate the changed status of art in the contemporary economy, postulating that a "structural shift" is under way: "What was once called the art business transformed itself into an 'industry engaged in the production of visuality and meaning,'" she writes. "This theory of industrialization is exemplified by the observation that the art world, like the fashion and film industries, is now governed by corporate mergers and the celebrity principle."[1] Graw qualifies her observation by noting that certain "archaic" aspects of the art market remain, presumably its focus on unique objects and individual relationships rather than mass markets. By and large, however, her theory about the "industrialization" of art appears to be little more than an excuse for a series of analyses of artworks that address themes of the market, while the question of how exactly this "industry engaged in the production of visuality and meaning" operates remains maddeningly vague.

In order to take stock of the unique pressures on visual art today, some more focused attempt at charting the plate-tectonic shifts in the material situation of art is demanded, along with an account of how they relate to changes in the economy as a whole over recent decades. Graw's thesis about art's transformation into a consolidated "industry" akin to fashion or music seems to me

75

to be overstated, an exaggerated charge designed to buttress visual art professionals' sense of their own continuing centrality to contemporary discourse. Like every other aspect of our world, the visual arts sphere has felt the effects of the neoliberal economic mutations unleashed since the 1970s, as wealth has trickled up and globalization has created vast new markets with which to keep up. Corporate influence has grown in some cultural sectors, as have the sums of money thrown around on buying works of art. However, the traditionally middle-class institutions of art have not vanished or even decreased in number; in some cases they have proliferated greatly. They do, however, face tremendous contradictory pressures due to the consolidation of inequality within the neoliberal economy. It is to these contradictions that we must turn our attention.

The Art Audience

The art scene has clearly expanded by leaps and bounds in recent decades, as anyone who has been out to a crowded evening of gallery openings will know. In the period after World War II, when US art first came to international prominence, one could say that the entire New York art world might fit in one room. "During the forties, the number of galleries specializing in the sale of contemporary American art was probably around twenty," Diana Crane writes. "Observers estimated that there were no more than a dozen collectors of contemporary avant-garde art."[2] This is clearly no longer the case. The art scene has become enormous. Commentators from all points of view trumpet the importance of the "cultural economy." However, upon closer inspection, any triumphalism about art and its increasing importance to society needs to be tempered.

Globalization has undeniably given the audience for art a boost, particularly via the dramatic growth of international tourism. The promotion of cultural attractions has been widely touted as a way for countries to compete for the attention of the global vacationer set. Attendance at top museums has steadily climbed over the last decades. To be one of the world's top-attended museum shows in 1996, one needed about three thousand visitors a day; in 2012, the equivalent figure was seven thousand.[3] This growth mirrors the more general doubling in global tourist volumes over the same period.[4]

Since the economic turbulence of the 1970s, museums have attempted to reorganize themselves to fight for an increasingly distracted domestic audience as well, boosting attendance figures to impress government and corporate sponsors.[5] The chief strategy on this front has been a turn to the conventions of mass marketing via so-called blockbuster shows: highly promoted, highly expensive exhibitions targeting big crowds. In the late sixties and early seventies, the popular charge was that museums were "elitist"; since the 1970s, the

opposite charge of "crass commercialism" has become more apt. By most accounts, a conscious cultivation of showy blockbusters has been successful in keeping up attendance at museums (such spectacular shows have led, among other things, to a rise in repeat ticket buyers, which fluff visitor totals[6]).

But the blockbuster strategy has meant that the stakes have become higher for museums, involving investment in expensive traveling shows to court a substantial but also highly distractible audience. In the current climate, even mega-institutions with iconic permanent collections like New York's Museum of Modern Art and Metropolitan Museum have their fates wedded to the success or failure of a handful of temporary shows. In 2011, the Met had a record year, attributable to the huge public appetite for the Alexander McQueen show at its Costume Institute; the MoMA, meanwhile, saw lowered attendance, as it failed to repeat the success of the previous year's Marina Abramovic and Tim Burton spectacles.[7] Yet the populist approach by no means guarantees success either. Even for an institution like the Brooklyn Museum, which is located in New York City (though out of the central tourist axis), a pursuit of crowd-pleasing initiatives—for instance, teaming up with the Bravo television network on an art reality show, *Work of Art: America's Next Great Artist*—has not stopped a plunge in museum attendance, while it has alienated its core constituency of art lovers.[8]

In fact, *in spite of* the concerted efforts to reach out to new tourist and domestic audiences, researchers point out that the art audience actually shows considerable signs of strain when you look beneath the surface. Keep in mind that since the mid-twentieth century, when museums and galleries were few and audiences thin, the population of the United States itself has doubled, from 150 million to 300 million. Some growth in arts attendance would be a natural side effect of this no matter what—and indeed the rise in population and the reality of a more educated public seem to be the key drivers of attendance growth. Adjusting for these things, the growth looks much less impressive—in fact, even before the new millennium, the figures show that the less educated were increasingly staying away.[9]

Since the turn of the century, various reports confirm that the audience for the traditional fine arts has been declining. The 2010 National Arts Index reported "a steady decline in the percentage of the population attending museums and performing arts events (symphony, dance, opera, theater)—decreases of 19 percent and 22 percent, respectively, between 2003 and 2009."[10] Another study found a serious erosion of the core audience for art, both in terms of the number of people who considered themselves regulars and in terms of the number of times these regulars visited.[11]

Perhaps most disturbing of all, as the population of the United States becomes more diverse, the art audience is going the other way. It is already vastly

whiter than society as a whole—almost 80 percent of the art audience is white. While museum attendance among whites shrank during this period—just 26 percent visited museums or art galleries in 2008, as opposed to more than 28 percent in 1992—the percentage of visitors identifying as Hispanic adults who visited museums or art galleries dropped a whole three percentage points, from 17.5 to 14.5 percent. African American participation, meanwhile, dropped truly dramatically, going from 19 to just 12 percent.[12] These are not the signs of a field whose future is secure.

The Art Market

There can be no doubt that the amounts of money being poured into the traditional visual arts have soared to unprecedented heights in recent years, taking on outrageous dimensions: In the period between 2002 and 2007 alone, the art market is estimated to have doubled in size to some $65 billion.[13] In 2010, following a short decline during the economic crisis, aggregate global art and antiques sales had returned to about $62 billion, with $31.5 billion being sold through dealers and $30.4 billion going to auction houses.[14] The amount now regularly brought in by single auctions at the major houses like Sotheby's and Christie's—where individual trophies can top $100 million—far exceeds the entire annual allocations in the federal arts budget in the United States through the decrepit National Endowment for the Arts.

If the art market has soared, it is not difficult to see why this might be—and it is not, as Graw's confused remarks might indicate, because visual art has become integrated seamlessly into the larger "cultural industries." Fashion houses, for instance, have grown into industrial powerhouses in recent decades by deemphasizing unique haute couture for an elite audience, focusing instead on mass-market accessories—today, the outlandish concoctions of the runway shows function mainly as ads for branded lipsticks, sunglasses, and perfumes, aspirational items for millions of consumers.[15] The art market's phenomenal ascent is linked to a quite different phenomenon. It has fared particularly well in recent decades precisely because it is an eccentric, old-fashioned sphere that produces unique goods for a high-status audience hungry to distinguish itself from the masses.

In an era of trickle-down economics, policies that favor the rich have caused massive redistribution of wealth to the top. This, in turn, creates giant amounts of surplus wealth that can be channeled into art. And so, as income for average families has stagnated and inequality has soared, there has also been an unprecedented expansion of the art market.[16] A 2010 paper by three economists found, in fact, that growing inequality was the key driver of the art

market: "A one percentage point increase in the share of total income earned by the top 0.1 percent triggers an increase in art prices of about 14 percent ... It is indeed the money of the wealthy that drives art prices. This implies that we can expect art booms whenever income inequality rises quickly."[17]

Recent history supports this hypothesis. The art market took its first real nosedive in years following the collapse of Lehman Brothers in 2008. However, it subsequently came back strong—much faster than the general economy. Since the response to the financial crisis by leaders around the world was to buttress the fortunes of the wealthy and powerful, and since inequality has continued to climb, the art market continues in rude health.

Though it has often been associated with luxury, art has not always been so exclusively identified with the megarich, nor does it need to be. There has historically been a market for visual art among the middle-income sectors of society (the Dutch Golden Age was produced for what was, by the standards of the day, a mass market, as household decoration[18]) and there continues to be one (the majority of art purchases, if not the most widely reported or the most flashy, remain relatively modest).[19] However, as inequality has increased and billionaires have proliferated globally, the discourse has heliotropically turned toward them.

The booming market for art has led, in the last decade, to the idea of "art as an asset class" taking hold of the imaginations of investors. As one enthusiastic report on the phenomenon puts it: "The positive performance and growth of the global art market in the last 10 years have coincided with a dramatic increase in the global High Net Worth Individual (HNWI) population, which was estimated to be 7.2 million in 2000 and has increased by 51% to 10.9 million in 2010. With art investment accounting for 22% of HNWIs' investments of passion, it is likely that the art market will continue to grow in line with the global population growth of HNWI."[20] Investing in art, in other words, has become a bet by the ultra-wealthy on their own continued enrichment.

An important note, however, is that the sheer quirkiness of art valuation and the lack of liquidity in the market (it is not easy to unload high-value artworks) still decisively prevents wholesale transformation of the sector into an arm of finance. The main motivation reported by art buyers remains personal satisfaction, and consequently the art market remains one driven centrally by old-fashioned ego and the quest for status.[21] Institutionally, the trend of the last few years has been the birth of the "ego-seum," that is, personal museums dedicated to the trophies amassed by the moguls of the New Gilded Age, rivaling the collections of public institutions.[22]

A final note about the impact of the market's growth on art is worth mentioning. One of the side effects of the tremendous creation of new money in the neoliberal economy has been a sharp reorientation of the center of the

market's gravity toward new art. Old Masters, Impressionists, and certain long-proven postwar artists (in particular Andy Warhol) continue to be considered the blue-chip stocks of the art market. However, contemporary art, by definition more difficult to value since it has no track record, has come to play the role of highly speculative stocks, increasingly displacing these more staid categories as the center of the action. In 2007, contemporary art became the largest category by value at the major auction houses.[23] By 2008, a Christie's official would say, "Contemporary art is now the driving force of an auction house."[24]

Museums and Nonprofits

Culture has traditionally been viewed as a good to be pursued irrespective of financial calculation. Consequently, the nonprofit form has had an outsized presence in the field.

Intensive investment in expanding museum infrastructure has characterized the recent period across the country, with cities seeming to compete against one another to build flashy new buildings to house art. The watchword of the new millennium was the "Bilbao effect," referencing Frank Gehry's triumphant outpost of the Guggenheim Museum in the beaten-down industrial town of Bilbao in Spain's Basque country, widely thought to have contributed to the economic revitalization of the area. In the face of deindustrialization, mainstream commentators promoted the idea that new "cultural industries" would replace old heavy industry; artists would be "the Johnny Appleseeds of the New Creative Economy," as one article on New England towns trying to transform their abandoned mills into cultural hubs put it. There was, the authors said, "a shift from first seeing investment in culture as amenity alone, to seeing it as a replacement for industry and eventually as an important component of large-scale makeovers."[25]

Chasing the "Bilbao effect," therefore, served as an attractive way to short-circuit discussion about deeper structural headwinds facing the economy. As a justification for building, the purely economic argument was always a bit threadbare, and more sober economic analysis was candid that such cultural showpieces were unlikely to deliver on their more extravagant promises. "It is *not* the task of a museum to stimulate the economy," economists Bruno S. Frey and Stephan Meier wrote after an exhaustive review of the literature on the subject. "There are generally much better means of achieving that goal. A theme park, for example, may be better able to stimulate the economy."[26]

What, then, caused so many cities to embark almost simultaneously on plans for flashy new museums over the last decade and a half, from Los Angeles and Miami to Grand Rapids, Michigan, and Roanoke, Virginia? (The latter's

flashy $66-million Taubman Museum opened in November 2008 and imme-
diately began to lay people off.) A 2007 article on the building craze made
the case that it was driven by the same root factor that tends to drive bubbles
of all kinds: "An overabundance of available money."[27] The craze that began
with Frank Gehry's Bilbao in 1997 corresponded with the recent history of
asset super-bubbles in the greater economy, which created huge fortunes in
technology, real estate, and finance. The new cadre of tycoons were instru-
mental in pushing through the unprecedented round of museum expansions
of recent years: "A lot of wealthy people are keen to have their names on
wings, galleries or walls of a museum designed by a world-famous architect."[28]

At the time, museum directors were described as being in a sort of "quiet
pain" over all the unwise building they were being asked to do. "Most museum
directors know better," Nelson-Atkins head Marc Wilson said. "They get pushed
into it by the trustees."[29] As a consequence, across the country, cultural institu-
tions saddled themselves with new, flashy buildings that are expensive to heat
and guard. "Subtly, the ratio between fixed costs, which are about the building,
and variable costs, which are the programming costs, has changed," Adrian Ellis
explained. "And that means more building and less art."[30] So, though the mu-
seum world has grown in stature, it has not necessarily grown on the healthiest
of foundations.[31] (There is an analogy with the concurrent phenomenon of
gratuitous stadium building, though there, as Dave Zirin points out, the boom
had more to do with corporate monopolies and the vanity of owners.)[32]

Increased competition expressed through expensive architecture and touring
exhibitions has also increased stratification between different tiers of cultural
institutions: "Is an outreach strategy based on blockbuster exhibits feasible, con-
sidering that the costs of putting on these exhibits may place them beyond the
reach of all but the largest museums?"[33] The lucky top tier of what are called
"superstar museums"[34] increasingly absorbs a lot of the available investment
and attention alike. *A Portrait of the Visual Arts* noted that at the turn of the mil-
lennium "the largest 20 percent of all art museums . . . controlled 95 percent
of the total revenues in the nonprofit visual arts sector and 98 percent of the
assets (not counting the value of the artwork itself)" and that "the largest 1 per-
cent of these museums controlled almost half of the total revenues and assets."[35]
This concentration, the authors predicted, would increase.[36]

Why? The largest art institutions have initial advantages on which they can
build. Aside from being best able to afford blockbusters, they are better placed
to lure corporate sponsors and private donations, which in turn have been
steadily growing in importance for US museums, most of which cannot gen-
erate sufficient revenues through tickets to meet expenses.[37] "Midsized muse-
ums," *A Portrait of the Visual Arts* concluded, "will need to think strategically
about their basic objectives, the audiences they are trying to reach, and their

comparative advantages. They will also need to consider ways to reduce their costs—for example, by cost sharing, loaning artworks, and joint ticketing."[38]

Meanwhile, regardless of the slump, small nonprofit institutions that service the visual arts audience have vastly proliferated in recent years. According to the National Arts Index, the crisis year of 2009 marked the first small decrease in the ranks of such organizations, after a phenomenal period of growth: "In the past decade, nonprofit arts organizations have grown 45 percent (75,000 to 109,000), a greater rate than all nonprofit organizations, which grew 32 percent (1,203,000 to 1,581,000)," the authors write, which means that between 2003 and 2009, a new arts organization sprang up every three hours in the United States.[39]

It is not surprising that the increased competition for funding has also led to increasing stress all around. The same report noted that even in the good years before the financial crisis, a full third of arts nonprofits were running a deficit. With so much competition in the field, the authors even went so far as to suggest that a responsible arts funding solution would be to help encourage more organizations to wind down or, as they charmingly put it, to "die with dignity."[40]

Galleries

It is fashionable to demonize the commercial side of the art market, but the commercial side of the art market is in fact not a monolithic thing. As a whole, the market is thought to have been split evenly between sales at auction houses and sales through galleries for some time.[41] However, the auction market is dominated by giants, above all the corporate titans of Sotheby's and Christie's, globe-spanning corporations locked in ruthless—and by some accounts, ruinous—competition for the most important secondary-market work.

The gallery side is much more varied and still consists primarily of small businesses—mainly very small businesses indeed. Opening an art gallery is a notoriously risky proposition. Graw's argument in *High Price* about the consolidation of the art world into an "industry" rests on a single named example, Gagosian Gallery, a billion-dollar chain that has opened franchises all around the world in recent years.[42] But the very exceptional stature of Gagosian proves the fallacy of the argument: few dealers indeed can compete on that level, even if the pressure to do so is increasing.

Just as the economy as a whole is marked by sharp inequality, so too is the art economy. Of the world's more than 375,000 art and antiques dealers, a mere 5,000 are said to be responsible for fully half of all sales. The average dealer isn't exactly cleaning up, either. One report on contemporary dealers

estimated that the average dealer's annual revenue is €60,000, or about $87,000 at the then-current exchange rate.[43] This total, of course, is skewed by the international nature of the sample and cannot possibly be true for an art capital like New York, where this wouldn't even cover rent on a storefront. Edward Winkleman, a gallerist and the author of *How to Start and Run a Commercial Art Gallery*, guesses that probable intake for a successful "emerging" New York gallery would be in the ballpark of $200,000 to $1 million per year, with expenses starting at $216,000 to $432,000 and rising sharply as the gallery expands.[44]

Because top galleries are the best equipped to attract the wealthiest clients, the effects of economic stress are not distributed evenly throughout the art sphere and, predictably, mirror the strains produced by growing income inequality in general. "Some dealers noted that wealth has become much more polarized at the top end in the last decade, with the super-wealthy remaining as the primary buyers in the market after the recessionary period from 2007 to 2009," the same report relays. "The upper middle class has not been able to keep pace with the wealthiest buyers, and therefore the middle of the art market has been the worst affected by the most recent financial crisis."[45]

A surprising fact yielded by this analysis is that the recent period of vast art-market expansion also coincides with a period of increasing anxiety for art dealers: "While dealers had ups and downs in the market, most agree that they had 'a good ride' up to the 1990s, but then lost buyers, and now actively struggle to make money in a competitively challenging marketplace."[46] Some of this has to do with a dwindling supply of market-ready Old Masters and quality antiques, but much stems from side effects of the same freewheeling economic policies that made the recent decades of neoliberal economic expansion possible in the first place: the consolidation of corporate power and the globalization of wealth.

Dealers compete for goods and clients with corporate giants like Christie's and Sotheby's, which lead in marketing, technology, and sheer scale, and which moved aggressively to dominate new spheres after the last art-market crisis in the early nineties. This conflict, by all accounts, has gotten livelier over time. Christie's contemporary art czar Amy Cappellazzo crystallized a lot of dealers' fears when she was quoted as saying that the auction houses were "the big-box retailer putting the mom-and-pops out of business."[47] As for globalization, much of the new money pouring into the art market has come from places like Asia, Russia, and the Middle East. For a successful gallery, the average is now for something like 28 percent of sales to be made outside of the home market.[48] Consequently, there is escalating pressure for dealers to be more global if they don't want to fall behind, which is why the indisputable trend of the recent period for first-rank galleries has been toward

opening international franchises (a development that is "among the purest extensions of economic globalization in the art market," according to Noah Horowitz, "enabling galleries to leverage their brand identity, access a widening client base, and provide economies of scale").[49]

It is necessary to understand these two factors in order to make sense of the most notable transformation of the commercial gallery sphere in recent years, what Clare McAndrew calls the transition toward the "event-driven marketplace": the art economy is increasingly focused on art fairs rather than physical gallery spaces.[50] The phenomenal rise of events like London's Frieze Art Fair and Art Basel Miami Beach in the United States since the beginning of the twenty-first century has been both a proactive way for galleries to tap into the global market and also a defensive reaction against the auction houses, attempting to offer the same commercial frenzy and concentrated, champagne-popping glamor of a Christie's evening sale to court fickle new money.

This strategy has, on the whole, been successful—but it is also a necessary evil, since the requirement to participate in the international art fair circuit raises the cost of business for art dealers, increasing the underlying strain on the smaller players. As it becomes more and more dominant, the "event-driven marketplace" increases expenses for galleries, sharpening the stress in an already stressed ecosystem. "Many dealers commented that the expenses to run a gallery (especially when traveling and attending fairs) are not justified relative to the sales made via this channel. (Some dealers reported that their gallery sales had fallen to as low as 5% of total sales.)"[51]

Artists

Where, at last, do these changes leave the artists, presumably the figures at the heart of it all? One expert paints the following picture of the present-day "cultural worker":

> From a large sample of studies on artistic labor markets, the following picture emerges. Artists as an occupational group are on average younger than the general workforce, are better educated, tend to be more concentrated in a few metropolitan areas, show higher rates of self-employment, higher rates of unemployment and of several forms of constrained underemployment (non-voluntary part-time work, intermittent work, fewer hours of work), and are more often multiple job-holders. Not surprisingly, artists earn less than workers in their reference occupational category (professional, technical and kindred workers), whose members have comparable human capital characteristics (education, training and age). And they experience larger income variability, and greater wage dispersion.[52]

This population has grown considerably in recent years across the industrialized world, as the sphere of the visual arts itself has grown.[53] However,

the same kind of increasing inequality across the economy and within the museum and gallery world also applies here:

> The number of artists in the visual arts has been increasing (as it has in the other arts disciplines), and their backgrounds have become more diverse. At the same time, however, the hierarchy among artists, always evident, appears to have become increasingly stratified, as has their earnings prospects. At the top are the few "superstar" artists whose work is sold internationally for hundreds of thousands and occasionally millions of dollars. In the next tier are the "bestsellers" whose work is represented and promoted by galleries, dealers, and auction houses and sold for substantial prices. In the third tier are the majority of visual artists who often struggle to make a living from the sale of their work. This increasing stratification is largely due to changes in the size and operation of the arts market.[54]

One popular guesstimate from the late 2000s had it that there were eighty thousand visual artists between the art capitals of New York and London; of these, just seventy-five are "superstar artists with seven-figure incomes"; about three hundred more were "mature, successful artists who show with major galleries and earn six-figure incomes from art." Below that, even artists who were showing were not really sustaining themselves through their artwork, instead piecing together a living from teaching, from second careers, or from supportive families or spouses (or were independently wealthy).[55]

Meanwhile, various studies of the boom in the creative economy seem to concur on one fact: growing artistic employment has been paradoxically accompanied by growing artistic unemployment and underemployment. Even as opportunities have expanded, they have not expanded fast enough to absorb the number of artists drawn in by artistic get-rich-quick fables. Life has consequently become harder for the average artist looking to find her way into the system.[56]

A final note about the growth of the number of artists is the increasing importance of the investment in education. Commentators sometimes talk about an "MFA boom" in recent years,[57] given the mushrooming size and importance of art schools.[58] Each generation of artists since the 1950s has been more yoked than the last to academia.[59] Today, the number of people holding MFAs has grown so enormous that a new phenomenon has appeared on the scene: the studio art PhD, pitched as a way for artists looking to support themselves through teaching to be able to distinguish themselves from the MFA crowd.[60]

Thus, while numerically more artists may be achieving success than ever before and success may come quicker for some, the stakes have also been raised in terms of the amount of resources that must be invested in order to enter the lottery. The growing pool of artists has led to the growth of a surplus population of highly educated people with limited or at least very precarious outlets for

their skills. This last detail, finally, has political effects. In fall 2011, aggrieved artists and art students were a notable part of the initial cadre of Occupy Wall Street, giving that movement some of its anarchic intellectual character.[61]

Prospects and Predictions

Surveying all these developments, what can we guess about the future?

It is customary to trace the origin of the modern art world back to the Italian Renaissance, which gave birth to both the myth of the autonomous genius artist and the art market as we know it, with the emergence of the first specialized art dealers. Yet the entire population of Renaissance Florence in the mid- to late 1400s was not more than forty thousand people, making it a small town in modern terms.[62] The number of craftsmen registered as painters during this period in Florence is thought to have been around thirty.[63] Today, the number of art students enrolled even in elite institutions like the Rhode Island School of Design, CalArts, or the School of the Art Institute of Chicago is in the thousands during any given semester.

Throughout history, an increase in the size of the artistic population has had qualitative effects on changes in both the channels through which art is produced and consumed and, consequently, on aesthetics.[64] The art market in its truly modern incarnation came to be, most agree, in the wake of the decline of aristocratic patronage after the French Revolution and the rise of the bourgeoisie following the Industrial Revolution. Under the French monarchy, representation at the official salon was only open to artists with credentials through the academy. After the revolution, these exhibitions were made open to all artists in the name of democracy. The number of artists participating ballooned from about eight hundred entries at the first open salon in 1791 to well over five thousand in 1870. Drawn by the promise of popular access to the art system, the influx of artists led to an expansion of potential artists that outpaced the capacity of the old structures to absorb it.

This expansion, in turn, give birth to bohemian society and the modern art movement, symbolically inaugurated by the "Salon des Refuses" of 1863, when a number of important artists rejected by the salon demanded to be heard on their own (including heroes of subsequent art history like Édouard Manet and James Abbott McNeill Whistler): "Having prompted many people to turn to art as a career and attracting large numbers of them to Paris, and having vastly expanded the audience for artworks, the French Salon system contributed to its own demise by creating demands it could not satisfy."[65]

It is impossible to say whether the current unbalanced growth of the visual arts economy will produce some similar sea change or lead to new channels

of artistic distribution—or even fresh artistic currents tied to social movements generated by the current instability of capitalism. What we can prophesy is that the sphere of the visual arts, buoyed by the developments of neoliberalism but also distorted by them and increasingly stretched and unequal beneath its patina of glamour and luxury, has created a situation that is highly combustible.

The future will be determined, in great measure, by what subjective forces come to the fore to respond to the objective material transformations that have taken place—which makes it all the more important to have a clear map of the contested territory.

The Agony of the Interloper

It is a bit of art theory boilerplate that "anything" today—post-Duchamp, post-Warhol—is potentially a work of art. The barrier between art and life has been breached. The everyday has entered the gallery. Endless examples can be adduced to prove contemporary art's outrageous openness. Did you hear the one about the man who served up a spicy Thai curry and called it art?[1] Or the joker who sold collectors the right to have lights turn automatically on and off in a room, on a timer?[2] Or the clever soul who placed a luxury speedboat on a pedestal and declared it sculpture?[3] The fact of art's absolute openness gets repeated over and over, as if it were a radical revelation. The only problem with this assertion is that it is clearly false.

For it is not at all true that "anything" may be considered a work of contemporary art. In fact, the category of things treated as fine art is forbiddingly exclusive, an extremely difficult club to enter—it cannot be any other way in a society where art stands as the ultimate luxury good, because this status depends on it being rare, and that necessarily hardens the barriers to entry. As a purely descriptive statement it is perhaps true that almost any type of object or act might be contextualized as a work of contemporary art, given the right sort of clever spin. Still, to put the matter in the terms of grammatical pedantry: just because anything *can* be treated as a work of art doesn't mean that anything *may* be treated as a work of art.

At this point, a close reader might accuse me of running together two different problems, the formal/ontological and the economic/sociological. But in fact, while apparently distinct, these two levels fold into one another, because the free play of art—the notion that "anything," within the bounds of the gallery or the museum, can today be regarded with the dignity of an artwork—is both distraction from and guarantee of its opposite, the reality that "visual art" is a very strictly delineated, rarified, and exclusive sphere.

Endless protestations of absolute pluralism are a *distraction* because, in many ways, the imaginary liberty within the carnivalesque kingdom of art clearly

allows participants to forget the very high walls that surround it to keep out the riffraff. Contemporary art's ludic character makes it seem infinitely expansive, when in fact what is called the "art world"—where protestations of radical artistic liberty are most vociferous—is territory commanded by highly trained and pedigreed professionals. As a purely historical fact, the long march of art toward total pluralism has corresponded with the ever-greater importance of artists' access to higher education in order to take part.[4]

This last fact, in turn, points to the sense in which art's self-satisfied pluralism is also a *guarantee* of the inequality surrounding art. Because while the radical diversity of art may seem to represent a democratic leveling of aesthetic values, the very complexity of the questions involved means that the sensibility required to join in the conversation is highly refined, requiring a very specialized visual and mental vocabulary in order to "get" what is going on. This by no means completely invalidates the radical experiments ushered in by sixties-style conceptual art, and the converse claim that "old-fashioned craft art" is somehow more innately democratic is open to its own critique (see "In Defense of Concepts," chapter 13), but you'd have to be a fool to think that any old person could declare any old thing "art" and be taken seriously. The lack of clear formal guidelines demarcating what is or is not art makes institutional approbation and a command of aesthetic discourse all the more important, and these things don't come naturally or cheaply.[5]

Why, though, does this obvious point seem so definitely not obvious? Why is it that the assertion that "anything" can be art takes up so much theoretical bandwidth, while the very real factors limiting who gets to make art garner almost no commentary at all? Leaving aside plain old theoretical laziness, the blind spot may well result from a kind of mental illusion, of the same order as the illusion that the light is always on inside the refrigerator. By definition, anything that passes within the ambit of professional commentary, good or bad, has already vaulted the bar for entry, already been declared licit as an object of consideration. One never gets to peer, therefore, into the darkness, where all the experiments that fail to make the cut live, because these by definition haven't raised themselves to the level where they are considered worthy of serious analysis.

Which brings me to the specific case I want to write about: the art of Billy Pappas. You or I probably would never have heard of Billy Pappas if it weren't for Julie Checkoway's 2008 documentary *Waiting for Hockney*—which is part of his interest for our purposes here. As a film, it's a solid entry into the follow-an-eccentric-around-and-see-what-happens genre, but as food for thought about the "art world" and how it functions, it provides a rather moving case study. (I'm going to spoil the plot, so if you need to, you may get up now and go watch the documentary before finishing this essay.)

Waiting for Hockney centers around Pappas, an artist from Baltimore who, we are told, has spent eight and a half years realizing a single hyper-detailed fourteen-by-seventeen-inch graphite drawing of Marilyn Monroe's face, based on a well-known Richard Avedon photo.[6] The artist we meet in the movie is a likable character, somewhat self-aggrandizing but also charmingly guileless. We glean that he studied drawing at the Maryland College of Art and has been in a single New York group show, at the Society of Illustrators, but is otherwise a foreigner to the art scene. From his testimony to the camera, we get the impression that he is driven by the desire to do something great but is self-conscious that, in his own estimation, he looks and sounds more like a bartender than an artist.

Indeed, it was while he was working as a waiter that he met an architect named Larry Link, a bowtie-sporting eccentric who was impressed by Pappas's bravado and decided to take him under his wing. What Link's motivations were is difficult to guess from what you see in the film, but you get the idea that he viewed Pappas as a kind of human guinea pig, a vehicle through whom he could test out some kind of quixotic thesis about the continued relevance of draughtsmanship in the face of the wilder experiments of contemporary art.

Each month, Pappas received envelopes of money from Link as he labored to complete his opus, *Marilyn*, painstakingly elaborating the surface, millimeter by millimeter, working with lenses strapped to his eyes, at twenty-times magnification. The movie begins after this creative labor is finished. Pappas, we learn, has seized upon the notion that the well-known British painter David Hockney is the person who will finally understand his work, and we follow him as he attempts to set up a meeting with the famous artist whose support, he believes, will rocket him to the "next level."

For the first three-fourths of the film, as we approach the inevitable encounter with Hockney (which occurred in 2004), it builds Pappas up as an eccentric, if lovably relatable, genius. You meet his endearing family. You watch his mother, Cookie, bake a cake for Billy to take with him to Los Angeles for his big meeting with Hockney. We meet his admirers, including "Brother Rene," a priest and high school principal, who accompanies him to L.A. and lingers in the background inexplicably. You listen to Pappas expound at length on what makes him tick. If you are a half-cynical person, you roll your eyes at all the mythmaking.

Then he meets Hockney. The encounter goes unfilmed, which is a shame (according to Checkoway, the elder artist wouldn't have it). Leaving, Billy and his entourage are captured crowing about how much the two men connected, predicting that Hockney will become Pappas's champion. As an omen of the disappointments to come, however, we see the inscription Hockney

left in an art book he gave his admirer: "For Billy with thanks and admiration for showing me your terrific drawing."

We cut to four months later. Nothing has progressed for Pappas. Hockney won't return his calls. The filmmakers return to interview Hockney's cohort Charlie Scheips about the encounter. Now you glimpse the meeting through the other end of the telescope: "I was a little bit underwhelmed immediately," Scheips reports of his encounter with the drawing. "Why did he pick Marilyn Monroe?" he asks, his disapproval at the subject matter evident. And finally, he quotes Hockney's own damning assessment of the drawing: "*It's still that fucking photograph.*"

Scheips—and somewhere in the background, Hockney—here stands in for the opinion of the professional art scene. Billy Pappas's *Marilyn* is fatally unsophisticated. Most stinging is the casual nature of Scheips's dismissal: "There was a bit of naiveté there, the naiveté of not having been part of the art world." All the hot air pumping up the encounter drains from the film. Pappas's drawing, first presented to viewers of *Waiting for Hockney* as his way to pry open the closed doors of art through sheer strength of will and quantity of effort—to "set the art world on its ear," in Link's words—simply bounces off the institution, which moves on, evidently impermeable.

Pappas owes $300,000 to Link for the years of support. He is now thirty-seven, and we watch him return to work as a bartender. He is heartbreakingly gratified as he counts out $40 from a shift's work. The film ends with Pappas, sitting once more in his studio, in front of what looks to be the ragged start of a nude self-portrait. "It's all done, except for the face," he explains of the inchoate work, an admission that seems to signal the trauma that the reception of the hyper-detailed *Marilyn* has inflicted on his ego. Pappas has been left an incomplete man. And that's the end of *Waiting for Hockney*.

What to make of Billy Pappas's *Marilyn* and its effect (or non-effect) on its intended audience? Notably, the more you consider Checkoway's film, the less you "get" the artist it is presenting. Like his image of Marilyn itself, Pappas appears very, very familiar on the surface—he's a guy from the neighborhood and is nothing if not direct. However, the closer you look, the more confounding he becomes. The art critic Lawrence Weschler, who figures in the film as the connector between Pappas and Hockney, is pictured musing of the drawing, "Is it art? Is it outsider art? Is it the most ecstatic endeavor in the history of scientific illustration? Is it insanity?" Hyperbole aside, this undetermined status sums up the case.

The label of "outsider art" to which Weschler refers emerged out of the great opening up of aesthetics in the post-sixties art world (picking up on the earlier modernist fascination with the art of the insane); it is one of the facets of contemporary art's celebrated mosaic of pluralism. The troubled term was

coined for figures like Henry Darger, Reverend Howard Finster, and Martín Ramírez—self-taught artists who emerged from outside the established channels of art, but who created elaborate and self-contained worlds of their own that rivaled any avant-garde production. The "outsider" label remains a form of packaging, a professional classification pioneered and exploited by curators and art dealers.[7] Among the preconditions for it to function is the spectacle of otherness, as the word "outsider" itself suggests (which is also why it has fallen out of favor).

Pappas and his work are too lucid by half to fit this description. His *Marilyn* is quite clearly in some kind of self-conscious dialogue with the conventions of official art history, undercutting our ability to appreciate it for eccentricity alone (the character we meet is more quirky than eccentric, putting on lipstick to use his own lips as a model for Marilyn, or goofily crafting an enormous magnifying glass to mail Hockney to get his attention). When it comes to the question of why Pappas selected his particular subject, all *Waiting for Hockney* gives us is a single line from the artist: "I was thinking about taking a very famous person and trying to bring that famous face something it couldn't otherwise have."

Monroe's face symbolizes blue-chip painting, courtesy of Andy Warhol's multitudinous Marilyns, so the choice reflects Pappas's desire to insert himself into the world of professional art. At the same time, the Avedon photograph has lodged itself far into the popular mind, beyond the cliquish art world. Marilyn is a popular icon and can be understood here simply as what she is: a famous person who has near-universal recognition. The very subject matter of this artwork therefore encapsulates Pappas's own particular suspended, inside-outside position with regard to art and its institutions.

The biggest mystery of the film is the one its title would seem to offer to explain: why select David Hockney as a mentor, a man who, while a proponent of good drawing, is hardly a defender of the kind of obsessive and almost scientific approach Pappas takes? Why Hockney instead of, for instance, a photorealist like Chuck Close? Hockney's name seems to have entered Pappas's consciousness via Gary Vikan, the director of Baltimore's Walters Art Museum and a sympathizer. But how Pappas connects his own work to the British artist is a mystery. It is Hockney as traditionalist that seems to speak to him—he repeats a phrase he associates with the British painter, "to the hand, the eye, and the heart"—despite the fact that his own labor would seem to imply an appreciation of an almost cybernetic precision.

The upshot, at last, is that Pappas produces a sort of abject image. Not just in the sense that Weschler notes—that the closer one gets, the more its detailed attention to (for instance) hair growing out of pimples becomes inexplicable and repellent. There is no place for the work to fit into exactly; it

is repulsed by our existing categories. Billy Pappas is not outside convention, but he's not in a comfortable relation with it either; he approaches it at a random, unstable angle, with no real place to land. Again, here's Weschler, this time from an article about *Waiting for Hockney* in the *New York Times*: "Depending on how you look at it, he's insane or stupid. Or it's a really en-thralling adventure. And it is both; it goes back and forth between the two."[8] Pappas has clearly done something remarkable—you do leave the film really wanting to see the work in real life—it just hits a button that doesn't plug into anything.

How to approach this kind of artistic phenomenon, then? In his book *Dark Matter: Art and Politics in the Age of Enterprise Culture*, Gregory Sholette attempts to coin the term "creative dark matter" as a way to describe the mass of "makeshift, amateur, informal, unofficial, autonomous, activist, non-institutional, self-organized practices" that goes unrepresented within art's official cosmology.[9] Far more creative activity goes on outside of the official sphere of the visual arts than in it, and Sholette wants to deflate its pretension to stand for creativity in general. In fact, he proposes founding a veritable political program on advocating for absolute aesthetic inclusion:

> Collectively, the amateur and the failed artist represent a vast flat field upon which a privileged few stand out in relief. The aim of this book is to raise an inevitable question: what if we turned this figure and ground relation inside out by imagining an art world unable to exclude the practices and practitioners it secretly depends upon? What then would become of its value structure and distribution of power? The answer is not to imagine the emergence of a more comprehensive social art history in which the usual art subjects are better con-textualized. Nor is it to take part in some rarified tour of this dark-matter world in which the mysterious missing cultural mass is acknowledged, ruminated over, and then re-shelved or archived as a collection of oddities. Instead, when the excluded are made visible, when they demand visibility, it is always ultimately a matter of politics and a rethinking of history.[10]

Though Sholette's focus on the social conditions of art-making and the exclusions that structure it is to be applauded, his blunderbuss approach re-mains confounding. What, exactly, his notion of "imagining an art world un-able to exclude the practices and practitioners it secretly depends upon" might mean is difficult to figure out. It either suggests a transformation of the critical framework of art to the point where we no longer care about questions of quality at all—where everything commands our equal attention, since any attempt to pick favorites amounts to being in league with a dis-criminatory system—or it is a slightly garbled program for a radical material transformation in the institutions of art, and indeed society itself, to make the resources of creative expression available to all. As millennial as this latter

proposition might seem, I'm more sympathetic to it than the former—but taking that road means admitting that the problem isn't simply a matter of "imagining" a new way of looking at art or coming up with some radical phrases about being inclusive.

Indeed, despite his focus on the institutions of art, Sholette appears to have much in common with those theorists of aesthetic liberation who think it sufficiently radical to declare that "anything" can be art. He deliberately sidesteps the issue of taste and judgment: "Attempts to define art and aesthetics have been avoided. . . . I allow those who claim to make 'art' to define it on their own terms, even if their identification with the practice is provisional, ironic, or tactical."[11] (This deliberate lack of clarity underpins Sholette's rather weird analytical decision to position "amateur and failed artists" in alliance with "those artists who self-consciously choose to work on the outer margins of the mainstream art world for reasons of social, economic, and political critique."[12] He seems to equate artistic failure with political exclusion or at the very least avoids the question of what it means that some artists might fail because their work is simply not that interesting.)

When applied to any real case, the unalloyed celebration of marginality becomes simply patronizing. Billy Pappas spent eight and a half years working on his drawing. By Sholette's logic he could have stopped after a week and it would have been neither more nor less interesting to him. Artistic effort is, apparently, always interesting enough on its own terms, no matter what. In fact, in *Waiting for Hockney*, Weschler's conclusion, which also seems to be the film's own conclusion, echoes this logic: Pappas, he says, should just be happy with the achievement of having accomplished something interesting to himself, even if no one quite understands him. But of course this makes no sense. *Of course* official approval matters—not just because of the money and other plaudits that go along with it, but as an acknowledgment that all that time and hard work and effort were worth it, that they accomplished something extraordinary that deserves to be treated alongside other extraordinary things.

The institutions of art, like all institutions in an unequal society, are warped by their context. They become tools to help replicate inequality, reflecting the biases of the powerful and the well connected and becoming permeated with the pettiness that results when the human desire to excel turns desperate in the face of the reality of scarce opportunity. But if that was all the institutions of art were, then there would be no reason to topple them, because they would tip over by themselves; everyone would just *see* that it was all corrupt, totally insulated from the values of most of the population, and turn their backs on it. The art system only functions by maintaining some legitimate claim on artistic "quality," a concept that is elastic

enough to include some degree of snobbishness and blind imitation of fashion as well as some representation of legitimate human aspirations. The whole reason it matters who has access to training and education and the resources that official institutions put at one's disposal is that these things can give someone who is otherwise struggling the space to flourish creatively. The advantages of being an "insider" are not illusory, even if they are not sufficient or even necessary to guarantee greatness.

In a very different context—the stormy debates about popular art that flowed from the Russian Revolution of 1917—Leon Trotsky once railed at "the sincere fools who have taken up this simple formula of a pseudo-proletarian art." The goal, he stressed, should not be just to celebrate mechanically whatever the masses were capable of at the moment, since that skipped over how inequality had robbed the average person of exposure to the best of the artistic tradition, a tradition from which there was much of value to be learned. "Proletarian art should not be second-rate art," Trotsky wrote. "One has to learn regardless of the fact that learning carries within itself certain dangers because out of necessity one has to learn from one's enemies."[13] The wisdom of this phrase holds good in our contemporary case—but accepting this lesson means that a solution cannot be as neat as turning the "figure and ground relation inside out," as Sholette would like, embracing the outsiders and dismissing the insiders.

As a critic trying to navigate the frontier between the realities of art in our far-from-ideal present and the broader potentials of human creativity, you're stuck with two positions, both partly true but each incomplete without the other. You don't have to be a snob to agree with Scheips and Hockney that Pappas's *Marilyn* is confounding. He could have benefited, somewhere along the line, from counsel that simply wasn't available to him that would have allowed him to commune with Hockney better. It would be a great thing if the language of art were not a code shared among a certain clique. On this level, Billy's plight in *Waiting for Hockney* is an argument for the wider dissemination of the values associated with established Serious Art, not an argument for completely rejecting these values.

But, at the very same time, it is also true that *Marilyn* is actually a fascinating creative enterprise. It is a one-of-a-kind accomplishment; it nags at you as an enigma. And looked at from this angle, *Waiting for Hockney* makes you wish that the discourse of Serious Art that we have to work with was a bit more expansive in the first place. The film becomes a fable about how limiting it is to define artistic value in narrow professional terms, how the language it offers us doesn't have words for all the objects of our experience.

In the end, there is nothing contradictory about saying that Pappas's magnum opus is *both* a testament to creativity thwarted and to creativity

redeemed, at one and the same time. It can be both at once because it is the product of a society that creates contradictions for how we view art. As an artwork, *Marilyn* is a kind of cipher for these contradictions—and therefore, possibly, the most honest kind of representation of the world we live and struggle and create in.

Beneath Street Art, the Beach

Ask the proverbial man on the street to name a contemporary artist, and he will almost certainly be more likely to name Banksy or Shepard Fairey than someone from the more traditional world of museums and galleries. Heck, I'm even willing to bet that lesser street-art stars like Space Invader or Swoon have fan bases that dwarf those of well-established fine artists like Matthew Barney or Kara Walker. Of course, it's not surprising that the man—or woman—on the street might connect more with such figures, given that such artists *work* in the street. The tremendous popularity of the loose global genre that has come to be known as "street art" is one of the unstoppable art stories of recent history. Consequently, debates about street art's legitimacy and potential have to be central to understanding how visual art works, or doesn't work, in the present moment.

In some ways this discussion might seem like an attempt to grasp something at the moment of its exhaustion or disappearance. Old-time graffiti artists talk about how the success of the genre has led it to be overrun by a "generation of dilettantes" with little serious investment in the craft.[1] Banksy's exceptionally entertaining, wildly popular 2010 documentary *Exit Through the Gift Shop*, which charts the success of a bumptious, bumbling character named Mr. Brainwash, is best understood as a kind of lament for the genre. It begins with a montage splicing together the exploits of legions of taggers and street artists hitting walls and evading cops, evincing a warm affection for their grassroots creativity and rebellion. But this imagery is meant as a counterpoint to the film's later scenes of air-headed L.A. scenesters raving about Mr. Brainwash's work, after most of the movie is spent showing how accidental his rise to fame is and how substance-free his art. The implication is clearly that whatever authenticity this subculture possessed has been leeched from it by media hype.

Street art's strange, conflicted status in the mainstream was again hammered home when the Los Angeles Museum of Contemporary Art (L.A. MOCA) hosted "Art in the Streets" in 2011, a survey of street-art stars that

attracted blockbuster crowds but also churned out one controversy after another. An Italian artist named Blu was asked to make a mural on the museum's Geffen Contemporary building to advertise the show in advance. He responded with an antiwar piece—dollar-bill-draped coffins—that was immediately whitewashed by the museum for fear of offending veterans, provoking anti-censorship protests and much commentary that the show represented not an embrace of street art but an attempt at defanging it.[2] The exhibition's run saw artists lay siege to L.A. MOCA and the neighborhood around it with unsolicited artistic interventions, much to the consternation of local business owners.[3] At the same time, even as "Art in the Streets" explicitly celebrated artists who had made the transition from the semi-legality of the street to gallery or design careers, the Los Angeles district attorney tried to make an example of an artist named Smear, arguing that because he had attempted to profit from his art by showing it in a gallery, his street work could be classified as illegal advertising.[4]

Contemporary "street art" is in some ways quite distinct from graffiti art, more image-based and multifaceted and gimmicky. It grew up alongside graffiti, but traces its lineage to the parallel and contemporaneous tradition of Jean-Michel Basquiat, Richard Hambleton, and Keith Haring—never members of New York's original graffiti scene, though often mistakenly associated with it[5]—as well as the San Francisco style of Barry "Twist" McGee and his folkie cartoons,[6] the offbeat New York postering campaigns of Revs and Cost in the nineties (the decisive influence on Shepard Fairey),[7] and the life-sized stencils of Paris's Blek le Rat (the object of Banksy's devotion).[8]

Yet graffiti and street art have grown up together, intertwined in the public mind, in terms of their sensibilities, and above all, in their shared spirit of reclaiming the urban environment for personal expression. The present-day outrages and disappointments of street art are in many ways phenomena that are as old as street art itself and part of the package. "The audience at any showing of *Style Wars* . . . always raises the same questions," documentarian Henry Chalfant explained in a 1987 essay on the classic graffiti film that, like L.A. MOCA's "Art in the Streets" show, was intended to be an exuberant promotion of the phenomenon. "Angry citizens berate us for encouraging vandalism everywhere," Chalfant said, while "the purists ask if we regret being part of a process that has destroyed urban folk culture."[9]

One imagines that people have been writing on walls forever. Graffiti histories sometimes begin by going back to Neolithic cave paintings or remarking on the scribbles on the walls of Pompeii. Roger Gastman and Caleb Neelon's *The History of American Graffiti* begins more plausibly with Depression-era boxcar artist Boxo Texino and World War II folk hero Kilroy.[10] But modern graffiti, the kind that has spread to be familiar the world over, is ac-

tually a *style* of art, and that style has a concrete history and definite origin. Graffiti culture is one of New York's big exports to the world, and though it preexisted hip-hop, it gained status as one of that culture's "four elements" alongside the Bronx-bred art forms of DJing, rap, and breakdancing. As Jeff Chang narrates in his masterful *Can't Stop Won't Stop: A History of the Hip-Hop Generation*, graffiti grew out of the conditions of urban decay in the 1970s and was always in some contradictory way both a symbol of and a reaction against it:

Living in a visually pleasant environment is a perfectly normal human impulse, something even hard-pressed communities have striven toward. When the Puerto Rican revolutionary group the Young Lords was seeking to organize in Spanish Harlem in the 1960s, its members surveyed neighborhood denizens about what they would like to see improved in the community. Almost unanimously, the answer they received was that there was too much trash on the streets. So they organized a plan for community garbage pickup. Alas, the Young Lords were undone by FBI infiltration and political infighting, a target in the government's campaign of persecuting urban radicals in the sixties.[11] The problems of blight that had animated its members remained and indeed worsened as the vicious stagnation of the 1970s set in.

Into this void stepped the gangs. In the Bronx, a history of targeted neglect came to a head, turning the neighborhood into a whirlpool of violence and despair. Fiercely and violently territorial, gangs marked their turf by scratching their names on available walls. The early graffiti writers developed a style inspired by this militant vandalism, though it was as much an alternative to as an extension of it, as Chang explains: "The young graffiti writers were the advance guard of a new culture; they literally blazed trails out of the gang generation. Crossing demarcated turfs to leave their aliases in marker and spray paint, they said 'I'm here' and 'Fuck all y'all' at the same time. Gang members, who had trapped themselves in their own neighborhoods, had to give them respect."[12]

Gang tags were about marking borders; graffiti art was about showing you could cross them. The new artists were, in addition, "more interested in projecting individual flash than collective brawn."[13] Norman Mailer, who wrote one of the earliest mainstream profiles of the graffiti scene in 1974, said that the "name" was the "faith of graffiti," that is, the motivating impulse was to make your existence known by stamping a personal signature on space.[14] In New York, graffiti artists' self-promotional zeal was symbolized by how the subway cars became their prime target, moving billboards that could send a name rolling across the city to be appreciated by fellow artists in far-flung corners of the metropolis.[15] From a mainly instrumental practice with a minor aesthetic aspect, writing one's name became an end of its own and grew to be increasingly elaborate as writers competed with one another for prestige.

To a certain extent, this mercurial art form was able to offer an alternative outlet for the angry and abandoned. Graffiti was born out of urban culture, from the hands of bitter youth. Later the skater punks, suburban nihilists, and other "beautiful losers" would make their mark. Ethnically, the scene was diverse—*much* more diverse than the official art scene, where Black and Puerto Rican artists were sometimes treated scandalously. But though it would become the official visual language of hip-hop, graffiti art was also bigger than just the neighborhoods with which it became most associated and always attracted practitioners who were better off as well as those who were down and out (it was, though, and has remained, a boys' world, with heroic exceptions). Still, graffiti indisputably had the rebel charge of an authentic youth movement.

"My first impression of why other people were writing was because I felt people were angry, upset that they didn't have a voice in the world, that the government was telling us how it was and how it was going to be," remembers graffiti pioneer LSD OM, "and I think people were too free to let that happen."[16] L.A. writer ZUCO remembers, "I got into piecing to beautify my community because that's what the colors were doing—motivating people."[17] The shape that graffiti art took forever bears the imprint of this origin, the unresolved hybrid of fuck-the-law nihilism and grassroots urban improvement.

It is no coincidence that graffiti first exploded in New York, with its concentration of media and creative industries. The Greek kid from Washington Heights who went by Taki 183 wasn't the first tagger, but he was the first to be profiled in the *New York Times* (in 1971), and the copycatting that this publicity inspired caused the scene to mushroom.[18] Meanwhile, the New York art connection would bring some sense of larger importance to an activity previously thought of as being by definition disposable. It was relatively early on, in 1973, that the United Graffiti Artists were showing at SoHo's Razor Gallery and doing live painting as a background for Joffrey Ballet dancers.[19] From O.K. Harris gallery's 1980 show of graffiti photos to Colab's woolly, up-with-people "Times Square Show" in the summer of the same year, which incorporated a cadre of graffiti stars, the road to New York–style graffiti's global influence came via its migration into downtown creative circles. By the time graffiti legend Fab Five Freddy was curating a show for the Mudd Club in 1981, Blondie was name-checking him in "Rapture" while rapping nonsensically about how the man from Mars was eating cars.[20]

As an aesthetic movement, graffiti art had some of the same historic winds in its sails as the more narrow fine art, which was then in a historic opening-up phase. It arrived after Pop Art, with its embrace of popular and junk culture, and as an adolescent art form it shared Pop's passions: "comic books,

Sunday funnies, cartoons, toys, advertisements, candy wrappers, cereal boxes, and album covers."[21] Its name-based character came after Conceptualism's "dematerialization of art" into pure language games; its rebel aesthetic came after the guerrilla urbanism of the Situationists, whose obtuse slogans ("Under the Paving Stones, the Beach") won an audience on the walls of Paris during May '68; its mercurial character came after Allan Kaprow's "happenings," which turned art into subcultural theater. The graffiti explosion was concurrent with the alternative-space movement, another sort of protest against the "elitism" of official art. Just as New York graffiti kids found themselves putting their ragged marks on the faceless city, the industrial certainties of Minimalism were giving way to Post-Minimalism (a term coined in 1971), with its sense of pathos and loss of control.

At the same time, with its vibrant Wild Style colors, classic New York graffiti represented an implicit if mainly unintentional rebuttal of Conceptualism's cerebral, anti-visual character, even as it showed concretely what the idea that "everyone is an artist" means in practice. That dictum, from German artist Joseph Beuys, was and is encouragingly utopian—yet in real life, hierarchies of power cramp and trouble what it might mean. Universal consumerism has indeed augmented the creative instruments at the disposal of the average person—the graffiti art scene was made possible, above all, by the mass accessibility of aerosol spray paint and Magic Markers—but this potential is not matched by opportunities within the sphere of official culture for people to realize themselves as professional creative individuals.

Graffiti is one of the essential artistic products of the neoliberal period. This quintessentially urban art form has coincided with the worldwide spread of urbanism itself—the dramatic expansion of cities, which are now home to more than half of the world's total population, is a phenomenon of the recent past.[22] Its rise is also coextensive with the onset of First World deindustrialization on the one hand—which has brought the hollowing out of old urban cores, leaving behind walls haunted by the void of a receding society—and gentrification on the other, cluttering public space with the symbols of consumerism to be appropriated and subverted. Finally, graffiti and street art are quick, populist, and sassy, qualities that give them a certain appeal that more traditional fine art lacks in an increasingly high-velocity technological society.

But above all, street art now, as graffiti then, attracts a passionate investment at least in part because it is felt to be a rebel act. There is a political, or at least proto-political, investment in the lifestyle. It's a way for those without a voice to carve out a space, for people to find a tribe of like-minded people. And in some indistinct manner, it is also perceived as a blow against private property and the domination of everyday life by faceless corporations and

cops. "Too much 'space' in our urban cities is sold to advertisers and large corporations," Marc Schiller, who runs the street-art website Wooster Collective, has said. "Street artists are trying to reclaim a bit of their space."[23] This is pretty typical rhetoric for the scene.

But there's no sense in being precious about it. Graffiti began with the practice of getting your name across borders as a kind of rebellion. For someone like Shepard Fairey, with his interminable "OBEY" campaign, this practice morphed into endless plotting to leave marks in ever-more-novel locales. When this becomes an end in itself, it's a short step to see it as simply doubling the rootlessness of the global branding campaigns that it is defacing. Street art's antiestablishment posture has often shaded seamlessly over into scrappy entrepreneurship rather than political radicalism. A contemporary superstar like KAWS won a following by defacing advertising posters (his signature is to X out the eyes and add cartoon details). These days he sells lines of art toys, styles sneakers, and does album art.[24]

Gallery art focuses, in general, on selling status symbols to rich people, but for this very reason, it has to maintain a certain distance from corporate design. Street art is hostile to established commercial art channels but has been altogether more comfortable moving in and out of mass commercial culture. Still, if the number of marketers looking to channel street art is ever expanding, this is also because this art form has a genuinely popular audience that more conventional fine art doesn't.

The endless graffiti-as-art versus graffiti-as-vandalism debate, it seems to me, is just a displaced version of the fundamental question raised by the tumultuous pluralism of contemporary aesthetics: "What is art?" In the case of graffiti, however, debate over the question is played out in the streets, where the cops and perfectly innocent, aggrieved small business owners get involved (or other street artists, for that matter, who don't take kindly to their work being covered over by inferior productions). The gallery's white cube serves to quarantine the debate over the acceptable frontiers of aesthetics, transmuting it into a question of abstract taste and intellectual posture when it is in fact a question of rival ideas—held by different communities and cultures—of how society works. Not everyone has equal access to the white cube. In fact, most don't.

The tremendous popularity of street art goes hand in hand with the troubled issues that dog it. Not in the sense that controversy attracts attention, which attracts crowds—though I suppose there is some of that, too. In a strange way, street art exists in a kind of tortured synergy with the official art scene, the former owing some of its popularity to the latter's inaccessibility. More people can identify with the outlaw route to aesthetic self-expression than with the esoteric route offered by traditional museum culture. And that,

ultimately, seems to be the lesson of street art, with its strange, contested status as both vastly popular and permanently persecuted: society has a creative potential too massive to fit within the cramped confines of official art. Trying to make street art into an official culture is bound to expose this tension rather than resolve it.

White Walls, Glass Ceiling

In May 1984, the Museum of Modern Art celebrated its expansion with "An International Survey of Recent Painting and Sculpture," a massive show organized by Kynaston McShine. It was billed as a summation of the challenging breadth of contemporary art; a press release boasted that the "Survey" would "reveal the high quality and extraordinary vitality of recent artistic production in acknowledging a variety of works by a younger generation of artists" and "impart a sense of the great diversity and individualism that is prevalent in today's artistic output."[1]

Today, these grand claims are all but forgotten; McShine's initiative is better remembered for what it didn't contain than for what it did. For of the "195 works, all made since 1975, by 165 artists from 17 countries" that it advertised, only thirteen were by women. Coming on the heels of the feminist art surge of the 1970s, this manifest *lack* of diversity triggered a wave of anger. The show was picketed. More enduringly, the incident sparked the creation of the art collective known as the Guerrilla Girls, who became known in subsequent years for dogged and humorous graphics pointing out the bias of museums and galleries, as well as their ingenious device of wearing gorilla masks to provide the group's members with the freedom of anonymity and to draw attention to their actions. (In 1989, they released what is perhaps their most famous graphic, aimed at the Metropolitan Museum. It featured a nude odalisque in a gorilla mask beneath the words, "Do women have to be naked to get into U.S. museums?" The text explained, "Less than 2% of the artists in the Met. Museum are women, but 83% of the nudes are female.")[2]

Today, the Guerrilla Girls' biting feminist agitprop is considered among the most important art that came out of the eighties. It is highlighted in most textbooks and in the permanent collections of many of the museums that they protested and is generally admired for its courage and wit. The Guerrilla Girls are part of art history. It is all the more striking, then, that the problem they addressed remains very much present with us today.

Two decades later, in 2005, PS1 Contemporary Art Center—a satellite of MoMA—held its second "Greater New York" show, a once-every-five-years survey that is supposed to bring together whatever important new trends are percolating from the city's art scene (not unlike McShine's long-ago "Survey"). The opening festivities were marked, once again, by a protest: Four women stood, wearing spiky pink wigs, outside the institution, silently pointing and generally making a spectacle of themselves. This collective, which called itself the Brainstormers, had taken it upon themselves literally to "point out" how women made up only slightly more than a third of the figures represented in this potentially career-making survey.[3] That total represented some progress from the disgraceful days of the mid-eighties, but was certainly far from satisfactory. In fact, it was kind of shocking.

Like the Guerrilla Girls before them, the Brainstormers used the raw outrage of simple statistics as their medium. In a pamphlet accompanying their action, they noted that women now made up more than half of students entering art schools—that year, at New York's School of Visual Arts, 71 men enrolled in graduate studies in the fall, compared to 134 women—yet less than one third of solo shows in Chelsea, the epicenter of New York's commercial art world, featured women.[4]

Like the picketing of the MoMA in 1984, the Brainstormers' modest gesture of artistic activism had larger ripple effects. It was written and blogged about. In subsequent years it became fashionable to a certain extent to report on the male/female ratio in big group shows like the Whitney Biennial, and major museums have made some gestures toward checking bias. When "Greater New York" returned in 2010, the percentage of women in it was up to forty-three.[5] In 2007, there was a mini-boom of shows celebrating the feminist legacy, including important historical exhibitions of feminist art like "WACK!" at the Los Angeles Museum of Contemporary Art (later at PS1) and "Global Feminisms" at the Brooklyn Museum, which provided the occasion for various panels and think pieces addressing the issue of bias in the art world. It was enough for observers to talk hopefully about a renewed "feminist surge."[6]

Yet not a year has gone by that some commentator has not found cause to report on continued discrepancies. In 2012, a group called the East London Fawcett Group took it upon itself to "audit" the Frieze Art Fair—a massive event with a focus on high-end contemporary art bringing together galleries from all over the world, and therefore a fairly good barometer of international trends—and found that just 27.5 percent of the 3,441 artists in the fair's commercial section were women.[7] Progress toward gender parity in visual art, it would seem, appears to be stuck.

When I was writing the first version of this essay during the initial outpouring of pieces on the topic in 2005, what struck me was how little ex-

planation there was for *how* this sorry state of affairs came to be. The question of sexism was implied to be a kind of freakish anomaly, a case of bad ideas that could be taken on simply by exposing them. And yet, there are plenty of powerful women in leadership positions in the arts—in fact, the majority of the vast curatorial team for the 2005 "Greater New York" were women. So what exactly was going on?

In her justly famous 1971 essay "Why Have There Been No Great Women Artists?," art historian Linda Nochlin argued that commentators had to reconsider the terms of the question, focusing less on the miracle of individual "greatness" and more on the structural realities that had prevented women from achieving success: "The question of women's equality—in art as in any other realm—devolves not upon the relative benevolence or ill-will of individual men, nor the self-confidence or abjectness of individual women, but rather on the very nature of our institutional structures themselves and the view of reality they impose on the human beings who are part of them."[8]

Today, women have battled for and won the right to be taken seriously as artists. On a certain level, the historical barrier to "greatness" that Nochlin outlined has receded and seems a thing of the past—anyone today who openly stated that being a woman was itself a barrier to being a great artist would have the full weight of art history against him and could expect to be challenged.[9] And yet despite the outward appearance of fair-mindedness, *in some ways* women remain disadvantaged as artists. Nochlin's perspective on this phenomenon remains crucial: the task still does not hinge on acknowledging "the relative benevolence or ill-will of individual men, nor the self-confidence or abjectness of individual women," but rather on figuring out the structural mechanisms that make bias tenacious and enduring.

Because the answer seemed hidden, I felt it was likely linked to the indistinctly understood networks that determined success in the arts, the hidden pathways by which consensus is formed about what is worth attention and who will be chosen to succeed. In his review of the 2005 "Greater New York," the critic Jerry Saltz made two important observations. The first was the low number of women artists involved. The other was that, despite curatorial rhetoric that the survey had been based on an "open call," "Greater New York" looked very much like a feeder for product already approved by New York's mainstream commercial art scene:

> "Greater New York" is so completely geared to budding artists that there's a whiff of pedophilia about it, the feeling that if an artist is over a certain age he or she has already worn out a welcome. In fact, young as they are, many of the "emerging artists" in "Greater New York" aren't even that emerging: 11 have been in a Whitney Biennial, one—the always intriguing Carol Bove—has been on the cover of *Artforum*, the duo of Oliver Payne & Nick

Relph has graced the cover of *Flash Art*, and over 100 are already represented by galleries.[10]

Digging into the subject a little, it struck me that coordinating these two observations—the lack of women and the commercial bias—was a good starting point in getting at the heart of the problem.

To understand the mechanics of success in the visual arts, one has to be clear that it is a complex space where moral, theoretical, or aesthetic motivations wrestle against brute commercial calculation. Rather than an ivory tower, as some claim, the "art world" is a golden pyramid whose broad and unshakable base is constructed of art dealers, who are at the end of the day small businesspeople. Whatever other passions they bring to the table, they must find someone to buy the aesthetic goods that they sell, or cease business—and the primary market for "fine art" remains people with large amounts of disposable cash. Therefore, the vicissitudes of how wealth is distributed in the economy as a whole will make a difference when it comes to who has the capacity to purchase art and whose interests thereby dominate.

The persistent "wealth gap" between women and men in the economy at large very likely has something to do with a bias toward male artists in the market, then. According to one stunning study, despite gains in income, women overall still have just 36 percent of the accumulated wealth that men do.[11] At its top end, the art market represents quite a small cluster of people, mainly individuals who have inherited vast amounts of wealth or who have accumulated fortunes as titans of industry or finance. The stereotypical art buyers of the new millennium, before and after the financial crisis of 2008, were Russian oligarchs and New York and London hedge-fund millionaires—both groups that are, it is safe to say, predominantly male. Review the lists of top art collectors and you will see that even if you count all the members of the various husband-and-wife duos separately, the ratio skews male.[12] If this fact entails even a slight bias in terms of which gender gets taken seriously, it might seriously affect who sells and thereby which artists go on to glory.[13]

On the supply side of the equation, the wealth gap and other ingrained barriers toward women's advancement in society more broadly are likely to make life more difficult for female artists. The National Endowment for the Arts says that the field of what it counts as "fine artists" splits almost equally between men and women. Yet, despite being better educated than their male counterparts (with more than 55 percent reporting having a "bachelor's degree or higher," as opposed to about 47 percent of men), female artists report just 81 cents of income for every dollar their male counterparts take in (a median income of $29,000 versus $36,000) and are far more likely to say they are pursuing their art career part time.[14] The income gap widens significantly for older women. The reasons are obscure but perhaps have something

to do with the burdens of raising children, which still disproportionately fall on women.[15] Perhaps this is one reason why, in the creative sphere, women are 6 percent less likely to have children than female workers as a whole.[16]

For women, the key kink in the system, however, seems to occur between art school—where they are generally thought to be at parity, if not in the majority—and initial contact with the system of gallery representation, where the number plummets. It seems, then, that a lot rides on understanding the mechanisms by which artists come to show at a gallery. This process is notoriously opaque, based largely on behind-the-scenes networks and back-room elbow-rubbing. Bravado takes you a long way in the image-driven world of art, and all the issues of eroded self-esteem and gender stereotyping that girls face from a very early age must take their toll here.[17]

Yet since there are plenty of assertive and confident women in the arts, we still need to see how discrimination insinuates itself in practice. The same year as the Brainstormers' "Greater New York" protest, Kathy Grayson, curator at New York's Deitch Projects—then the epicenter of emerging-artist hype in New York—put together *Live Through This: New York in 2005*, a slender and lively book that attempted with some prescience to round up the best of the contemporary scene. It included profiles of such soon-to-be-stars as Cory Arcangel, assume vivid astro focus, Dan Colen, and Terence Koh. The twenty-seven entries mention exactly three individual women: Bec Stupak, a creator of psychedelic, tribal films and performances inspired by rave culture; Misaki Kawai, who realizes aggressively whimsical environments incorporating cartoon themes; and Julie Atlas Muz, a burlesque dancer. (The female-dominated music acts Tracy and the Plastics, Le Tigre, and Avenue D were also mentioned as part of the broader hipster constellation.) In her accompanying essay, Grayson is quite clear about the personal ties that underpin this constellation of figures:

> The most interesting part of the organization of this group of people is the insane degree of complexity with which everyone is interconnected. Brian Belott and the Huron Street people, who came from various Providence beginnings, put the Dearraindrop people up when they're in town, who in turn used to affiliate with the Paper Rad people, who have gone on tour with Cory [Arcangel], who also curated a show featuring a bunch of the artists in this book including Justin [Samson], who collaborated with AVAF [assume vivid astro focus] in Miami and lives with me and Ry [Fyan], who in turn showed with Dash [Snow] and Dan [Colen] at Rivington Arms a while ago, Dash having used Brendan [Fowler], Dan, Ryan [McGinley], Ry, Keegan [McHargue]—I mean, the majority of these people—as his subjects, Dash's awesome-looking living room wall being the subject of Dan's next painting, who seems to be in all of Ryan's early photographs—Ryan who is close friends with Brendan and Philip and Terrance [Koh], who are all in the next *K48* issue Eli [Sudbrack]'s

friend Scott is doing, which also includes Jules [de Balincourt], Matt Leines, Devendra [Banhart]—and on and on, ad infinitum.[18]

Of such raw social materials are artistic careers made, as the line between who is cool and who is not, who is in and who is out, who is marketable and who is not, is subtly drawn—and, with the exception of Grayson herself, *not a single woman* features in that account. If there is an initial disposition for dealers to bring in male artists and those male artists are then disposed to recommend and work with their own male friends, then this state of affairs has the potential to create a cascade effect. Grayson's exciting new scene sounds a lot like the old boys' club.

Lucy Lippard once wrote about the need for special initiatives to promote women artists, the project to which she dedicated herself in the early 1970s:

> A large-scale exhibition of women's art in New York is necessary at this time for a variety of reasons: because so few women have up until now been taken seriously enough to be considered for, still less included in, general group shows; because there are so few women in the major commercial galleries; because young women artists are lucky if they can find ten successful older women artists to whom to look as role models; because although 75 percent of the undergraduate arts student body is female, only 2 percent of their teachers are female. And, above all, because the New York museums have been particularly discriminatory, usually under the guise of being discriminating.[19]

In the decades since, a large number of female artists have won serious respect and commercial credibility. The situation in the new millennium has been unmistakably transformed since Lippard penned those words (although when confronted about the disparity in "Greater New York" in 2005, curator Klaus Biesenbach could still defend himself by saying, "Any discrepancy is due to the quality of the art"—pretty much the definition of being discriminatory in the guise of being discriminating).[20] But the persistence of the issue shows that it is wrong to think that some progress means that the fight for equality can be put on autopilot and that art history is on an inevitable march toward greater equity. The statistics from the book *After the Revolution: Women Who Transformed Contemporary Art* (2007) are worth quoting at some length in this regard:

> Because certain women artists—from 30-year-old Dana Schutz to nonagenarian Louise Bourgeois—currently have high profiles in galleries, major private collections, museums, and the marketplace, it may be perceived that the situation for women artists has improved significantly over the past 35 years. But by examining the number of solo exhibitions by women artists presented from the mid-1970s until the present, through a representative sampling of influential galleries, we can see that while the situation did improve until the 1990s, it appears to have reached a plateau. In the 1970s, women accounted for only 11.6

percent of solo gallery exhibitions. In the 1980s, the percentage of solo exhibitions by women crept up to 14.8 percent, and in the 1990s the number increased to 23.9 percent, but the percentage has dropped slightly, to 21.5 percent, in the first half decade of the 21st century. The current number of solo gallery exhibitions by women artists is not notably better than the average of women's exhibitions for the entire period under consideration, 18.7 percent. While the number of women artists' exhibitions has doubled since the early 1970s, it has really only kept pace with an expanded market: women still have roughly one opportunity for every four of the opportunities open to men. Museums have only a slightly better track record. During the 35 years we surveyed, 27 percent of solo museum exhibitions presented the work of women artists.[21]

What might account for this subtle erosion of women's gains in the gallery during this period? In the book *Witness to Her Art*, Michael Brenson hypothesizes that it might have something to do with "the return of the art market as the nearly unquestioned arbiter of value and success" and "the rise to unprecedented prominence of the private collector" at the turn of the millennium, as museums began to compete more seriously for the attention of the swelling ranks of newly super-rich patrons in the neoliberal New Gilded Age.[22] Through the nineties, the center of curatorial and critical discourse was still held by theories that bore the charge bequeathed to them by the feminist movement, in however distorted a form. The triumph of the market, Brenson believes, undermined that heritage:

> After a period in which "marginal," "alternative," and "peripheral" art had, it seemed, finally been aesthetically and culturally legitimized, museums were again becoming dependent on collectors who had little interest in art shown outside powerful galleries and mainstream art centers. By 2000 it was clear that the struggle to attract collectors and their collections was controlling patterns of acquisition in most influential American museums.[23]

And yet—and this is important—the backsliding on feminist issues is hardly confined to the rarified world of the arts. In an age of escalating inequality, just because women are more visible than ever before in leadership roles does not mean that the lives of the great masses of women are necessarily better. Contemporary pundits talk about "The End of Men" and the inevitable triumph of the Second Sex, even as women continue to make less money and face demonstrable discrimination.[24] Across the economy, the decades of the 1960s, 1970s, and 1980s saw a dramatic integration of women into traditionally male-dominated fields. And yet researchers have sounded the alarm that the subsequent two decades have been characterized by either stagnation or reversal of these gains.[25] The gap in wealth between the sexes remains even more alarming. As Mariko Chang put it bluntly to the Clayman Institute for Gender Research in 2011, "The gender revolution has stalled."[26]

It doesn't take a brain surgeon—or a Brainstormer—to hypothesize that the two stats—the status accorded to women as artists and the status of women in general in the economy—might be interwoven.

The sixties and seventies gave birth to a combative women's liberation movement that scared the powers-that-were into according more respect to women's points of view in almost every field, made reproductive rights a central axis of politics, and left in its wake numerous women's organizations and advocacy groups. This critical sensibility created a public for women's art, found its way into the establishment, and by the nineties had made multiculturalism and feminism central aspects of exploration and research.

But a thirty-year backlash against feminism can't help but take a toll. Without a dynamic and activist-oriented women's rights movement, institutional gains remain fragile and contradictory. Mainstream women's organizations, dominated by middle-class politics, became more focused on lobbying largely perfidious politicians than on mobilizing numbers to protest.[28] In the arena of art, as in the academy in general, feminism turned inward toward postmodern identity politics, away from even a symbolic connection to popular protest.[29] Meanwhile, the golden lure of individual success for a few superstars in a booming art market distracted from the importance of arguing for systematic accountability and provided a context in which persistent biases could fester.

These factors set the stage for the strange and disorienting postfeminist quagmire of the new millennium. It is to these factors that we must turn our minds and energy if we want to do something about the sorry state of affairs we find ourselves in now. Focusing narrowly on changing attitudes within the "art world" is a case of tilting at ideological windmills, unless it is self-consciously linked to the larger issues facing women in general. Without making this connection, we can neither understand the problem nor hope to alter it.

CODA

This particular essay holds a special place in my heart. Beginning to investigate the enigma of the underrepresentation of women in the supposedly liberal and feminist art world was what first led me to try and grasp the mechanisms by which artistic success is attained and how these mechanisms connect with the larger inequalities affecting society—both subjects that often remain concealed beneath the glittering parade of new spectacles. Pulling on that particular thread uncovers unpleasant realities that disadvantage women but also frustrate the vast majority of artists, male and female: the blind biases of an art market dominated by the superrich and

the privileges commanded by clubs of insiders. Sexism has its own special dynamics that have to be specially combated. But for me, the connections made in this essay point to how the fight for equality can be waged on the basis of genuine solidarity, in the name of a world where art's value escapes the deformities imposed upon it by an unequal society.

Hipster Aesthetics

One doesn't really expect to discover paradigm-shifting inspiration in the *New York Times Magazine*, but that is more or less what I got when I opened up the August 2010 cover story on late-blooming young people, "What Is It About 20-Somethings?"[1] Not that this essay transcended the limits of the middlebrow think piece (as one commentator pointed out, it really felt like it should have been titled "The Science Behind Why You Don't Have Grandkids Yet"[2]). But I had just been to see the latest "Greater New York" show at MoMA PS1—the usual half-satisfying cattle call for new talent—and the sociological developments to which the article alluded caused the art in that show to snap into place for me, offering hints of a material explanation for the heretofore-ineffable shared sensibility underpinning a range of otherwise eclectic work. It really was a kind of "eureka" moment.

The art critic Donald Kuspit once argued that "the emergence of the avant-garde is correlate with and inseparable from the emergence of 'adolescence.'" The latter concept only came into focus in the writings of psychologist G. Stanley Hall at the turn of the twentieth century, making it roughly contemporaneous with the emergence of the wilder forms of modern art.[3] Youthful rebellion and artistic rebellion were born as twins. The *Times Magazine* article, for its part, declared that a variety of intersecting social conditions had metastasized to create a de facto new life stage suspended between adolescence and adulthood with its own features, dubbed "emerging adulthood" If that intuition was even half true, then it might plausibly be thought to find its own reflection in how artists relate to tradition and to the world in general. The concept of "emerging adulthood," I thought, might well be a correlate of today's "emerging art."

· The 1960s are customarily remembered as the golden age of youth culture, the template through which all subsequent youthful self-exploration is viewed. It may be useful, then, to call attention to just how much has changed

for young people since those halcyon days. In the book from which the *Times Magazine* article largely draws, Jeffrey Jensen Arnett's *Emerging Adult hood*, the author lays out his case:

> As recently as 1970 the typical 21-year-old was married or about to be married, caring for a newborn child or expecting one soon, done with education or about to be done, and settled into a long-term job or the role of full-time mother. Young people of that time grew up quickly and made serious enduring choices about their lives at a relatively early age. Today, the life of a typical 21-year-old could hardly be more different. Marriage is at least five years off, often more. Ditto parenthood. Education may last several more years, through an extended undergraduate program—the "four-year degree" in five, six, or more—and perhaps graduate or professional school. Job changes are frequent, as young people look for work that will not only pay well but will also be personally fulfilling.[4]

As the language here suggests, Arnett's views on "emerging adulthood" have a bias toward those from relatively well-off backgrounds (he acknowledges as much, and we'll get to the implications of this bias in a minute). However, some of the factors contributing to the new expectations about youth, such as the expanding length of time spent in higher education, represent broad shifts in society across a range of backgrounds. And the most important factor in Arnett's theory of "emerging adulthood"—the increasing age at which people settle down—represents a broad-ranging social shift indeed. Among other things, it is connected to the salutary impact of the struggles of the sixties, above all in sexual mores, where women's lives have been completely transformed, opening up previously impossible professional possibilities, making sexual exploration widely accepted, and shattering the expectation that identity be defined primarily in terms of wife or mother.

In 1950, the median age of marriage was about twenty for women and twenty-two for men; in 1970, on the far side of the free-loving sixties, these totals had risen—barely—to twenty-one for women and twenty-three for men.[5] But by 2010, the average women wouldn't expect to be married until after twenty-six; the average man would wait until after twenty-eight.[6] (The percentage of adults who choose to marry at all has itself seen a steady decrease; it has dropped from 72 percent in 1960 to barely over 50 percent in 2011.[7]) The result of these social transformations is that the typical way that many young people experience their twenties has changed, with that period now being filled with a greater range of experimental living situations, partners, and lifestyle shifts.[8]

Arnett offers a handy numbered list of the features that he sees as characterizing "emerging adulthood":

1. It is the age of *identity exploration*, of trying out various possibilities, especially

in love and work.

2. It is the age of *instability*.

3. It is the most *self-focused* age of life.

4. It is the age of *feeling in-between*, in transition, neither adolescent nor adult.

5. It is the age of *possibilities*, when hopes flourish, when people have an un-paralleled opportunity to transform their lives.[9]

Now, for an art critic, what is striking about this list is how it coincidentally seems to capture a lot of the themes of recent art. Looking back at the art of the first decade of the new millennium, the critic Hal Foster tried to summarize the "condition" of its art: "No concept comprehends the art of the past decade, but there is a condition that this art has shared, and it is a precarious one."[10] That might be seem a too-dark take on the matter, but a short list of themes would include impermanence, a certain self-absorbed hermeticism, a focus on identity exploration and masquerade, deviance, perpetual experimentation, and general fucked-up-ness. This was the shared texture I detected beneath the otherwise impossibly diverse work in a show like "Greater New York."

Thus, you had David Benjamin Sherry (born 1981), an artist whose photo-based work featured psychedelic symbolism and natural landscapes given an artificial look, dominated by vibrant colors. Sometimes the works featured the artist himself in body paint doing a human chameleon act, as in *Self Portrait as the Born Feeling Begins*, where a green-covered Sherry emerges from a soupy green swamp. "There's truth in the work for me," he explained. "I look to the images for a sense of who I am, and I hope people can sense that. A lot of these pictures have me in them. Some people ask, 'Are you a narcissist?' But I don't think so. . . . I'm just dealing with myself."[11]

Objection Room by Dominic Nurre (born 1980) offered a cryptic environment that incorporated recorded hyena howls, salt licks, a pipe fixed across the space that visitors had to duck under, and "glory holes" cut in the wall. You might have had to read Lauren O'Neill-Butler's interview with the artist to get the idea, but the installation was all about simulating a place for anonymous public sex, with a quasi-mythical twist (the hyena howls were, it turned out, a reference to legends that hyenas are homosexual animals). Nurre explained the whole thing as exploring personal symbolism, fluid sexuality, and the generally mercurial bonds between humans: "I'm attracted to the thought of something being nourishing and constructive but at the same time not allowing a real community to grow."[12]

Another highlight in "Greater New York" was the work of Kerstin Brätsch (born 1979) and Adele Röder (born 1980), a duo who collaborated in the guise of an invented collective entity: their dummy "import/export" agency

DAS INSTITUT (founded 2007). Under this name, Röder created strange fragmented digital abstractions in Photoshop, which Brätsch then translated into paint on large hanging sheets of clear mylar, which Röder then reinterpreted again, and so on ("import/export"). As one critic quipped, the experiment of DAS INSTITUT, with its strange corporate form, murky message, and vibe of groovy group invention, "treats referents like refreshments at a party."[13] It was predicated on a vision of art as limitless, objectless screwing around.

The broadly experimental feeling of these examples has its precedents in the media explorations of the previous "postmodern" generation. Yet if you compare the set-up photos of Cindy Sherman to Sherry's photo experiments, the melancholic psychosexual environments of Robert Gober to Nurre's coy installation, or the great German painter Gerhard Richter's zig-zag shifts between photorealistic and abstract work to DAS INSTITUT's free-flowing goof on painting, there is a definable contrast in temperaments. The elder figures' experiments with media all had some kind of polemical aspect, which in turn formed an important part of how they were received critically. For the young Greater New Yorkers, it felt more as if an art-school period of genre experimentation had been extended into a limitless default position.

Relating contemporary aesthetics to "emerging adulthood" might give some social background to recent art-theory hand-wringing that the paradigm of "postmodernism"—a term that, for all its limitations, still had some critical and intellectual juice in it—has given way to the looser, merely descriptive term "contemporary art."[14] The two things look a lot alike—just the way the experimentation of contemporary young people looks a lot like the angst and soul-searching of their parents in the sixties and seventies. The difference is that this experimentation has become a norm that is passively inhabited, not territory to be claimed.

At this juncture, it might be worth noting that there is no need to build out a whole new cultural theory in relation to "emerging adulthood." A ready-to-hand name for this kind of aesthetic attitude already exists—in fact, it is one of the major cultural bugaboos of the recent past. That name is "hipsterism."

Few characters have inspired more vitriol than the "hipster," and by now the consensus is that the term and its trucker-hat-sporting referent have been exhausted by media overuse, as indicated by the title of a volume of essays published in 2010 by the literary journal *n+1* entitled *What Was the Hipster? A Sociological Investigation*. Various expert voices in *n+1*'s compendium on the subject deny that hipsters can even be artistic, defining them as consumers of cultural signs, not producers. Yet when you sketch the themes associated with this cultural category, they start to sound very similar to the themes explored by art like that in "Greater New York": self-presentation that alternates between the

arch and the deliberately naïve; an obsession with cultural trivia and/or blank nostalgia; a romance with neo-bohemia, neo-collectivism, neo-tribalism.

If the framework of "emerging adulthood" provides a way to contextualize such phenomena without the baggage that comes with the term "hipster," *n+1*'s consideration does add a sense of the cultural stakes, above all because one of the key defining aspects of the "hipster" is an over-ostentatious investment in cultural signifiers. In *What Was the Hipster?*, Mark Greif makes a convincing case that the phenomenon is rooted in "the return of rich whites to big cities in the '90s and '00s" and the corresponding transformation of former industrial or marginal neighborhoods into urban hotspots (the paradigmatic example being Brooklyn's Williamsburg).[15] The culture's social basis, he hypothesizes, is "neo-bohemia . . . a culture of artists who primarily work in bars and coffee shops and rock clubs, while providing an unintentional milieu for 'late capitalist' commerce in design, marketing, web development, and the so-called 'experience economy'—and also the '90s culture of indie or indie rock."[16] More generally, it represents the mass of urban young people who are "overeducated and with a psychic investment in hipness to compensate for their inferior real capital."[17] Greif further elaborates:

> At age 22 . . . when ambitious post-collegians travel to central metropolises, subculture can take on a new role. Many experience a sudden *declassing* in cities relative to college and even high school. The young graduate comes from a high status position but is suddenly without income and has no place in a city indifferent to college hierarchies. He or she still possesses enormous reserves of what Pierre Bourdieu termed *cultural capital*, waiting to be activated—a degree, the training of the university for learning tiny distinctions and histories, for the discovery and navigation of cultural codes—but he or she has temporarily lost the *real* capital and background dominance belonging to his class. Certain kinds of subculture allow cultural capital to be re-mobilized among peers and then within the fabric of the "poorer" city, to gain distinction and resist declassing.[18]

As with Arnett's "emerging adulthood," this faux-hemianism is, for Greif, a transition stage, marking a sort of racy purgatory where young whites nurture a rebellious self-perception before emerging from the chrysalis to become the corporate hacks they always were underneath it all. Greif writes, with withering disdain, that "every micro-generation will be surprised by the number of its members who have been secretly preparing law-school applications while making fun of rich people who wear suits."[19]

Here we hit up against the in-built limits of analyzing matters through the lens of the "hipster," the main one being that it is a chimerical figure with which no one truly identifies; "hipster" is always an insult used to belittle other people's tastes, never to describe one's own. The failure to move beyond a purely censorious framework is, I think, a weakness of Greif's account. In

my more sympathetic alternative narrative, I'd emphasize that during the high-water moment of "hipsterism"—1997 to 2003 is the locus classicus for Greif, the period of trailer-park chic, oversized belt buckles, and endless founts of PBR, while a less defined Phase 2 stretches to the present[20]—the US economy may have grown, but the prospects of all those college-educated white kids he describes did not. As the economist Paul Craig Roberts put it (somewhat hysterically) in 2006—that is, even before the Great Recession—the job-creation statistics indicated that the turn toward the service economy meant that the United States was becoming "a nation of waitresses and bartenders," not some cultural-economy utopia.[21]

In fact, Greif's comment about law school is particularly telling. About the same time that *What Was the Hipster?* was published, the *New York Times* ran an article on the absolutely bleak job prospects of those who pursued a law degree during the very period Greif considers. This classic dream of ambitious would-be professionals was now described by the Paper of Record as "a catastrophic investment."[22] In fact, social mobility in the United States has been in notable decline,[23] and today's young Americans are actually considerably less likely to rise from the class position in which they were born than their peers in other Western economies.[24] By 2011, polls showed that optimism that young people would have a better economic future than their parents had hit an all-time low.[25] Reflecting on what this particular poll meant, the writer Christine Slocum posted to a blog dedicated to Generation Y voices:

> Education, that magic bullet, seems to have crippled our generation more than it has helped. The best job an awful lot of people I know have is the same job they would have received without a degree. Grrrreat. I stay awake at night wondering how we're going to make ends meet enough to have children before my fertility dries up. Compared to my folks, who owned a house by my age and were well on their way to starting a family . . .
>
> Yeah. I can see the reasons for the pessimism. After all, I am living a few of them.[26]

Slocum goes on to enumerate a list of factors she sees as characteristic of her peers—including the buildup of student debt, the increase in temporary employment, and the greater number of couples cohabiting without committing—and declares, "We're the generation of instability." This is both a clear echo of Arnett's "emerging adulthood" thesis and an important corrective to his general optimism ("today's emerging adults have unprecedented freedom"[27]). Arnett argues, for instance, that the more frequent job changes among young people today are the result of a culture of self-exploration, as they hold out for satisfying work. But it is also surely the result of the reality that the old corporate model in which people dedicated their lives to a single company that, in return, took care of them, has withered away under neolib-

eralism, with various forms of precarious work becoming more and more common. Similarly, young people spend increasing amounts of time in higher education not just because they are looking to explore themselves but because an extra degree has become even more important in a hypercompetitive and technology-based job market, and there are fewer entry-level jobs that offer clear paths into a satisfying career.

These hard realities do not mean that there is nothing to the positive side of the "emerging adulthood" thesis. Young people are living more mercurial, less settled lives—that's true. This can be a result of both the slowing of upward mobility, as achieving the means to settle down moves out of their reach (as Slocum's account suggests), and of generally more liberated expectations toward sex and alternative lifestyles (as Arnett would want it). In fact, I'd guess that it is the clash of the two things—a hopeful sense of potential combined with stagnant real prospects—that gives hipster culture its distinct coloring, an air of exuberance set against a sense of wheel-spinning or inward-directedness. As for its cultural manifestations, I'd see this sensibility in Cory Arcangel, who taps into Nintendo-generation nostalgia in digital artworks layering together images from *Super Mario Brothers* and *Duck Hunt* with art-historical references; in Ryan McGinley, known for photos capturing his beatific friends on neo-hippy road trips; and in Ryan Trecartin, auteur of videos conveying a polymorphous, dystopian vision of present-day media-saturated consciousness.

If Arnett's account is too sunny, though, then Greif's account in *What Was the Hipster?* is almost definitely too dismissive and one-sided. Is hipster culture sometimes nihilistic, consumerist, asinine? Absolutely—but it is not as overdeterminately so as Greif paints it. I am not certain that wearing ironic T-shirts constitutes quite the barrier to political engagement that he seems to think it does. I graduated from college in 2001 with a degree in cultural studies. With no idea what to do with that, I went to work in a bookstore. All my coworkers had degrees in English or philosophy, and we all had scorn for the tastes of our customers—in exact proportion to our keen awareness of the uselessness of our own more cultivated sensibilities, the worth of which apparently topped out at $12.50 an hour. What do you do in that situation except be ironic?

The US economy in the last decade threw many more college graduates into this same type of limbo—still relatively privileged, but going nowhere. My best guess is that it is this group, with its wounded pride and self-consciousness at its own superfluousness, that forms the basis for the Quentin Tarantino-esque aesthetic vogue for useless cultural trivia. (Tarantino, in fact, is himself a former video-store drone.) Whether a characteristically ironic sense of self gets articulated in a political direction or turns into a kind of consumerist nihilism depends on what kind of social movements are there for it to intersect.

In fact, recent history offers a great case study in the Occupy Wall Street (OWS) movement. Demographically, the early supporters of OWS were exactly the types of downwardly mobile college-educated young whites Greif demonizes.[28] The issues that animated this movement (the waning of opportunity, student debt, rampant inequality) and the strategies it employed (the neo-communalism of its campouts, its individualistic "leaderless" structure, its keen eye for mobilizing symbolism) both suggest what a radicalized hipsterism might look like. To be sure, this reality represents as many challenges as it does virtues—the need to reach out to more diverse audiences, the need to develop a strategy that reaches beyond symbolic theater—some of which were begun (OWS became more racially diverse as it took up issues of police brutality that mattered to people of color) and some of which remain unfinished (its most ardent adherents are still, at the time of this writing, stuck in the quagmire of leaderlessness).[29] But the tremendous power of the Occupy movement to inspire and to transform the conversation about inequality surely demonstrates that anyone who stood back to sneer, "fuckin' hipsters"—as some did—would have been wrong.[30]

The lesson, I think, is that it is a waste to expel so much rhetorical ammo attacking what amounts to *a style*. Having located the possible sociological conditions that form the referent for a cultural form, in its positive and negative dimensions, you must then craft any cultural critique with an eye to transforming those conditions or you fall into a closed circle or feedback loop, an endless debate over the content of signs worthy of the most unfashionable of things, "vulgar Marxism." Since the entire thrust of Greif's critique in *What Was the Hipster?* is that an obsession with signifiers of cultural distinction represents a deflection of real-world social concerns, one might add that the presence of a genuine political program is the only real way to distinguish the critic from his or her object. Without this key ingredient, any critique simply falls into the trap best illustrated by the *Onion* headline: "Two Hipsters Angrily Call Each Hipster."[31]

Art and Theory

Agnes Denes, *The Human Argument*, 1969–70, Ink on graph paper, 22 x 18 inches,
Collection of The Museum of Modern Art, New York, © Agnes Denes, Courtesy of Leslie
Tonkonow Artworks + Projects, New York

Commerce and Consciousness

Perhaps it is no coincidence that 2007—right before the collapse of the US housing bubble touched off the Great Recession—also saw a spectacular peak in terms of a certain kind of contemporary art excess.

That was the year that not-so-young-anymore Young British Artist Damien Hirst introduced the world to his *For the Love of God*, a platinum cast of a human skull encrusted with more than 8,500 diamonds. The asking price for the macabre bauble, broadcast far and wide, was £50 million. It drew lines when it debuted outside his London gallery White Cube, and won a place in pop culture as a symbol of luxury hubris (funnyman Stephen Colbert name-checked it on his "Colbert Platinum" segment satirizing the shopping habits of the superrich). Hirst went on to design a line of skull-studded jeans and jackets for Levi's, which were dutifully given a runway show at his New York gallery, Gagosian.

This was also the year that Takashi Murakami, the "Japanese Warhol" known as much for his collaborations with Kanye West and his adroit re-design of the Louis Vuitton brand (he's the man behind all those multicolored monograms) as for his anime-themed sculptures and paintings, held a career retrospective at the Los Angeles Museum of Contemporary Art. As part of the show, the organizers opened a functioning Louis Vuitton pop-up boutique inside the museum, offering limited-edition Murakami-styled luxury handbags and other memorabilia. The store did blockbuster business.

In New York, for the annual Macy's Thanksgiving Day Parade, the venerable American neo-Pop artist Jeff Koons finally decided that he was a big enough deal to join in the super-sized fun. A giant helium-filled version of his signature giant steel sculpture of an inflatable balloon rabbit floated down Broadway, alongside Shrek and Hello Kitty. Koons has always been insistent on embracing the most immediate sorts of pleasures—his best-known work is *Flower Puppy*, a towering sculpture of a seated pooch made of hundreds of potted flowers. Now his artwork was in effect reconceived as a massive ad for itself.

Many more examples could be mentioned. These three, however, are particularly key in the ways they illustrate how the moment seemed to mark a definite qualitative shift in some of art's core orienting principles. Hirst's *For the Love of God* was infamous in the way that its much-publicized price tag deliberately became a part of the show. Murakami's Louis Vuitton pop-up store was presented not as a commercial side note but as an artistic provocation by curator Paul Schimmel, who wanted to define the artist's open embrace of commercialism as part of what made him avant-garde.[1] As for Koons, he had always traded in a pretty blank irony, but his artworks were once thought to at least be *about* commercialism rather than a crass enactment of it—they were not just kitsch but some kind of rarified translation of kitsch themes into a more cerebral, formal context.[2] Now Pop Art, it seemed, was ready to reenter pop culture on something approaching level footing.

When the bottom dropped out of the world economy in 2008, there was a brief flurry of speculation that art would get back to "content" and "sincerity." This prediction did not, by and large, come true. In fact, at the end of 2009, the Tate Modern even gave the new art-commerce synergy a kind of manifesto in exhibition form with "Pop Life: Art in a Material World," a show specifically designed to celebrate artists "from the 1980s onwards who have embraced commerce and the mass media to build their own 'brands.'" The roster ranged from Warhol and Keith Haring through Hirst and Koons to more recent stars like Piotr Uklański and Maurizio Cattelan. For the occasion, Takashi Murakami produced a music video of the actress Kirsten Dunst in a sexy maid outfit, running around Tokyo and lip-synching to the Vapors' hit *Turning Japanese*. "I believe this is a new style," the artist told the *Wall Street Journal* of the clip's queasy collapse of art and MTV.[3]

What is going on here? Scholar Johanna Drucker has attempted to provide some kind of theory for this "new style" in her book *Sweet Dreams: Contemporary Art and Complicity*, which considers the signature characteristic of recent art to be its embrace of both commerce and the values of the mass media. The notion of "oppositional critique"—the idea that criticism should challenge the reigning values of its time—has in her estimate become largely a relic of academic writing, which has been displaced by the dominance of popular culture and reduced to justifying artwork based on political correctness. Drucker attempted to coin the term "complicit aesthetics" to describe a pervasive sensibility that has jettisoned the need to see visual art as existing in tension with or as an alternative to other forms of media. Instead, the new "complicit" strand of art—which Drucker sees in figures ranging from Elizabeth Peyton, a painter who crafts deliberately naive portraits of celebrities like Kurt Cobain, to Gregory Crewdson, who stages slick photos

that look like scenes from blockbuster movies yet to be made—exists in sated dialogue with corporate media and consumer culture.

Vanessa Beecroft provides Drucker with a test case to show the way art practice has parted ways with the terms of a criticism that is still struggling to catch up. Beecroft is known for staging fetishistic living tableaux of naked models in high heels. Art critics steeped in a tradition of critique or counterculture have sometimes persisted in looking for a political kernel in Beecroft's work as a way of validating it—Drucker scornfully cites one writer who dubs her practice a "post-feminist critique of the catwalk."[4] But quite obviously, Beecroft is not attempting to resist the values of fashion. She is replicating them in the space of art—and sometimes outside of it as well. For the opening of a Louis Vuitton store in Paris in 2005, she staged *VB LV*, a happening for which (in *Artforum*'s words) "30 naked models—black and white—sat silently on shelves alongside classic Louis Vuitton handbags and luggage."[5] Framing Beecroft's art as an act of critique would be like calling ketchup a vegetable.[6]

Drucker's account of the new spirit of libertine "complicity" has a polemical thrust. She argues that, in essence, writers should drop any claims for art's critical potential. The loss of art's distinction as an alternative to media spectacle, she holds, is not just a matter of some artists' choices but is rather an existential condition that all artists simply have to accept and therefore something that should be embraced. Drucker speculates that art developed its myth of purity and critical independence in the first place as a defensive reaction to mass culture, with its higher production values and larger audience. But art today, she vaguely suggests, may finally be ready to give up the ghost and merge with "the greater power of visual culture and its industrial strengths."[7] Visual art's "oppositional" pretensions are, for Drucker, just bad ideas that should be waved away in the face of technological advance.

At this juncture, the art-historically savvy reader might experience a surge of déjà vu. For, in fact, while the phenomena Drucker analyzes may be novel, the thrust of her academic treatise is not. A decade before *Sweet Dreams* hit the college bookstore, rabble-rousing critic Dave Hickey reacted to the high-minded rhetoric of the nineties art world, arguing that art-making should be considered no different than any other form of cultural activity and that it should ditch any pretense to being virtuous or righteous. By Hickey's lights, the attempt to see art-making as anything other than a form of entertainment was bad consciousness: "Music and movie people are not in denial about the frivolity of their endeavor, while the contemporary art world . . . feels called upon to maintain the aura of spectacular unction that signifies public virtue, in hopes of maintaining its public patronage."[8]

Reaching farther back still, the man most associated with the term "Pop Art" itself, Lawrence Alloway, based his entire critical outlook on debunking

the tradition that saw art as standing in opposition to the more degraded pleasures of the common man. He turned an inquisitive and enthusiastic eye to the ways that "junk culture" was setting the pace for creative experience. Way back in 1958, Alloway was arguing that the theories of an older class of tastemakers who believed in the higher status of fine art as something formally exalted or spiritually redeeming no longer fit the realities faced by either artists or the public in an urban and industrial culture. "The elite, accustomed to set aesthetic standards, has found that it no longer possesses the power to dominate all aspects of art," Alloway declared confidently.[9] Much like Drucker, on the basis of this descriptive statement, he advanced a prescription: "What is needed is an approach that does not depend on the exclusion of most of the symbols that people live by."[10]

The exact form by which art's special status has been challenged has varied slightly from Alloway to Hickey, and from Hickey to Drucker—but the basic underlying issue has evidently persisted, despite their insistent claims that the opposition between the values of high and low art has been rendered passé. Only after solving the puzzle of how art's pretensions can simultaneously have been obsolete and have persisted for so long might you accurately assess the recent vogue for what Drucker calls "complicity."

And what it comes down to, I think, is that art's standoffish approach to popular culture is not merely a foolish set of ideas that can be waved aside. There has been, and remains, a quite real *material basis* for these ideas, a material basis that is threatened by mass culture but that also continues to persist despite it, and that explains art's enduringly lofty but also somewhat tortured and contradictory sense of itself. Often, academic art critics (including Drucker) just tag everything that involves commerce as "capitalist" and leave the analysis there. This, however, is an impoverished idea of what it means to be capitalist. There are different ways to relate to commerce, and the production and distribution of what we still insist on according a special status as "visual art"—the kind of creative expression that museums and galleries and other such institutions are designed to house and promote—is defined by *particularly middle-class relations*, not by wage labor at the service of corporations.

Popular culture, which has today become the all-pervasive orienting point for cultural consciousness, has been called the "folklore of industrial society." As Jim Cullen shows in his book *The Art of Democracy*, its preconditions are urbanization, industrial techniques applied to cultural production, and a mass audience ready to absorb the products and make them its own.[11] It is thus the child of capitalism and has grown up as capitalism grew up and pervaded ever deeper into everyday experience. For our purposes, what this means is that the well-known art historical trajectory from the mid-1800s on, whereby fine artists had to seek always-new theories and styles to justify themselves as new

technologies entered their lives, can be rewritten. First, artists ceded the field of depicting reality as photographic entrepreneurs and film moguls outflanked the masters of pigments and modeling clay; eventually, they were trumped in sheer imaginative might as the "culture industries" refined their special effects and absorbed increasingly impressive quantities of creative talent. What this process represents is not the confident advance of front-line cultural innovation but rather the tortured maneuvering of a predominantly middle-class tradition in a largely defensive struggle as capitalism progressively undercuts its status.[12]

The Museum of Modern Art, back in 2005, hosted a show of concept art by Pixar animators relating to their work on blockbuster films like *Finding Nemo* and *The Incredibles*. But it does nothing to denigrate the very real gifts of these digital wizards to note that the corporate environment that produced this work fosters a very different set of creative values than those we encounter in the fine-art sphere. Anyone walking into those galleries would have seen a quote concerning the creative process by Tia Kratter, one of the Pixar artists, posted on the wall and presiding over the work as a motto: "It is total teamwork. There is no individual in this thing." As salaried technicians toiling according to specifications that they don't determine, Pixar's army of artists function as skilled laborers with little personal—let alone economic—stake in the resulting images.[13]

Fine artists generally work outside of such clearly defined corporate structures. If there is "no individual" in the kind of work done at Pixar then, on the contrary, the uniquely middle-class nature of creative labor in the visual arts would seem to explain its alternative emphasis on the individual, that is, on the virtues of personality and small production, as well as a whole host of other stylistic tics and affectations—the recent vogue for low-fi, childlike creativity; visual art's characteristic questioning or ironic attitude; the value of the artist's signature and the "artist's statement"—that are associated with it.

But why would such aesthetic strategies be *necessary* rather than just personal decisions? Take an appealing contemporary artist like Michael Bell-Smith, one of the more compelling figures working with digital material. He is known for video projections, depicting landscapes or scenes from space, constructed using appropriated computer and video game imagery. His *Up and Away* (2006), for instance, is a hypnotic video consisting of a continuous scrolling loop of stolen video-game backgrounds, one unraveling from behind the next as we climb forever upward. Pyramids, skyscrapers, forests, magical cities, deserts, oceans, highways, and more all flow smoothly by, triggering flashbacks to eight- or sixteen-bit adventures past, but vanishing almost as fast as you can recognize them.[14] It's a very cool work.

In one of its aspects, Bell-Smith's videos are a form of digital Pop Art, "complicit" with digital culture in the way that it piggybacks on the pleasure

one gets from re-encountering snippets of graphics embedded in one's memories from old Nintendo and Atari games (though he himself downplays this aspect). However, his digital collages have an inscrutable, decidedly low-fi energy all their own and at any rate are very far from competing with the absorbing interactive extravaganzas of the contemporary videogame industry—nor could they be, given that cutting-edge video games are the product of large corporations, employing vast amounts of sophisticated labor from teams of computer engineers. Perhaps unsurprisingly then, as an artist, Bell-Smith's practice bears less of a resemblance to commercial digital culture and more of a relationship with the sprawling subculture of sampling and remixing on the Internet, made possible by the massive proliferation of digital tools—a subculture of technologically empowered amateurs whose existence Bell-Smith acknowledges creates "an interesting and tricky space for artists working with similar approaches."[15]

It is at this juncture, reflecting on how his work distinguishes itself from the various strains of mass entertainment and vernacular culture with which it is in dialogue, that the whole apparatus of the art world, with its particular battery of critical tropes, enters the picture for Bell-Smith:

> A lot of my work is inspired by "non-artist" projects. That's not to say, however, that I'm not interested in fine art and the discourse around it, or that I don't believe in the structures of the art world. You can think of it in terms of forms of distribution and the audience that comes with them. YouTube is great, but if you want something to be discussed critically, or read in relationship to movements in art, then you might be better off trying to work within the art world.[16]

In *Sweet Dreams*, Drucker lays into academic writers who champion esoteric artistic strategies, insider references, and "oppositional" posturing. Like Alloway before her, she views these strategies as making art seem out of touch with the realities of contemporary life. The sociologist Pierre Bourdieu, for his part, famously emphasized that the difficult values associated with "high art" reflect the outlook of a particular social group, expressing an elite or upwardly mobile audience's need to distinguish itself from the "common" sorts of pleasures associated with the less educated.[17] If we even partially accept this analysis, then art's need to justify itself as intellectually superior to mass culture via various "oppositional" strategies would clearly be as much about raw commercial interest as it is about contingent intellectual posturing. It is (in one of its aspects) a way of justifying its superior cachet to a class of potential consumers.

There is, however, a twist. In his study *Photography: A Middle-Brow Art*, Bourdieu could still assume that when it came to the popularly accessible art of his day—photography—aspirations to distinction would be expressed through

virtuosity, that is, by a mode of practice that was more technically refined than that consumed by the average consumer, who enjoyed photography mainly in its most basic form, the snapshot.[18] In the contemporary media universe, however, popular culture is often more technically sophisticated than fine art. Consequently, an intellectual *distance* and not an intellectual *mastery* of popular forms is what tends to be championed as an aesthetic virtue. To return to our example, the very qualities that might limit the mass appeal of Bell-Smith's art when considered in relationship to a more pervasive digital culture—its cerebral approach, its cryptic art-historical references—are emphasized as its virtues. Refusing full "complicity," in other words, is not a choice. It is constitutive of Bell-Smith's ability to create an object of value, period.

Art's position relative to the broader economy has changed in the past and is sure to continue to evolve.[19] In recent years, unprecedented amounts of money and media attention have been aimed at contemporary art, creating a definite pressure to redefine its values in various ways that are synergistic with corporate media and advertising. Taken together, such developments might suggest that visual art's mode of existence is changing to be something more akin to contemporary fashion, where designers make unwearable, esoteric prototypes that are then reprocessed for mass consumption, where they find their true home (and where almost all of the actual business is).

What would such a shift toward full-on "complicity" entail? Dana Thomas has given an account of the mutations in the fashion industry that might provide some guide. In the last few decades, as couture has become more dominated by corporate combines, the production of luxury goods has moved decisively from boutique production toward fully capitalist industry focused around maximizing markets: "In the old days, when luxury brands were privately held companies, owners cared about making a profit but the primary objective in-house was to produce the finest products possible. Since the tycoons have taken over, however, that objective has been replaced with a phenomenon I call the cult of luxury. . . . [LVMH boss Bernard] Arnault and his fellow luxury tycoons have shifted the focus from what the product *is* to what it *represents*."[20]

In short, in the name of expanding the amount of merchandise that can be sold to consumers, the luxury goods trade has been detached from the hand of the unique master craftsman. It has become less about an object's uniqueness and enduring quality and more about branding and conspicuous trendiness.[21] This is the pivot that has allowed the industry to turn from its focus on a small group of elite consumers to a mass audience.

Has there been any similar change of focus in the visual arts, away from the cult of the unique object? In the 2011 book *The Art of Not Making: The New Artist/Artisan Relationship*, Michael Petry assembles a large assortment of

examples of contemporary art-making to show how the traditional identification of artistry with craft labor has been displaced by a new type of creative production more akin to that found in architecture or film, where the artist acts as a director, marshaling a large number of other laborers to realize her creative vision.[22] Examples range from Mona Hatoum, who tapped Tuscan artisans to create the unique and ethereal glass globes strung together for her installation *Web* (2006), to Fiona Banner, who has her bronze public sculptures made to look like immense exclamation points, commas, and periods manufactured at a "fine art foundry," to the extreme example of Do-Ho Suh, whose full-scale fabric re-creations of buildings have him working with a studio of some forty people, including architects, sculptors, and product designers.[23] In effect, while practices like painting and traditional sculpture still have a place at the contemporary art table, a certain broad class of artists now works more as a kind of engineer of experience, overseeing the production of highbrow spectacles and environments.

This loss of a direct, necessary connection with the hand of the artist needn't completely overturn the values we associate with visual art, however—a lawyer is still a lawyer, after all, whether or not she has paralegals to help with research and the like. Artists have *always* worked with assistants who prepared their pigments or even painted large parts of their canvasses. Industrial fabrication has been a fascination of visual art, from the Bauhaus in the 1920s to the Minimalism of the 1960s.

That's not to say that pervasive changes in the expectations about an artist's relationship to his or her work can simply be dismissed, or that these changes don't have their dubious side. A mega-successful contemporary painter like Kehinde Wiley, who made his career with the clever trick of painting anonymous African American men cast from the streets of Harlem in the overblown style of baroque court portraiture, now has his canvasses done by workers at a studio in China.[24] His fans don't seem to mind—but it is hard not to feel that this assembly-line style of production has turned his recent paintings into rather formulaic exercises. For artists whose works express deep personal emotion, the sheer administrative burden of maintaining the apparatus necessary to play the game of contemporary art may inspire some angst. "I started out as an anarchist and a hippy," the late Mike Kelley once remarked, with overtones of wry self-loathing, "and now I'm an entrepreneur with 15 employees."[25]

For all that, the contemporary vogue for "not-making" definitely does not preclude deeply felt and challenging work. British artist Mark Wallinger created *State Britain* for the Tate Britain's Turbine Hall in 2007, presenting a complete one-to-one replica of a sprawling antiwar encampment that had been dispersed by the Serious Organized Crime and Police Act of 2005 from

in front of the Houses of Parliament, based on hundreds of photos he had taken of the protest. In effect, *State Britain* offered a lucid political spin on the tradition of appropriation art, using the elevated space of aesthetic display as a tool to return repressed dissent to the center of public discussion. As a simulation, it both forced people to look again and seemed to ask the question: What does it mean that something like this is now OK to show as art but not as an actual protest? It remains one of the more thoughtful works to take on the erosion of civil liberties that has accompanied the war on terror. The fact that the actual production of the replicas was contracted out to a boutique design facility, Mike Smith Studio, does not deplete its charge, at least not for me.

Similarly, the Chinese artist Ai Weiwei has used the spectacular language of contemporary art to good effect—and paid a high personal price, having been beaten, detained, and generally harassed by authorities—venting his volcanic anger at official corruption in the People's Republic. Despite Ai's role as overseer rather than personal maker, who could fail to be moved by his installation *Remembering* for the Haus der Kunst in Munich in 2009? Covering the façade of the building with thousands of children's backpacks, the work spelled out the words, in Chinese characters, "She Lived Happily on This Earth for Seven Years." The phrase came from a mother who lost her young daughter in the devastating Sichuan earthquake of 2008, when thousands of students perished in shoddy government-constructed buildings—malfeasance that Ai has made it his crusade to investigate and memorialize.

And yet, for a small subset of superstar artists, the new realities of art production have made it possible to transform themselves into boutique industrialists, licensing out their cachet to help brand a wide variety of products and events. In effect, they function as the heads of design firms, with art objects being just one of the various product lines they are engaged with turning out (if still the most central). In the past, I have attempted to call such figures "superartists": "From figures of narrow significance within a certain tradition they have evolved into cultural impresarios, bringing their trademark art sensibility to cartoons, clothing lines and commissions for tourism boards."[26]

The Danish-Icelandic artist Ólafur Elíasson, for instance, specializes in installation works that play with one's sense of light and space, but has also turned his environmental sensibility to making bespoke installations for Louis Vuitton stores around the world, an ice-coated concept car for BMW, giant fake waterfalls as a lure for tourists in the East River in New York, and a line of commercially available solar-powered lamps. In addition to his own work with Louis Vuitton, Takashi Murakami has done all sorts of branding, including wallpaper and cushions with his signature flowers on them, as well as an electric

concept car for Nissan. Hirst, of course, has put his signature spots, splashes, butterflies, and skulls on everything from hubcaps to refrigerator magnets.

It goes without saying that not just any artist's work is susceptible to this kind of treatment—it has to be at once suitably iconic and suitably abstract to make the jump. So even when they are working in the conventional art sphere, the works produced by "superartists" tend to deemphasize personal vision and nuance and center more around the familiar values of mass entertainment and consumption. And so you get the Ripley's Believe It or Not spectacle of Hirst's diamond-clad skull and the long lines awaiting it; the crossover appeal of Murakami's sculptures and paintings, with the way they catalyze manga-mania; or the amusement-park enthusiasm of crowds observing each other within the haze of Elíasson's most famous work, an enormous artificial sun installed at the Tate Modern in 2003.

Here, in this hybrid form that merges high art and design, you may have the beginnings of a transition akin to the corporate wave that overtook the luxury goods industry, taking it from an artisanal tradition to a mode more associated with mass consumption. But this sort of art is still, I think, an awkward hybrid. At the end of the day, the production of visual art is unlikely to be transformed in quite the same way as the market for handbags or fancy dresses. The latter are functional items. Thus, it is comparatively easy to redefine what counts as desirable, as long as they maintain their core utility. In contrast to this, the *main function* of contemporary visual art is that it serves as a mythologized representation of something more meaningful than objects of ordinary consumption. That aura is what justifies the obscene sums of money paid for its products, on the one hand, and the sacrifices that people make in order to be artists in the first place, on the other.

For all its self-importance, the kind of art that is distributed through art galleries and museums remains a boutique affair and generally participates as a junior partner when it enters mass culture, which plays on a much bigger field. The "superartists" remain an aristocracy of superstars, performing a (not-always-successful) balancing act between maintaining the uniqueness of their own creative enterprises and meeting the demands of a hyperactive corporate hunger for media-friendly events. Damien Hirst's *For the Love of God* cost an estimated £14 million to fabricate (about $28 million at the 2007 exchange rate), making it an all-time symbol of artistic excess.[27] This is not even equivalent to the marketing budget for a single mass-market film.[28] That Hirst himself had to form a consortium to purchase back *For the Love of God* is testament to how the logic of "complicit aesthetics" has a real internal limit, tending to push visual art beyond its means.[29] At the same time, recent work by Hirst has lost an estimated 30 percent of its value when resold—a fact directly attributed to his dubious flirtation with mass art. "I think Hirst was a

very good artist at the beginning," said Georgina Adam, "but he has been a fabricator of luxury goods for a long time now."[30]

Playing directly on pop culture's field, the pressure is on for artists to do it again, only bigger, while at the same time they sacrifice qualities that art is probably in a better position to express, like personal investment—the kinds of things that lead hopeful young people to sacrifice higher-paying careers to become artists in the first place. While the success and relative visibility of "superartists" affects the tone of the entire field, the resources required here are open to only a handful of artist-entrepreneurs and can't truly justify the practice of the average art-school grad. Some kind of critical or autonomous stance remains required by the vast majority of artists to justify the importance of the relatively small world that they inhabit.

The rise of the values of aesthetic "complicity," then, represents a kind of simmering identity crisis, not some happy new equilibrium with popular culture. It opens up a potential rift within the identity of art, between those who aspire to be mini-corporations and those who still identify as artisans and intellectuals. It heralds, finally, the sharpening of a dilemma for contemporary art—and is likely to promote angst, not to put an end to it.

Crisis and Criticism

Long before the financial crisis became a terrifying global economic disaster in 2008, long before the euro crisis provoked sleepless nights for the world's policymakers, art criticism was feeling its own simmering "crisis." One great buzz term of the aughts was the "post-critical condition." The increasingly insistent sense was that contemporary criticism lacked purpose and that it was losing influence over the art that was being produced. The idea of a "crisis in criticism" was everywhere: in books, in popular art writing, in academic journals, in the art magazines, even at the art fairs—even though a good many observers felt that the overheated art market itself was part of the problem. The name of a panel at the Miami Beach fairs from the height of the 2007 art boom was "Is Money the New Art Criticism?"[1]

The Great Recession interrupted some of this hand-wringing, though it also accelerated a different but not wholly unconnected crisis for art critics, as struggling print outlets cut staff and liberal arts departments felt the squeeze of budget cuts. Ruminating on the "post-critical condition" while art critics were being unceremoniously kicked aside left and right would seem to be a bit of an aside. Yet, beneath it all, the new and dire situation also gave real urgency to the question of just how relevant art criticism is, or was, or could be. Did it have the sense of purpose left to make it through hard times?

Certainly, criticism faces daunting challenges. A capitalist society is not going to make life easy for "critical" thought—all the profit lies in going with the flow. And yet my feeling is that the sense of a "crisis"—which, after all, is one of the most venerable themes of art criticism itself—is mainly subjective. It stems from how more vital strands of critical thought have been eliminated from discussion, leaving only half-theories and false debates in their stead. Before leaping ahead to consider what tools we might need to cut through the malaise, however, perhaps it is worth seeing if we can figure out where it is really coming from in the first place.

1.

An excellent starting point to understand the "crisis of criticism" debate was the Raphael Rubinstein–edited *Critical Mess: Art Critics and the State of Their Practice*. As the title indicates, the slim volume rounded up the most distinguished voices to respond to the question of what, if anything, might explain the problems thought to be facing the field. This exercise, in fact, proved amazingly telling, because it turned out that, while all the key players seemed to agree that there was a "crisis in criticism," no one could quite agree what that crisis was.

Take the essay by Thomas McEvilley in *Critical Mess*. McEvilley declared that the problem for art criticism was that "the lingering dominance of the issue of quality and of the value judgment seems to outsiders to render our discourse elitist and irrelevant." His advice for critics was "stress analysis, not appreciation."[2] But if you turned the page to Michael Duncan's essay, you found quite a different diagnosis. "Academic theory can be held largely responsible for the impotency of contemporary criticism," he stated. "Personal commitment to tastes and values seems largely missing in critical writing today."[3] In other words, Duncan's problem was McEvilley's solution, and vice versa.

Elsewhere, James Elkins suggested that the "crisis" stemmed in part from "the lack of restraint that is granted to art critics by the absence of an academic home."[4] Carter Ratcliff, on the contrary, argued that the problem is "critic-theorists" who have found "niches in the academic establishment" and who "address those who want to be told what to think."[5] Apparently, in the same way that light can be both particle and wave at once, art criticism could be at once too scholastic and not scholastic enough. You get the point.

Moving past this unpromising circular-firing-squad routine, what seemed most striking was the lack of any kind of well-developed explanation on all sides for what, if anything, the cause of the "crisis" was, aside from the general lousiness of whichever camp of people was perceived to dominate the "establishment." Was the "crisis of criticism" simply the result of bad decisions? What were the prospects for reorienting things? At times, the "crisis" was explained by vague references to the increased power of the market, with Benjamin Buchloh's oft-repeated declaration that "you don't need criticism for an investment structure, you need experts" standing as the deepest point of the analysis.[6] At their most systematic, the attempts to explain the "crisis of criticism" reflected an inkling that discourse might in fact float atop something material and historical—but this notion remained fairly impressionistic, and nobody seemed to have much interest in delving too deeply into such connections.

2.

To begin to suggest my own answer, it seemed best to home in on a specific symptom, "the loss of the old, exciting *Artforum*" (as Katy Siegel summed up the meme in her contribution to *Critical Mess*).[7] Speaking personally, it was discovering *Artforum*—for many years indisputably the most important art magazine in the world—that drew me toward writing about art. The kind of theoretically informed, academically oriented art criticism associated with *Artforum* may have been the source of the popular stereotype that art critics write in unintelligible jargon, but to a young writer just out of college, the magazine's stew of references to Freud, Adorno, and Deleuze and its self-consciously serious treatment of visual art seemed to indicate that art was a place where ideas truly made a difference to people and where intellectuals had some influence on practice.

So what can we say about the historical circumstances that gave birth to the "*Artforum* mode" of theory-driven criticism? Here are some facts about the magazine:

1) *The Market*: As laid out in *Challenging Art: Artforum 1962–1974*, Amy Newman's interesting history of the magazine's early days, *Artforum* became the leading art magazine sometime after it moved to New York from Los Angeles in 1964.[8] It pioneered a then-novel approach to covering the art scene, concentrating on the newest, most up-to-date work rather than covering everything from Old Masters to Abstract Expressionism, as its rival *Art News* did. Its context was the later part of the "Great Boom" of the postwar period in the United States, a time of historically unprecedented economic expansion, which in turn led to an "art boom" by the 1960s—symbolized by the white-hot Pop Art scene—which gave a new importance to focusing on contemporary work. This was the first period when relatively young American artists could hope to achieve star status and make money from what they did. Jasper Johns set the stage when he sold out his debut show in 1958 at Castelli Gallery, an achievement unprecedented at that time.

2) *The University*: The other distinctive contribution of *Artforum* was its heady theoretical language. This served the purpose of amping up art criticism's importance by giving it a more intellectual ring—its explicit antagonist was what Barbara Rose termed the "mental doodling" of poet-critics (whose redoubt was, once again, *Art News*).[9] If, however, the success of *Artforum* was to create "a kind of art magazine that seemed to be sustained, respectable, serious enough to gain admission to academic territory" (Robert Rosenblum's words), such a feat was only possible because the "Great Boom" also entailed a rapid and truly dramatic expansion of the

educational system itself.[10] The new postwar phenomenon of mass uni-
versity enrollment created the base for the shift to the new criticism, as
well as the climate for an expanded discourse about art in general. Pretty
much all of *Artforum's* early star writers were creative types who went
into academia and found a calling there.

3) *The Government*: Lastly, if the "*Artforum* mode" of criticism—first strident
formalism and later the muesli of psychoanalysis, deconstruction, and crit-
ical theory we know today—served the purpose of establishing some
seemingly objective criteria to examine brand-new work that had no es-
tablished historical worth, it is also the case that there was every reason
to feel that art had a new, more "objective" importance for US society in
this period. In 1965, the National Endowment for the Arts (NEA) was
founded, putting the stamp of official recognition on a field formerly per-
ceived to be pretty "out there." The motives behind the move were po-
litical, both in terms of domestic consensus-building by the Democrats
and the international calculus of Cold War; in the words of Arthur
Schlesinger Jr. to John F. Kennedy, the goal of public art support was "at-
taching a potent opinion-making group to the administration" and "trans-
forming the world's impression of the United States as a nation of
money-grubbing materialists."[11] However, any artist who labored in the
beatnik days of the pre-NEA period can describe the shot of self-esteem
that this gave the visual arts, making art seem to be a legitimate career.

3.

Having set this background, we can then ask ourselves, forty years on: what
has changed?

Well, for one thing, the economic background is massively transformed. By
the mid-seventies, the triumph of art theory was complete; as Hal Foster writes,
at this moment "theoretical production became as important as artistic pro-
duction."[12] At the same time, however, the pseudo-Keynesian, big-government
model of economy that had reigned during the Great Boom, with its mantra
of "labor-management partnership," entered into crisis on the teeth of its own
internal contradictions, ushering in the transformations of the 1980s.

The anti-government orthodoxy that is today recognized by the jargony
name "neoliberalism" presented itself as a solution to seventies-style stagnation.
Its doctrines were: cut taxes for the rich; attack labor; cut or privatize govern-
ment programs and services; deregulate economies to let capital move freely.
These policies were a stable feature of the establishment for this entire period,
for Republican Ronald Reagan ("government is not the answer, it is the prob-
lem") as much as for Democrat Bill Clinton ("the era of big government is

over"). At the end of thirty years of such developments, here is where art criticism found itself by the aughts:

1) *The Market*: The neoliberal boom did create a tidal wave of new wealth, some of which flowed into conspicuous consumption. This had a dramatic effect on the art market, creating an unprecedented expansion in the number of art buyers. An art boom in the 1980s ended with an art crash after the savings-and-loan crisis, before the market built up again at the end of the nineties to previously unprecedented heights. Powered by the new art boom, the aughts saw a number of new factors coming decisively on the scene. Art fairs emerged as the new center of discussion (Art Basel Miami Beach debuted in 2002, Frieze in 2003); the tycoons of the New Gilded Age broke free of the established institutional culture, looking to found their own new "ego-seums"; and the "emerging artist" wave saw galleries harvest kids fresh out of school (Alex McQuilkin's *Fucked*, a limited-edition video of the nineteen-year-old artist having sex while putting on makeup, made while she was at NYU, infamously sold out on opening night of the 2002 Armory Show).[13]

2) *The University*: If the earlier rise of theory-crit coincided with a postwar boom in education, the neoliberal expansion of the period from the eighties to the aughts coincided with a gradual assault on the idea of education as a right. To take only one germane example, the sixties saw New York's network of universities (CUNY) open in the name of racial equality, under public pressure. In 1975, however, tuition fees were imposed for the first time as a result of the city's fiscal crisis.[14] "Since 1990, privatization has been the dominant trend in American higher education," one study of US educational trends reports.[15] The results have been both the dramatically expanded expense of going to college and the marked increase of the debt burden for students and their families. Education is more stratified than it was when *Artforum* first hit the scene, a fact that might be expected to change any fleeting claims academic-oriented criticism had on universality.

3) *The Government*: Finally, to sell a pro-corporate agenda, Reagan detonated the "culture wars," appealing to the wingnut right as his claim on mass appeal. The NEA's modest artist grants program was finally defunded in 1995, after a series of scandals. The affair was political Kabuki: The artists who got the program in trouble, Robert Mapplethorpe and Andres Serrano, had benefited from the NEA's grants for institutions (which were kept), not individual grants (which were gutted). As Michael Brenson points out in his history of the NEA, *Visionaries and Outcasts*, the very feature that was once cited as justification for launching the program—that it symbolized the American public sphere's capacity to tolerate diversity and individualism—

was what was now under assault.[16] Such political rhetoric creates a quite different backdrop for art criticism than that of the earlier era. It is designed to create—and succeeds in creating—a sense for visual art and its supporters that art is on its own, confining it to a gilded ghetto.

What does this add up to? Well, everything about *Artforum*-style "theory-crit" requires the reader to buy the idea that the academy is the most important tastemaking center. By the 2000s, the commercial explosion had created a space where all the coverage of the market and the social scene, institutional moves and their political ramifications, felt more relevant to what was really going on than the most high-minded criticism. Meanwhile, the topical, factual, breezy, business-oriented writing favored by the mainstream news outlets (which you might call the "*Art Newspaper* mode," after the trade publication of the same name), focusing on art as a business and the personalities that drive the market, gained strength against the background of the insular "*Artforum* mode," in very much the same way that the latter developed against the mushy "*Art News* mode" in the sixties, to fit the realities of a different period.

In 2004, *Artforum* itself launched its online "Scene & Herd" column, focusing on reports from parties and gallery openings. "Scene & Herd" represents something like the return of the repressed in relation to the paper magazine, when you consider that often you could read the latter's theory-driven criticism of art and not know that the art existed in a real physical space at all, let alone one that was highly commercialized and part of a "scene." "What would it be like," editor Jack Bankowsky wrote later, reflecting on the thought process that led him to champion the idea, "to run a magazine within a magazine, a forum inside *Artforum*, and one whose purview, rather than art itself, would be 'the art world,' the 24–7 social whirl the parent publication's very identity depends on holding at arm's length?"[17] In a kind of dialectical response to theories of aesthetics that don't have that much to say about art's context, you get reporting on art's context that doesn't have that much to say about aesthetics. And there can be no "crisis of criticism," because the art object that was to be criticized seems to have vanished altogether, becoming merely the pretext for some very interesting parties.

4.

Such reflections make me think that the loss of luster for "serious" criticism—whether of the "*Artforum* mode" or its sturdy antagonist, what Ratcliff calls the "poet-critic"—has less to do with some terminal death spiral than it does with some weaknesses internal to old and cherished theories writers used to employ to make what they did seem important to themselves. The diverse

"crises" perceived by assorted and apparently contradictory viewpoints coalesce out of a common background noise.

The idea that the dominant form of writing about art has become less rigorous—more cheerleader-ish, more focused on business and entertainment, less on questions of taste and history—hits home for the same reason that the charges that theory-crit is out of touch are also more likely to stick: *both are true*. Both have a common root in the changes in the economy over the last decades. These changes have taken the form of an erosion, an incremental but relentless shifting of the balance of forces, which is why the "crisis of criticism" manifests itself as a nagging, recurring, but ever-more-insistent theme rather than a sudden revelation.

If the two sides have a common underlying cause, it should also be possible to synthesize them in some way. For me, this involves addressing the question of how to coordinate the sense of purpose theory-crit gives to writing with sensitivity to art's diverse, subjectively complex reality. How to avoid the choice between criticism based on random personal preference and criticism based on toeing a theoretical line? On the one hand, I have to believe that some theory about art's purpose is important—without a seriously argued perspective on what makes visual art distinctive, all you have left is the art world as a crappy arm of pop culture or a place for high-end gambling. On the other, what passes for art theory has become startlingly out of touch, invested in problems that have very little to do with the particulars of aesthetic experience.[18]

Returning for a moment to *Critical Mess*, what interests me is that the key debates about "crisis in criticism"—the "thinkers" like McEvilley and Elkins versus the "feelers" like Duncan and Ratcliff—appear to be a proxy for a political debate, with both sides claiming the progressive mantle in some form. Popular types defend some kind of humanist vision of the individual imagination against the art-theory bureaucrats; theory-heads clamor for art that has a didactic value, that doesn't capitulate to popular wisdom, that takes a stand.

And this, it should be noted, is one of the all-time classic false oppositions.

5.

In 1938, deep into the wreckage of the Great Depression, Leon Trotsky helped pen the manifesto "Towards a Free Revolutionary Art" with Surrealist don Andre Breton and Mexican muralist Diego Rivera (it was published in the *Partisan Review* and was signed by the two artists, but was written mainly by the exiled Russian). It is, true to form, a polemic, informed by an analysis of the crisis facing art in that particular historical moment, within the context of ascendant fascism in Europe and a consolidated Stalinism in the Soviet Union. Yet the manifesto also echoes the larger framework for ap-

proaching aesthetic matters laid out in Trotsky's earlier *Literature and Revolution*. Underneath the topical analysis in "Towards a Free Revolutionary Art" lurks a more general idea about the relation of art and politics, and artists and society, which implies its own critical framework.

"To those who urge us, whether for today or for tomorrow, to consent that art should submit to a discipline which we hold to be radically incompatible with its nature, we give a flat refusal and we repeat our deliberate intention of standing by the formula *complete freedom for art*," the manifesto declared.[19] The theory of "revolutionary art" it offered, then, was emphatically not about advocating a particular mode of engaged art-making (a fact made clear by the very figures who signed onto it, Breton and Rivera, who represented two very different aesthetic ideals indeed).

Since today's political-minded "theory-crit" often implicitly speaks in the name of one radical political position or another, it is worth noting that this most radical of art texts repudiates such an operation—and in the very urgent context of revolutionary political struggle at that. Instead of demanding that art serve politics, "Towards a Free Revolutionary Art" begins the other way around, by proposing what politics might promise art. To this end, it begins by attacking the idea that art should be outwardly subordinated to any political agenda at all.[20] The manifesto's operation is to outline the way that both capitalism and Communism (in the form it had taken under Stalin) deform the artistic impulse by submitting it to various ideological pressures, concluding that an authentically radical program for art will distinguish itself by standing against all impositions and for freedom of intellectual and creative exploration.

Trotsky is well aware, of course, that an attack on politicized aesthetics runs the risk of being taken as a justification for political disengagement, under the cloak of "art for art's sake." Thus, the manifesto continues, "It should be clear by now that in defending freedom of thought we have no intention of justifying political indifference, and that it is far from our wish to revive a so-called pure art which generally serves the extremely impure ends of reaction."[21] Essentially, the manifesto proposes that both art and politics benefit from an alliance, not a merger. The political struggle doesn't dictate the form or even really the content of art; however, artists have an interest in being politically engaged inasmuch as they are interested in laying the basis for art to flourish free from constraints.

To realize oneself as a creative being is one of the most cherished dreams that society holds out, and contemporary art, based in what I have described as the middle-class form of creative labor, is a major conduit for this desire. This can be a barrier to serious political engagement, when artists find in the imaginary freedom of the "art world" a way to ignore the realities of a civilization that is brutally alienating for the majority of humankind. Yet it

can equally be a politicizing factor, if an awareness of the roadblocks to re-alizing oneself as a creative individual is linked to a political analysis of these same realities—which is what Trotsky's manifesto tries to do. Our capitalist world makes life difficult for people who want to go their own way; it de-grades the imagination. Art, viewed in this context, would therefore not be political because it adheres to some particular "critical" program. It becomes political in how its individualistic DNA is transformed by political analysis into the living tissue of social engagement. An art critic's primary job in re-lating to the art object cannot be to stump for any particular "aesthetic or political school," as Trotsky put it to Breton elsewhere.[22] The aesthetic flows into the political without the one being the other.

The social and economic context that gives rise to different kinds of art objects and different types of art gestures is subject to systematic analysis and investigation. It is even vital for a critic to have a theoretical analysis of the world—otherwise you end up with criticism that is eloquent when parsing aesthetic influences but falls back on the dopiest conventional wisdom when politics or economics come up, as they tend to do. Arguing that art criticism benefits from knowledge of the world beyond the temperature-controlled confines of the gallery, however, is very different than saying that critics must be perpetual downers demanding that art always be about death and dis-cord—the position that most people associate with a "political" art criticism.

Criticism's goal should be, rather, to "oxidize the atmosphere in which artists breathe and create" (Trotsky again), to open the circuits between pol-itics and art and let them share their passions.[23] Politically engaged but de-fiantly in love with art for what it is—that is what criticism has to be if its own nagging "crisis" is not to turn into a crash.

In Defense of Concepts

If you read Lucy Lippard's great history of conceptual art and its allied currents, *Six Years: The Dematerialization of the Art Object*, what you take away, above all, is an appreciation of the authentic *pleasure* of this kind of work—its spirit of adventure and purpose. Lippard's emphasis is on the countercultural germs that the movement contained: the catholic nihilism that animated it, the can-she-top-that quality of its proposals, the puckish way that the various figures in its loose international association took pleasure in outraging the dominant sensibility—all these things were interwoven with a whole set of experimental communities and alternative spaces, notions of wanting to live differently, and an overall drive to make an art that was limber and contemporary, that could be shared in a different, less restricted way than more traditional forms of art. The idea of making art out of concepts was *by design* outside of the conventions of art as business.

Yet already in 1973, the era when Conceptualism could maintain this sense of itself had passed. In that year, after the first publication of *Six Years*, Lippard could look back ruefully:

> Hopes that "conceptual art" would be able to avoid the general commercialization, the destructively "progressive" approach of modernism, were for the most part unfounded. It seemed in 1969 ... that no one, not even a public greedy for novelty, would actually pay money, or much of it, for a Xerox sheet referring to an event past or never directly perceived, a group of photographs documenting an ephemeral situation or condition, a project for work never to be completed, words spoken but not recorded; it seemed that these artists would therefore be forcibly freed from the tyranny of a commodity status and market-orientation. Three years later, the major conceptualists are selling work for substantial sums here and in Europe; they are represented by (and still more unexpected—showing in) the world's most prestigious galleries. Clearly, whatever minor revolutions in communication have been achieved by the process of dematerializing the object ... art and artists in a capitalist society remain luxuries.[1]

Conceptualism, of course, didn't fade away as it joined the mainstream, even as it became distanced from some of its aspirations. Instead, it became conceptualism with a small *c*. It expanded outwards, sank into the tissue of how art worked, and in one form or another, became an accepted part of the aesthetic vocabulary, manifested in a diffuse sense of expanded possibility that settled around the art object as it continued to exist. In that form, conceptual art is these days less and less spoken about as a historical movement, with certain meanings and capacities; it has instead become a kind of neutral descriptor, or, more often, an epithet.

Thus, writing about contemporary art's relationship to the public, British critic Adrian Searle described a debate he took part in at Oxford University in 2009. Here is his description of the event:

> The proposal was "This House believes that conceptual art is no art at all." Interesting or ludicrous, I thought, till ludicrous it proved. Rather than a radical re-reading of an avant-garde movement, the proposal amounted to thin stuff, and one that confused conceptualism with all sorts of other things: the YBAs [Young British Artists], Fluxus, the opacity of contemporary art and art writing in general. It was in many ways a preposterous event. . . . What shocked me was not just the paucity of argument in the proposal, but the general cultural ignorance behind it, the unexamined prejudices, the knee-jerk anti-intellectualism and cultural suspicion of contemporary art.[2]

For a sizable—and educated—audience, it seems that the term "conceptual" has come to be more or less a synonym for decadence. It is as if what its foes really want to say is "trick art."

In the United States, this mindset—cultural ignorance, unexamined prejudice, knee-jerk anti-intellectualism, and all—was given gem-perfect form in an October 2009 *New York Times* op-ed by the late Denis Dutton, appearing under the title "Has Contemporary Art Jumped the Shark Tank?"[3] His argument here was that a love of "traditional art" could be justified on the basis of evolutionary biology, whereas "conceptual" art—a term he deployed in the same meaningless, vituperative way as Searle's Oxfordian anti-conceptualists—was some kind of perversion of a natural "art instinct" and therefore illegitimate.[4]

Though it would be wrong to say that Dutton was a particularly important figure among artists, he was an influential figure in shaping the public's impression of art, appearing in outlets as diverse as NPR and *The Colbert Report* to make his case. So it's worth noting that an implicit politics lurks behind his remarks that make them well worth challenging. Cultural conservatism has long served as a proxy, in art, for a kind of political conservatism. Back in the nineties, Dutton achieved some notoriety for his "Bad Writing Contest," for which he would hold up writing by jargon-heavy—and generally left-

leaning—cultural theorists like Judith Butler and Fredric Jameson to scorn. Yet the sheer number of intellectual errors that he managed to cram into his *New York Times* essay was truly amazing. In effect, what Dutton unintentionally provided was a demonstration piece about how disastrously wrong the conservative case against "conceptualism" is. It is worth, then, dissecting his argument point by point.

1) Dutton's archetypal examples of the ills of contemporary art were Damien Hirst and Jeff Koons. He used these two convenient villains to illustrate his core thesis: that "appreciation of contemporary conceptual art . . . depends not on immediately recognizable skill, but on how the work is situated in today's intellectual zeitgeist." Consequently, Dutton insinuated, art today has become a game for insiders with no connection to wholesome popular values of art.

What is comic about this assertion is that Damien Hirst and Jeff Koons are probably the two most *popularly* identifiable contemporary artists. Neither can be summed up as opaquely "conceptual" in the way that Dutton wants to argue, not if the term has any real meaning. You may or may not like Hirst's *The Physical Impossibility of Death in the Mind of Someone Living* (the shark in the tank) or Koons's towering *Flower Puppy*, but these are both artworks that have an in-built "wow" factor. Arguably, a more informed criticism of these two artists would be that they pander to a need for flashy, immediately legible spectacle derived from the media, which is part of why they hog so much attention.

The only possible way to get around this minor definitional problem would be to somehow produce an idea of "immediately recognizable skill" that only applied narrowly to whatever it was Dutton himself already defined as art, excluding, say, the kind of skill that goes into somehow procuring a Great White shark and magically transporting it into a tank or the skill that goes into scaffolding an enormous sculpture with tons of potted flowers. But Dutton was by no means able to restrict his definition of skill in such a way, as evidenced by the conclusion of his op-ed: "Now and again I walk past a jewelry shop window and stop, transfixed by a sparkling, teardrop-shaped precious stone," he wrote. "Our distant ancestors loved that shape, and found beauty in the skill needed to make it—even before they could put their love into words."

Yes indeed, cut and polished gemstones are objects of fascination—which is why a showman like Damien Hirst covered his infamous sculpture *For the Love of God* with thousands of them.

2) Dutton's primary concern was to argue that "human beings have a permanent, innate taste for virtuoso displays in the arts," and that "conceptual

art" is bad because it neglects this natural affinity. (In fact, the article was framed around the conceit that "works of conceptual art have an inherent investment risk," with Dutton seeming to insinuate that the art market would do better to reorient around "Acheulian hand axes," that is, Paleolithic tools that, he explained, show the unmistakable signs of aesthetic striving, as opposed to the dreck we call art today.) He identified the notion of "virtuoso display" almost completely with handicraft, as if a well-crafted philosophical essay weren't a "virtuoso display" of its own sort.

3) This, in turn, led him to two serious errors. The first was evidenced in his claim that, as opposed to the insider gamesmanship of contemporary art, "we are still able, as with the great bronzes or temples of Greece or ancient China, to respond directly to craftsmanship." Dutton, it would seem, believed that the experience of appreciating sculpture is summed up by surveying it and saying *Nice bronze work!* or, *Wow, they really knew how to put together a temple!* In fact, appreciating art of any kind implies a command of the narratives around it; ancient Greek and Chinese art require a great accumulation of cultural knowledge to "get" them today. All art is conceptual if by that you mean that actually having a rewarding encounter with it implies something beyond just the brute facts before your eyes. (Since Dutton's evolutionary perspective led him to insist that the "virtuoso displays" of art are related to the mating instinct and the attempt to impress a potential sexual partner, you really wanted to remind him of the old line that "the brain is the biggest sexual organ.")

Dutton issued a dire warning about contemporary art: "Future generations, no longer engaged by our art 'concepts' and unable to divine any special skill or emotional expression in the work, may lose interest in it as a medium for financial speculation and relegate it to the realm of historical curiosity." But my sense is that the average nonspecialist visitor walking through the Metropolitan Museum of Art's Greek and Roman galleries appreciates the works there as precisely that: "historical curiosities." They spend an average of thirty seconds on masterpieces that have had whole books written about them, take a picture, move on.[5]

A second error of Dutton's argument—more crucial when it comes to understanding specifically contemporary art—came in his bold call that we should stop kidding ourselves that craft is "a value left over from our grandparents' culture." I certainly don't believe that craftsmanship is a dead issue, but Dutton seemed to believe that nothing significant has changed that might affect our way of appreciating craft—not just from our grandparents' time, but literally since the Stone Age.

Presumably, the value of craft in contemporary art will have something to do with how craft is viewed in contemporary society. If one is engaged in craft labor, one is also better placed to appreciate the craft labor of others. Industrialized consumer culture, however, is characterized by the widespread alienation of people from the processes that produce almost all the goods that make up their everyday life-world, from food to clothing to entertainment. So *of course* this implies entirely new modes of aesthetic appreciation and gives new shades of meaning to craft when it is employed. People still make themselves things, but compared to life in past centuries, our own experience of craft labor is today just a small part of our daily experience. Correspondingly, the traditional craft-based arts are just one color in a very broad rainbow of aesthetic possibilities for contemporary art lovers. It could not be any other way.

All this should be really basic stuff. If Denis Dutton got a platform in the *New York Times* to voice his prejudices, this is because he was able to give a sophisticated-sounding argument (Acheulian hand axes!) to a pervasive sense of the fundamental worthlessness of contemporary art that large numbers of people feel, justifiably or not. Back in 2007, I spoke on a panel about contemporary art. When the question period began, a hand shot up and a woman demanded of the panelists, with an aggrieved tone in her voice, "Don't you think that the artist has an *ethical responsibility* to make their own work?"

"Well," I replied, "pouring your guts out onto the canvas is one kind of artistic expression. But even within the terms of things that we normally think of as 'artistic,' it's not the only one. Architects don't make their own buildings, but we still recognize their labor as creative; choreographers don't always dance their own work; and so on." Or something like that. In the moment, I was proud of the answer as a kind of snap defense of a broad-minded approach to art. Immediately, twenty hands shot up, apparently to challenge me. Sensing that we were hurtling toward a quagmire, our moderator quickly steered us back to the artists at hand.

But maybe that conversation should be had. If you look around the professional art scene, of course, you would never really know that there was any need to make the case for "conceptual" art, which is by now an established part of the artistic vocabulary that artists and critics alike treat rather casually. "I foolishly thought we'd gone beyond all that, and that an awareness of visual culture was, well, normal," Searle writes. "That's the cloistered critic for you, imagining himself at the centre of the world." It might be worthwhile cultivating a sensibility that appreciates how challenging conceptualism can still be—and how mind-bending these challenges have been, à la Lippard—rather than being blasé about it.

But the thing is, I don't believe that the present debate about "conceptual art" versus "traditional craft" is really about those terms at all. The debate is a distorted reflection of something else, with the word "conceptual" standing as a kind of code word. Searle noted that one of his foes in the Oxford debate, the artist Mark Leckey, "said he was on the philistine side of the debate because he hated everything the [Young British Artists] stand for. He wasn't against conceptual art, but what he regarded as the pop version of it." Dutton tellingly fixated on the high prices that Hirst commands at auction, thereby implying that a romantic investment in craft would represent a rebellion against shallow commercialism (as if contemporary paintings by Gerhard Richter or Peter Doig didn't also trade at obscene and inexplicable amounts of money at auction).

What I think its critics secretly or not-so-secretly mean by "conceptual art" is art that is valued not on the basis of intrinsic merit but because of the ideas around it. "Conceptualism" is conflated with the laissez-faire permissiveness that is perceived to govern the contemporary "art world." Because "conceptual art" is idea driven, it is dismissed as a whole for being the product of cliquishness and hype. Of course, it is not false to say that cultural value has been warped by money and PR. It is the fact that such backward-looking, culturally conservative critiques seem to hit on this reality that make them sound plausibly righteous—even if what is happening is that a whole manner of art-making is being collapsed into the scene around it and conflated with the products of its worst representatives.

No one, least of all me, is going to dispute that there are a lot of smug, half-assed conceptual gestures out there, produced for an in-crowd audience. But there are also good, committed conceptual artists doing challenging things because they love them. I've always appreciated, for instance, the gravitas of On Kawara. His simple paintings of dates, each signaling the day on which he made it—a project maintained for decades—have a real intellectual beauty as a kind of meditation on the passage of time. I love also the sly, polymathic work of Agnes Denes. Her famous series of works "The Human Argument" incorporates maddeningly detailed graphs and layers of interlocking formulae, engaging in the satirical project of attempting to render every conceivable human relationship in deadpan symbolic logic. (If such art seems impossibly heady, it may be worth remembering that the same questioning temperament led Denes to become one of the founders of ecologically conscious art, creating some of the first projects credited with self-consciously calling attention to humanity's tortured relationship to the earth. Most famously, for her *Wheatfield—a Confrontation* [1982], she cultivated an actual wheat field, incongruously, in Lower Manhattan, below the site of the World Trade Center.)

Many more examples could be offered. At any rate, in terms of quality, contemporary conceptual art is no different from "traditional" art. Plenty of interesting painting and sculpture is being made today; plenty of boring, derivative painting and sculpture is being made as well.

What I find notable about the present attack on "conceptualism" by Dutton and his cohort is that it is a symmetrical, distorted reflection of the very critique of "traditional" art that led artists to adopt diverse "conceptual" strategies in the first place. As Lucy Lippard's *Six Years* so movingly attests, a great many of these attracted the zeal of their purveyors in the sixties and seventies because they seemed to promise some kind of meaningful critique of the art market, and through it, of capitalism in general. Traditional art forms like painting and sculpture were—and still are, in some circles—considered to be corrupt because the objects they produce lend themselves to being sold, owned, and traded.

That such strategies devolved inexorably into their own sort of market-friendly style just illustrates a point. On both sides, "traditional" and "conceptual," the perceived ill of the other is just the displaced face of the market itself, with its tendency to transmogrify and vulgarize everything. Which should provide a lesson for critics about what kind of promises they make for art: there are no formal or aesthetic solutions to the political and economic dilemmas that art faces—only political and economic solutions. Consequently, the only critical temperament that makes any real sense is an eclectic one that doesn't build up one or the other side into the answer for problems that they both share.

FOURTEEN

The Semi-Post-Postmodern Condition

Do we still care about postmodernism? It was once deemed "the most widely touted term in cultural theory."[1] These days, the conviction that it provides any serious guide to the present appears to have unceremoniously evaporated, consigned to the bin of historical curiosities alongside other now-inexplicable obsessions of a previous era, like *Seinfeld* or the Atkins diet. Not so long ago, I asked two friends of mine, both working curators, if postmodernism mattered to their practice at all. The answer was an unambiguous no. "It makes you sound like an undergrad."

At the end of 2011, London's Victoria and Albert Museum offered "Postmodernism: Style and Subversion 1970–1990," which purported to be the first exhibition that treated the whole complex of postmodern style as a cultural movement delimited by a discrete historical trajectory, thereby putting a period on the whole thing. Or maybe a question mark. In one wall text, placed at the end of that show, the curators concluded by asking, "Do we still live in a postmodern era?" Despite the exhibition's attempt to consign the term to the past, their answer to this question was not particularly clear, postulating that postmodernism had left behind "unresolved intellectual provocations" and that rather than having come to an end, its effects had become omnipresent: "Like it or not, we are all postmodern now."[2]

So the question is, how do we think about ourselves? In what kind of present do we live?

In response to this gap, there has been a sputtering series of intellectual attempts to coin a new term for whatever period we are currently living under. French art theorist Nicolas Bourriaud, previously successful in lodging the term "relational aesthetics" in the vocabulary of the visual arts, took it upon himself to brand the new epoch as "altermodernism."[3] Harvard literary scholar Svetlana Boym has proposed her own new classification, "off modernism," to describe a contemporary sensibility that looks back to overlooked aspects of modernism.[4]

157

Art critic Rosalind Krauss, who once championed postmodernism as "a great critique of essentialist thinking" in art, has officially abandoned the position in favor of the "continuance of modernism."[5] Another of the lights of theory, Hal Foster, has offered the following assessment of the situation: "Such paradigms as 'the neo-avant-garde' and 'postmodernism,' which once oriented some art and theory, have run into the sand, and, arguably, no models of much explanatory reach or intellectual force have risen in their stead."[6] Instead, he notes, a more nebulous categorization, "contemporary art," has become the default category dominating artistic discussion, a term that is if anything even more difficult to pin down than the notoriously contested "postmodernism."

At this point, those who are familiar with the more obnoxious excesses of postmodern criticism might just say good riddance to bad baggage. Yet what I am going to argue here is something different, namely that while the fall from grace of "postmodernism" reflects the notion's own internal dilemmas, it is still too soon to bid the term adieu, inasmuch as its core assumptions still form the framework for much of the debate. Until we have accurately defined its borders, it is premature to say we have escaped its territory.

1.

Perhaps unsurprisingly, given its association with relativism and language games, "postmodernism" has always meant different things to different people, taking on (at least) two different types of uses. First of all, for many in the arts, "postmodernism" represented a certain critical paradigm that art and theory had adopted as a critique of the more strident forms of modernist art that preceded it. This is the sense that both Krauss and Foster mean, above. Postmodernism embodies the "critique of essentialism," a rejection of the idea of stable truth, liberated irony. Aesthetically, this was thought to involve a number of coherent characteristics. In the eighties, the influential critic Craig Owens thought that he could detect, underneath it all, the rising importance of something he called the "allegorical" in contemporary culture: that is, a play on multiple levels of meaning:

> Appropriation, site specificity, impermanence, accumulation, discursivity, hybridization—these diverse strategies characterize much of the art of the present and distinguish it from its modernist predecessors. They also form a whole when seen in relation to allegory, suggesting that postmodernist art may in fact be identified by a single, coherent impulse, and that criticism will remain incapable of accounting for that impulse as long as it continues to think of allegory as aesthetic error.[7]

Leaving aside a truly peculiar grouping of tropes—how on earth is "site specificity" to be thought of as intrinsically "allegorical?"[8]—the larger prob-

lem with this type of framework was the way it defined postmodernism as a set of aesthetic chess moves. Subsuming diverse artistic phenomena beneath an even more abstract intellectual construct—in Owens's case, a theory of "allegory"—became more important than reading their relationship to any animating historical context. The result was a kind of unexamined philosophical idealism. After all, you could go paint a horse in a cave tomorrow; the gesture would have a very different meaning than the cave paintings at Lascaux or Altamira. Strategies like "appropriation" or "accumulation" are no different, and yet they were invested with an aura of intrinsic rebellion in the foundational writings on critical postmodernism.

Thus, the artist Félix González-Torres was believed to embody all the good characteristics of the postmodern sensibility. Artworks like his piles of candies, offered up for viewers to take (and perpetually replenished), gained tremendous cachet from their loose-limbed conceptualism, their allegorical use of ready-made objects, and their embrace of audience participation. As Joe Scanlan put it in an essay about González-Torres for *Artforum*, "rosy scenarios of democracy, generosity, collective authorship, and empowerment have dominated our discussions of it."[9]

Scanlan was out to debunk this investment, exposing González-Torres's works' "'dark side'—their affinity with social control, finance, and private property." He notes that the interactive spirit of the candy stacks and poster piles looks, in hindsight, a lot like the bogus sense of participation promoted by contemporary Internet culture "where superficially user-friendly atmospheres mask deeper emotional and psychological manipulations."[10] Yet it seems to me that the very bitterness of Scanlan's critique implies a residual belief in the same false notion that underlies the overenthusiastic interpretations of González-Torres that he is attacking: that artists should strive to create effects that possess some kind of critical value in and of themselves, outside of a specific moment or polemical context. *Of course* artistic ideas—that is, the gestures of individuals—are always being absorbed by powerful institutions, just the way Cubism became one of the inspirations for military camouflage[11] or Dada word games and montage came to inform the freewheeling sensibility of modern advertising. And *of course* tropes like "audience participation" represent different things when used in different ways to different ends, just as swinging a hammer means something different when you are building a house and when you are aiming it at someone's head.

Another example: "institutional critique" was thought to be the good, politically engaged side of postmodern art, the attempt by seventies artists like Hans Haacke and Michael Asher to interrupt the museum-going experience in such a way as to make visitors aware of the hidden dynamics that

determined the experience of the spaces that art inhabited. Consider, however, the work of a present-day art provocateur like Urs Fischer, in many ways a human encyclopedia of "institutional critique" themes, repurposed as spectacular bits of theater without any underlying social agenda. Fischer rose to fame with *You*, a work for which he had Gavin Brown's gallery space in New York completely excavated, leaving only a cavernous pit of dirt. (*You* was purchased by newsprint mogul Peter Brant, who restaged it by digging a big hole in his Peter Brant Study Center in Connecticut in 2010).

Fischer's big hole would seem to echo a 1986 project by performance art grandee Chris Burden closely, for which he excavated the foundation of the Los Angeles Museum of Contemporary Art. As that piece's very title, *Exposing the Foundation of the Museum*, indicates, the gesture was thought to be about laying bare the base matter that lurked underneath the museum's veneer of civilization and to therefore have possessed some critical force. Fischer's piece, on the other hand, didn't even attempt to make an argument that it was about anything other than being a bit of can-he-get-away-with-it showmanship. Nevertheless, formally, the pieces are almost identical. What has changed is the surrounding context.

The point is that the waning of postmodernism's cachet as a theoretical guide to artistic action may just be a coming-to-consciousness of the flaws that were always there—specifically, the overvaluation of theory and discourse over context and political analysis. If you make unrealistic claims for art, you are sure to be disappointed. The waning of "postmodernism" represents, in this way, just the inevitable return of the historical realities that were left out of its original account. It is the revenge of history.

2.

We arrive, then, at the second definition of "postmodernism," which is postmodernism as historical phase. Marxist literary theorist Fredric Jameson's formulation, first pronounced at a lecture at the Whitney Museum in 1982, is still the most famous: "Postmodernism is the cultural logic of late capitalism." In this definition, "postmodernism" is neither a good nor a bad thing; it is just a condition that everyone is responding to whether they like it or not:

> It is not just another word for the description of a particular style. It is also, at least in my use, a periodizing concept whose function is to correlate the emergence of new formal features in culture with the emergence of a new type of social life and a new economic order—what is often euphemistically called modernization, post-industrial or consumer society, the society of the media or the spectacle, or multinational capitalism.[12]

This is an advance on the more thematic conception, pointing us to the material basis for the "postmodernism turn" in broader underlying changes in society. But it is not really the last word either. For one thing, the astute reader will note that the "new economic order" that Jameson is referencing in this first pass at defining the term is not really very specific. What is "late capitalism," really? The pungency of Jameson's suggestion that "postmodernism is the cultural logic of late capitalism" has meant that the term has passed into the common rhetoric of art writers and literary intellectuals. Yet it is truly bizarre that the piece of Jameson's theory that is supposed to be its keystone is the least worked-out, least discussed part of it. Even Perry Anderson, in an adoring book about Jameson, notes that he essentially adopts the idea of "late capitalism" as ready made, without exploring what it means too much.[13]

The concept of "late capitalism" comes from Fourth Internationalist thinker Ernest Mandel and in its original form has relatively little to do with the concepts of "modernization," "post-industrial or consumer society," or "the society of the media or the spectacle," though it does have something to do with "multinational capitalism," supposedly designating a "third period" of capital dominated by global corporations. But its specifics are hardly uncontroversial. In a critique of Mandel written in the early 1970s, Paul Mattick declared the theory of "late capitalism" to be not really much of a theory, arguing that it is eclectic, riddled with contradictions, and in many ways simply historically false—among other things, Mandel's conception of late capitalism implied that the share of the world economy of underdeveloped countries was declining and doomed to continue its decline.[14] (At any rate, unless you are prepared to defend the existence of "Kondratiev waves" on which it is based, you should not refer to "late capitalism" as if it were some self-evident condition.)

As Alex Callinicos writes in his assessment of Jameson's fast-and-loose use of Mandel, "The slippages in his analysis . . . and rather casual uses of economic sources suggest that his belief in 'a cultural transformation of signal proportions, a historical break of an unexpectedly absolute kind' is more of an intuition informing his criticism than an inference from empirical investigation of the contemporary world economy."[15] If this is true of Jameson, it is even more so of his epigones. Referencing the term "late capitalism" has simply become a way for scholars who have no interest in economic matters to seem as if they have seriously thought about them.

I prefer David Harvey's definition (in his *Condition of Postmodernity*) that the postmodern sensibility should be associated more narrowly with the changes that came out of the last global economic crisis in the 1970s. The story he tells goes something like this: The explosive economic growth in

the post–World War II period was sustained under conditions of relatively closed economies, stable currencies, and highly regulated labor markets. By the mid-sixties, the dramatic economic reconstruction of Western Europe and Japan was complete; internal markets were saturated and everyone had to search for new export markets, driving down global profit rates. By the end of the sixties, in the face of mounting debts, the only way to sustain business as usual for the United States was through inflation.

Frightening stagnation set in through the 1970s. Harvey notes that the problem was widely perceived to be one of economic "rigidity"—economies were too slow, too top-heavy to compete in the new situation. The response was a turn to more limber policies, what Harvey calls a doctrine of "flexible accumulation," and what these days we call "neoliberalism" (by no means subsumable under the concept of "late capitalism"). Currencies were allowed to float. Finance was deregulated. Derivatives were introduced. Labor was attacked. Government services were privatized and sold off. Globalization became the rule. John Maynard Keynes was out; Milton Friedman was in.

All this provided a pretty coherent global pattern, yielding a new texture for daily life. It did indeed restart economic growth in the 1980s and create epic tidal waves of new wealth, albeit at the cost of a long-term stagnation in wages for ordinary people. Here, then, is a paradigm shift that provides the background for the theoretical and artistic rise of "postmodernism," which does indeed represent an acceptance of the flexible, the free-floating, and the mutable as all-embracing existential realities.[16]

The emblematic figure of "postmodernity," in this sense—the person who stands at the nexus of its political, economic, and cultural aspects—is neither artist nor philosopher, but ad man Charles Saatchi. In the political field, the Iraqi expat got his start masterminding the 1979 "Labour Isn't Working" campaign that helped bring Margaret Thatcher to power.[17] On the economic plane, if the sixties saw the "Creative Revolution" in advertising, with rebel ad agencies forging hip new identities, the seventies were all about "global integration"—and Saatchi & Saatchi became one of the archetypal faceless multinational conglomerates of the era, the biggest name in advertising's era of "Eighties Extravagance."[18] As for art, in the nineties, Charles Saatchi would become the single most influential art collector in England and possibly the world, using his wealth to make the careers of the Young British Artists, whose tabloid aesthetic fit his own splashy commercial sensibility perfectly.

Unprecedented new wealth; a more mercurial environment of speculation; the celebration of individualism brought on by the attack on the welfare state; demoralization and fragmentation—all these form the background for the artistic vocabulary of "postmodernism." (This wasn't always just an indirect connection: Jeff Koons in fact started out as a commodities trader before be-

coming a fine artist.) Meanwhile, for art as well as for politics, the more radical energies survived principally in the academy, as street-level counterculture and political movements alike went into a long defensive period. Praxis correspondingly took an esoteric turn. It is this background that underpins the complex sensibility of postmodernist art.

Does it seem improbable to link the themes of postmodernism to this background? If so, it's worth noting that the economic paradigm shift was actually the explicit correlate for the original articulation of theoretical postmodernism, French philosopher Jean-François Lyotard's vaguely technological-determinist 1979 manifesto, *The Postmodern Condition*, an important influence on art. Here is Lyotard describing the background for what he described as the waning of "grand narratives," the most important of which was, of course, the Marxist dream that society could actually be changed for the better:

> The reopening of the world market, a return to vigorous economic competition, the breakdown of the hegemony of American capitalism, the decline of the socialist alternative, a probable opening of the Chinese market—these and many other factors are already, at the end of the 1970s, preparing States for a serious reappraisal of the role they have been accustomed to playing since the 1930s: that of guiding, or even directing investments.[19]

For Lyotard, the upshot was clear: If states could no longer control the economy, then we were in a new landscape of free-floating and shifting ideology, and no single narrative could command our attention. The intersection of the theoretical assumption—the "end of grand narratives"—and historical events is clear here, even if the link is covered up or turned into an abstract logic in later articulations.

3.

Still, some questions remain. A "neoliberal period" can be identified in recent history, corresponding to real economic and social changes that have affected broad swathes of the globe. The way both governments and the world economy function have been restructured since the 1970s. But "neoliberalism" designates something else, an ideology that has been used to sell all these changes—that individual interest is all that matters, that we are in a new "postindustrial society" where unions are irrelevant or unnecessary, that class is an obsolete category, that we have reached the "end of history" and unbridled capitalism is the only game in our global village.

Consequently, in one respect at least, rather than continuing to reiterate Jameson's formulation that "postmodernism is the cultural logic of late capitalism" it would be much better to concede that "postmodernism is the cultural

ideology of neoliberalism." It is not only a neutral descriptive category, as Jameson tends to describe it, but refers to a body of assumptions that have been used to naturalize a situation that is in fact a historical product. That means that, when addressing its objects, you have to move beyond just formal questions and address how contemporary artworks are being put to work ideologically.

Take a figure like contemporary installation artist Josephine Meckseper. She often creates vitrines filled with various jumbled, fetishistic objects, displayed on mirrored shelves like objects in some kind of crazy department store of the mind. In one work, for instance, a box of men's underwear with a hunky model on it is displayed next to a roll of pink toilet paper, which is in turn displayed next to the foot of a mannequin modeling a sock, which in turn neighbors a black-and-white portrait of Karl Marx. The jumble of objects is meant to reflect a kind of flattened subjectivity, mapping a global mental space where the objects of experience appear cut off from any meaningful history. They consciously mix together seductive images from fashion with references to politics, hinting at the dark side of globalization (Meckseper's vitrines are even "meant to trigger a resemblance to the way store windows appear just before they are smashed by demonstrators," in her words).[20]

In one sense, Meckseper's edgy jumbles consciously reflect upon the contemporary political and economic situation, the sense of a globalized condition of consumer capitalism, complete with its repressed underside. Yet at the same time, Meckseper's work has often lent itself to promoting an unfortunate ideological agenda, with critics reading it as a statement about the futility of developing any productive political consciousness today: "Meckseper is the first contemporary artist to dare break what could be considered the ultimate taboo: not sex, but politics," theorist Sylvère Lotringer writes approvingly. "Presenting imagery of protest culture and revolutionary myths side by side with art installations, she exposes consumerist and counter-cultural discourses as if they belonged together."[21] According to Lotringer's logic, Meckseper's work promotes the image of a world in which, in effect, you may as well go shopping as try to take a stand against racism or inequality or religious fundamentalism. This kind of self-satisfied cynicism may be highly useful to preserving the status quo, but it is hardly an enlightened truth to be "exposed."[22]

Nor is Lotringer's style of apolitical nihilism disguised as radical critique an aberration. In some sense, it is still the dominant form of sophisticated art criticism. Thus, in an essay attempting to define the essence of "the contemporary" in art, the well-regarded art theorist Boris Groys offers up Mexico-based Belgian artist Francis Alÿs—specifically, his gently affecting animation *Song for Lupita* (1998), which loops an image of a woman pouring water from one vessel to another as a voice sings the words "*mañana, mañana*"—as an artist who embodies the spirit of the age. Groys boldly reads the video as an allegory of

"wasted time," a post-political condition in which all art can do is endlessly preoccupy itself with humanity's failure to realize a better future. Here is Groys explaining the state of the world, as he sees it:

> The future is ever newly planned—the permanent change of cultural trends and fashions makes any promise of a stable future for an artwork or a political project improbable. And the past is also permanently rewritten—names and events disappear, and disappear again. The present has ceased to be a point of transition from the past to the future, becoming instead a site of the permanent rewriting of both past and future—of constant proliferations of historical narratives beyond any individual grasp or control. The only thing that we can be certain about in our present is that these historical narratives will proliferate tomorrow as they are proliferating now—and that we will react to them with the same sense of disbelief. Today, we are stuck in the present as it reproduces itself without leading to any future. . . . The loss of the infinite historical perspective generates the phenomenon of unproductive, wasted time. However, one can also interpret this wasted time more positively, as excessive time—as time that attests to our life as pure being-in-time, beyond its use within the framework of modern economic and political projects.[23]

Now, I like a little "wasted time" as much as the next guy. But if Groys's account of the concept isn't a philosophical version of the same old neoliberal "end of history" narrative, I don't know what is. Its basis is particularly flimsy, too: just because we are bombarded with "cultural trends and fashions" doesn't mean that all human endeavor has been reduced to a trend or a fashion, any more than just because our stores are stuffed with junk food our only mealtime option is to eat junk food.

Most importantly, however—particularly given Groys's picture of a constantly morphing historical narrative with no stable center to hang onto—this passage could have been lifted whole from Lyotard's long-ago writings on the "postmodern." All the classic tropes are there: the fall of master-narratives, the futility of political idealism, the underlying technological determinism, the universalizing claims masked as admissions of irreducible particularity. (Who is the "we" in the sentence "we are stuck in the present as it reproduces itself without leading to any future?") Rather than being some bold new account of contemporary art and its relation to contemporary life, Groys's art theory is threadbare, thirty-year-old ideology.

4.

Which brings us back to the initial question, the starting point and destination of all this. Where do we stand today in relationship to the theme of "postmodernism"?

In recent years, the art world's trendy philosophies all suggest an interest in politics, rather than the semantic games and neologisms of classic deconstruction: the dilettantish political mysticism of Giorgio Agamben; the Maoist mathematics of Alain Badiou; the orotund autonomism of Antonio Negri; the gentleman's anarchism of Jacques Rancière; the erratic musings of Slavoj Žižek. I take this as a hopeful sign of a hunger for some alternative to the more cartoonishly relativist theoretical "postmodernisms."

Yet do any of these figures offer anything resembling a clear, historically rooted response to today's problems, any graspable alternative vision of social organization or political strategy? I would say no. They are eccentric stars in the theoretical galaxy of postmodernism, but they are not outside of it.[24]

As for art theory proper, so far, dissatisfaction with the term "postmodernism" reigns, but not much in the way of a convincing alternative is on offer. Few have taken Bourriaud's "Altermodern Manifesto" seriously as a proposition, partly because it is extremely unclear what he could possibly mean. "Many signs suggest that the historical period defined by postmodernism is coming to an end: multiculturalism and the discourse of identity is being overtaken by a planetary movement of creolisation," he wrote, trying to explain the concept.[25] In other words, he seems to think that "postmodernism" corresponds to "multiculturalism," meant as some naïve celebration of discrete identities, and that "altermodernism" represents a new reality of happy-go-lucky global remixing. Yet, according to this scheme, the architecture of Robert Venturi, who promoted a populist mix-and-match aesthetic of historical and cultural pastiche and who helped crystallize the entire idea of cultural "postmodernism" back in the early 1970s, would be quintessentially "altermodern."

Similarly, from the art journal *October*'s fall 2009 issue on the concept of "The Contemporary," I note that one dominant academic reaction to the "crisis of postmodernism" debate is a kind of haughty nominalism. The problem with "postmodernism," we are told, is that it was a theory that actually attempted to characterize the situation; we should just celebrate the diversity of art and cultural practices.[26] The funny thing is that, in its hostility to explanatory narratives and implicit celebration of untotalizable micro-narratives, this program sounds a lot like what people would call stereotypically "postmodern" thinking in the first place.

What about the economic and political situation? It has been often remarked that the economic crisis exposed by the collapse of the US housing bubble in 2008 represented a crisis of neoliberal ideology. This is true. The crisis grows out of the systematic structural imbalances that derive from globalization and the excesses of unregulated speculation—in effect, the very strategies that were used to resolve the 1970s crisis that Harvey described have hit their limits. In the years since, though, have we truly seen any reorientation of governing

logic on a level equivalent to the transition from paternalistic Keynesianism to party-hearty Milton Friedman market fundamentalism in the seventies?

Certainly, there was a lot of talk about a "return to Keynesianism" in 2008 and 2009 (just as there was speculation that a crash would shake art out of its decadence and make it meaningful once again). [27] But in fact what we witnessed at the height of the financial plunge was an emergency banking rescue organized by the government but executed on the terms of superstitious respect for the "free market," leaving the power of private finance essentially untouched.

It is not impossible that some new ideological pattern will emerge. But years into the crisis, we have seen what looks like a minor inflection in the dominant ideology, not any full-blown change of direction. Glance again at the factors Lyotard lists above as providing the underlying correlates for "postmodernism." How many have been reversed? None. If anything, for the moment, there seems to be a radicalization with regard to all of them—the instability brought on by "vigorous" economic competition, the erosion of US hegemony, the lack of a political alternative that anyone can believe in, and so forth. If there is any new economic ideology, it is only in its nascent stage, emerging from the heroism of the Arab Spring and the inchoate but inspiring Occupy Wall Street protests of fall 2011 (which were both, it should be noted, vigorously supported by many visual artists).

So where are we? On the level of theory, you have the waning of something, but an inability to articulate anything that sounds like a credible alternative. On the political and economic plane, you have the discrediting of the old ruling logic, but nothing new to do the job—so neoliberal notions that corporate power must be reasserted at the expense of the average person continue to be the default wisdom. At every level you have something like "semi-post-postmodernism," a deliberately ugly term for a disorienting period.

In an April 2010 lecture to the London School of Economics, David Harvey chided his audience: "Actually, we have to think about what the macro problem is, and confront and deal with the macro problem as it is." The question today, he said, is "are we going to get out of this crisis the same way we were?" His answer: "If academics continue the way they are, the answer is yes." [28] Harvey was talking specifically about economic theory, but you could say the same about art theory: If the "serious" side of the art world continues to recycle the same old antihistorical academic bullshit, then it is going to continue to be a place of intellectual irrelevance and triviality that no one takes seriously besides the people who inhabit it.

The world is undergoing dramatic changes. According to whose interests these changes will be enacted is not yet set, and what new paradigm will emerge from the chaos remains anyone's guess. Partly, it depends on what we

do, what ideas are advanced, and whether they intersect with forces organized enough to make them heard. My feeling is that if art and art theory are to play a productive role in this process, they need to ditch the twin platitudes of "my art is my activism" and "my theory is my practice." Moving beyond "postmodernism" as a paradigm has to mean a shift away from the myopia and cynicism that has characterized our recent past, if it is to mean anything at all.

Unless and until such a shift occurs, simply giving up the term or changing it out for a new one is not going to do much good. After all, swapping word games for a meaningful relationship to political reality was part of the problem in the first place.

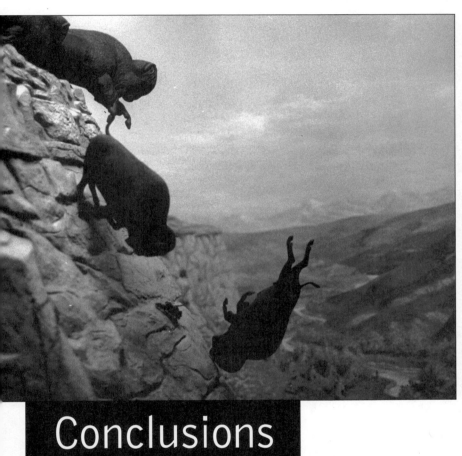

Conclusions

David Wojnarowicz, *Untitled (Buffalos)* 1988–89, Gelatin silver print, 40 ½ x 48 inches.
Courtesy of the Estate of David Wojnarowicz and P•P•O•W Gallery, New York.

FIFTEEN
Beyond the Art World

I don't care for the term "art world." It's a useful term, of course, a kind of shorthand for something like "the professional sphere of the visual arts." Thus you can say, "The art world thinks . . ." or talk about "art-world concerns." But the truth is, art is not a world unto itself. Art is part of the world. That fact has to be a fundamental starting point for everything we write about the subject.

It is not my goal to become an "art person." For some people, becoming an "art person" is their main ambition. Paradoxically, when I talk to such people, I quickly become confused about why they are interested in art at all. They are interested in art as a world, I guess, as an environment to inhabit: for the parties, the people, the gossip, the money, the vague and ill-defined aura of intelligence and importance that art gives off.

Art-making is a complex social act and one of the primary passions; perhaps not so primary as food, or love, or sex, or shelter—but very, very important. People will suffer for art, for a shot at creative self-expression. Nevertheless, art cannot and does not exist on its own; slipping into the habit of addressing the sphere of the visual arts as a self-enclosed universe is a recipe for sapping art of its social vitality.

The movement of art and art criticism, as I have come to see it, is one of threading, of finding the points where art and its world connect back to everything else, the big, beautiful, sometimes fucked-up and scary world beyond it. If you can't stomach being interested in the wider world, having a thought about it, and figuring out how that relates back to what artists are doing in the present, then all you are left with is professional opinion of interest mainly to other art professionals or those in their spell.

To say you should approach art politically is not necessarily the same as demanding that art be political. In fact, quite often the sterile imperative to make "political art" is just a kind of inverted expression of "art world" solipsism. To whom is this political art addressed? If it is only addressed to "art people," then

171

it can't be that political at all. One mark of the insularity of the visual arts has been that its productions mainly become part of the larger political conversation in a negative way, at those moments where some exhibition comes under fire from conservatives, and once again art's supporters trot out all the arguments about the fundamental social importance of culture that no one bothers to make otherwise.

We are all creative people. We all have art in our blood. Yet not everyone gets to express herself or himself equally; that is something people fight for. The way I see it, when you judge something as an artwork, you are judging how it plugs into a larger conversation, on at least two distinct levels.

First, an artwork must connect with an audience's understanding of what "art" is in society today, which is just a tissue of topical conventions and historical precedents. On this level, what is thought to be good art is indeed determined mainly by professional concerns. I think of this as the "horizontal" level of analysis, because it is just a matter of connecting one art reference up with other art references, in an endless plane. Much present-day art writing stops at this level, of assessing whether something is original or derivative in relation to the accepted battery of art conventions and references. Hence, you get a kind of aesthetic algebra—"artist x is like artist y meets artist z"— always ensuring maximum tension between the variables to generate a sense of historical novelty. Thus an artist can be "Édouard Manet meets Maxfield Parrish," or "like Roy Lichtenstein combined with H. R. Giger," or even, perhaps, "the love child of Jackson Pollock and Banksy."

Secondly, there is the "vertical" level of reference, the way a particular artistic gesture is rooted in the earth of its social present, the energies and forces of the world that surrounds it. To feel truly passionate about a work of art means connecting it up, consciously or unconsciously, to a way of thinking, an existential world, a social reality. "The mere desire for novelty plays a relatively small part in the alternation of styles, and the older and the more developed a tradition of taste is, the less liking for change it shows of its own accord," Arnold Hauser once wrote. "Hence a new style can make its way only with difficulty, if it does not address itself to a new public."[1] In fact, without some sense of the social background, it is hard to make sense of artistic forms at all. At one historical juncture, a particular type of art can seem heroic, while at another the same gesture might seem obvious or derivative, a reflex of the establishment. At one instant, it is a symbol of daring and innovation, relating to the social outlook of freaks and eccentrics; at another, it becomes associated with the preachings of professors and the calculated provocations of ad men.

I once wrote an essay about the Bauhaus in which I tried to show how the legendary art school's trajectory from its origins as a kind of hippie arts-and-crafts commune to the prototypical font of industrial design was deter-

mined not just by intra-aesthetic debates but by the pressure of having to jus-
tify an art school's existence amid the turbulence of Weimar Germany.[2] To
get at what this particular artistic movement really meant, I said, was to look
beyond the parade of exciting forms it generated, to see the underlying social
struggles to which they were related and thereby "to put the history back
into art history." This perspective, mutatis mutandis, also holds true when it
comes to the art of the present: the task should be to make contemporary art
feel truly contemporary, part of the present and not removed from it.

The specter of the "art world" casts a mesmeric spell upon creative dis-
cussion, constantly absorbs new forms into its professional orbit, and sets all
kinds of bad examples because, of course, those who succeed are not neces-
sarily the best artists or writers—merely the best "art people." But the "art
world" is not the avatar of some all-consuming "society of the spectacle"
that has come to foreclose any possibility of critical thought or artistic pas-
sion. It is, at most, a theater for people's professional aspirations, a stage that
some people get stuck in and that some other people pass through and then
transcend. When you have learned its terms and then learned not to care
about it, you have achieved a kind of state of grace, and that is where good
art begins.

SIXTEEN

To the Future

In December 2012, I found myself once again at Art Basel Miami Beach, the big annual art fair. I was taking a final walk around the convention center with a colleague, surveying the endless aisles lined with pricey modern and contemporary artworks. In my head, I was trying to make sense of it all, trying to figure out what to say about this kaleidoscopic panorama of money and art, when something stopped me short.

One corner of the convention center was dominated by a large plaza of rolling Astroturf, designed as a kind of funky oasis where the fair-weary visitor could sit down and read the official guide or chat with friends. Booths dedicated to emerging artists were arrayed around its periphery. On this particular afternoon, the park was packed, mainly with lollygagging teenagers. The figure who had caught my eye was an older African American man in a ball cap, sitting by himself and reading a book. Nobody seemed to be paying him much attention. He stood out mainly because he had three small hand-lettered cardboard signs propped up in the grass in front of him. They read, respectively, "Art Needs a Home," "Homelessness Is a Condition, Not a Disease," and "Hungry Not Starving."

We paused to speak with him. At first, he didn't seem to want to talk, but when I said I was interested in the message of his signs he began to tell me a story that sounded like a parable.

He said that he was from Atlanta and that he lived in a studio at the top of a building. The view was so good, he said, that he didn't need a television. He said that from his windows, he could see into a small park where homeless people slept at night. There was also some public art; men and women who lived in the street would defecate behind it sometimes. The public couldn't see this from the street, he said, but he could see it from his room. He said the art had been built for the Atlanta Olympics and that the artists who made it were all dead now. But he thought that they wouldn't have minded—maybe they even would have appreciated people getting some use out of their work.

"So what do you do?" he asked me, coming to an end. "What does an artist do about problems like that?"

Now, the reality of Miami's large homeless population juxtaposed against the frenetic orgy of parties and luxury events that populate Art Basel week is always one of the most disturbing things about the experience. And I was just about to tell the man that I was from New York and that I had been reading about how in New York we broke a record that year for the number of kids sleeping in shelters: twenty thousand in one night.[1] Our billionaire mayor, Michael Bloomberg, had cut subsidies for housing to low-income households, which had forced more families onto the street.[2]

I was about to say this—but right then, as if on cue, a policeman appeared.

Lieutenant Carulo didn't ask the man what he was doing or calmly request that he put away his signs (not that either of these would have really made sense either). His tone was immediately threatening. "Sir, I need to talk to you right now. I need you to get up and come with me." The man with whom we had been talking—later, I would find out that his name was F. Geoffrey Johnson, a poet and artist who has endeavored to catalogue the stories of overlooked populations—asked the policeman what he had done.[3] "Come with me, sir. Pack up your things. Come with me right now."

In the end, Johnson was led away into a back room where he was accused of trespassing. When he was able to prove to the fair manager that he had bought a ticket, he was told that his signs counted as art, and that the fair did not allow artists to show works without permission. He was told that if he returned, he would be arrested.

◆

"What does an artist do about problems like that?"

My encounter with F. Geoffrey Johnson has stuck with me and will probably stay with me long after the artworks on view that week have disappeared from my mind—and not merely because of what it illustrates about how "art-world" liberalism is often secured by ejecting any menace of living political consciousness. It stays with me because the question that Johnson asked me is also something that I have asked myself many times.

Inequality in the United States, after years of a grinding recovery from the Great Recession, has hit record postwar highs.[4] Upward mobility has flat-lined; America is now the developed world's capital of social stagnation.[5] At home we incarcerate a number of people to rival the Gulag at the height of Stalin's madness, while above the rocky landscapes of foreign lands, we deploy robot planes to terrorize hapless populations—as if the ambition of our leaders is to turn the present into an approximation of some cautionary sci-fi dystopia.[6] And all the while, the Earth's polar ice melts away. Our profit-mad economic

system will shortly convert the planet's surface into an unlivable wasteland, if left to its own devices: "All that can be said with certainty is that the sooner the world supersedes capitalism the greater the chance for survival."[7]

When you start like this, art can seem very small.

Yet I truly believe in the cause of art, which means I believe in art as part of the cause of a better world. It is just that, if you aren't very careful about how you mean it, protestations about the importance of art become platitudes—in fact, they become a way of setting it above other, less glamorous human concerns, and consequently can serve to justify deplorable incidents like the one I witnessed that day at the fair. There are, in fact, two things you might mean by "art" when you talk about its importance, and distinguishing between them makes the difference between an ideology with a broad and even revolutionary social significance and something that is much narrower and more dubious.

On the one hand, "art" might refer to the products of human creativity in general. All human labor has its creative element; in this sense it all is, potentially, appreciable as art. On the other hand, the term "art" points us to the domain of "visual artists," a professional classification. Talking about "art" in the second sense means talking about an occupation with some highly specific and even esoteric conventions and concerns, like veterinary medicine or entertainment law. Commentators who wax poetic about the importance of art routinely confuse these two senses, letting art in the narrow sense usurp the status of representing creativity in general.

Certainly, the profession of visual artist has plenty that is interesting about it. I've argued that the essence underlying the mysterious and multiform productions of contemporary art is the middle-class form of creative labor. That is, what is most characteristic about "visual art" is not a medium or a set of themes, but how artists have an unusual amount of say over the content of their own creative output. Personal fulfillment and professional ambition overlap—the classic middle-class aspiration. The difference between a visual artist and a commercial artist is not unlike the difference between someone who owns their own food stand and a cook who works at a restaurant. Both make food. One has more say over what, how, and when it is made and to whom it is sold.

Our globalized capitalist world is dominated by corporate colossi, a reality that gives middle-class autonomy a glow of rarity and preciousness. But the celebration of the heroic visual artist has a kind of latent ideological weakness that must be confronted head-on. At least since the Italian Renaissance, which gave the free-thinking autonomous artist its modern form—the form that has spread internationally through the conveyor belt of capitalism[8]—the world has been "divided into workmen who were not artists, and artists who were not workmen," as William Morris once put it.[9] "Art" defines itself by its opposition

to common labor and, by dint of its creators' unique freedom, commands a higher value.[10] The notion, consequently, often goes hand in hand with a certain inbuilt sense of social superiority (though, to be fair, this haughty sensibility often has a kind of defensive character to it, since the struggling majority of artists need to steel themselves against a society that doesn't particularly reward their efforts); to say, "I am an artist" often also means, "What I do is more free than what you do—and that makes me *more* than you."

Now, capitalism has throughout its history built up middle classes only to then disenfranchise them.[11] The history of Western capitalism and Western art, at least since the middle of the nineteenth century, has been a long narrative of industrial processes of image production encroaching onto art's territory, entering into the field of visual culture and forcing artists to seek new justifications for their craft. And at least since the middle of the twentieth century in the United States, the "culture industries" have been so sophisticated and all-pervasive that any pretension of visual artists to be the leading innovators of culture can only be maintained in ever-more-tortuous forms (a condition that accounts for some of the febrile character of contemporary art theory).[12] The upshot is that, in some ways, preserving a mythical ideal of middle-class creative autonomy in the face of a wider culture that has superseded it is the main thing that contemporary art now does, its main contemporary mission.

False superiority and bloated individualism are not all there is to visual art, however. Even so astringent a Marxist art critic as Julian Stallabrass will concede, "The freedom of art is more than an ideal. If, despite the small chance of success, the profession of artist is so popular, it is because it offers the prospect of a labour that is apparently free of narrow specialization, allowing the artist, like heroes in the movies, to endow work and life with their own meanings."[13] The middle class, by definition, is a middle layer between labor and capital; if the reflexive need to elevate itself above "common" alienated work is one pole of its existence, a natural hostility to Big Capital is the other. (As a famous letter from King Leopold to Queen Victoria warns, rather amusingly: "The dealings with artists . . . require great prudence; they are acquainted with all classes of society, and for that very reason dangerous."[14]) In a world as disenchanted as ours, desires to escape the routine humiliations of the economy are often channeled into the notion of becoming a visual artist. This investment can, in turn, imbue the profession with a genuinely radical character, making it a hospitable conductor for all kinds of alternative energies. It's worth looking briefly at a few canonical examples from art history in the United States for inspiration.

The 1930s are not remembered as the golden age for American art. A grinding depression brutalized artists whose basis of patronage was still fragile,

making them dependent on government support to survive. Under the conditions of quasi-unionization that art acquired under Franklin Delano Roosevelt, US painters, sculptors, and printmakers distinguished themselves as particularly outspoken in their support for labor struggles amid the era's vast left-wing surge. According to one memoir, only the sailors matched the artists in their enthusiasm for showing solidarity on the picket line.[15] In art, the thirties are remembered as the age of socially engaged content, particularly in photography and public murals. But it was more than that as well. Stuart Davis, the painter whose jazzy abstractions are remembered today as a prequel to Pop Art, was in fact an outspoken activist and a leader of the Artists' Union, which in 1936 opened an American Artists' Conference in New York with a statement decrying "oaths of allegiance for teachers, investigations of colleges for radicalism, sedition bills aimed at the suppression of civil liberties, discrimination against the foreign-born, against Negroes, the reactionary Liberty League and similar organizations, Hearst journalism, etc."[16] Influenced by Marxism, Davis also wrote extensively defending the legitimacy of experimental and abstract painting as part of a materialist philosophy and indeed as a component of a program for social transformation.[17] This radical's support as editor of the journal *Art Front* is credited with helping to seed the ground for the later triumph of "American-type" abstraction after the war, a fact on which the latter's more apolitical champions would do well to meditate.[18]

Decades later, in the wake of another period of social upheaval, the seventies saw visual art achieve one of its defining moments of radical resonance as a conduit for feminist "consciousness raising." Inspired by (among other things) Betty Friedan's *The Feminine Mystique* and the anti-authoritarian agitation at Berkeley, artists Judy Chicago and Miriam Schapiro—both formerly abstract painters who had moved toward self-consciously feminist content—helped direct a group of female California Institute of the Arts students to create *Womanhouse*, transforming an abandoned Los Angeles mansion and opening it as a temporary collaborative art environment at the start of 1972.[19] The result was a mix of "high excitement, intense emotions, and wild humor," as participant Mira Schor recalled later, each of the domestic spaces reworked into reflections on their significance, developed out of participants' conversations about their own experiences.[20] Close to ten thousand people filtered through *Womanhouse* during its one-month run, with the public's documented reactions ranging from scornful laughter to open tears, most movingly in front of *Leah's Room*, a performance that saw Karen LeCocq ritualistically apply and remove makeup, enacting a never-ending ritual of self-criticism and self-cancellation. *Womanhouse* has been endlessly debated and critiqued, for reasons valid—the notion of women's experience that it conveyed was limited by the social backgrounds of its art-student participants—and not so

valid—for instance, on account of its uncool earnestness. But its weaknesses were the flip side of its strengths; it had the turbulent character of people saying things that needed to be expressed but hadn't yet been worked out. And incidentally, in being forced to invent new forms to convey their own experiences, feminist artists like those who cut their teeth in *Womanhouse* shifted the vocabulary of art, incorporating biography where it was formerly verboten and bringing the body, sexuality, and performance center stage. "Feminism has generated the most influential art impulses of the late 20th and early 21st century," the critic Holland Cotter has written. "There is almost no new work that has not in some way been shaped by it."[21]

The 1980s are remembered in art as the era of supersized machismo and market hubris. Yet it was also the era of the AIDS crisis, which in New York hit the artist community particularly hard. Of the many subjects of Nan Goldin's classic photographic elegy to the East Village demimonde of the eighties, *The Ballad of Sexual Dependency*, almost all were dead by the end of the decade, many felled by AIDS.[22] Gran Fury, the artistic arm of the activist group ACT-UP, threw itself into creating protest graphics attacking the indifference of the government to the unfolding crisis facing the gay community. In this urgent context, professional niceties became all but irrelevant. "The aesthetic values of the traditional art world are of little consequence to AIDS activists," wrote Douglas Crimp. "What counts in activist art is its propaganda effect; stealing the procedures of other artists is part of the plan—if it works, we use it."[23] And yet, at the same time, this terrible moment also inspired artist David Wojnarowicz (who was to die of the disease in 1992, at the age of thirty-seven) to create some of the era's most haunting artworks. His photo *Untitled (Buffalo)* (1988–89)—a dreamlike image of a trio of buffalo tumbling through the air as they are herded over a cliff to their doom (actually a diorama at the Smithsonian Natural History Museum, a fact that gives the image its frozen and hallucinatory character)—symbolically united the unfolding public health crisis to the deep history of America's foundational brutality. *Untitled (Buffalo)* is the *Guernica* of the AIDS epidemic. It escapes the blunt eloquence of Crimp's "propaganda effect" to convey a sense of a social tragedy on a mythic scale.

These are all particularly dramatic examples of how powerful art and radical politics have drawn from the same well, in complex and sometimes confusing ways. And yet they are perhaps just illustrations of a relatively uncontroversial fact, true in good and bad times: that *relevance* is one of the things that makes art *resonant*. We should press our explorations a little further, because the account of politics and art here remains a celebration of the labors of particular professional individuals. Without expanding what you mean by "art," you can easily end up in the dubious position of those who righteously condemn cuts

to government arts subsidies in the name of the social importance of culture, even as they stay mute about cuts to basic services for the needy, like food stamps, public housing, or welfare. Unless the former struggle is consciously linked up with the latter, you end up simply defending artists as one interest group, thereby cutting art off from its wider social significance.[24]

"Stupid people often accuse Marxists of welcoming the intrusion of politics into art," John Berger once wrote, with his customary pugilistic elegance. "On the contrary, we protest against the intrusion. The intrusion is most marked in times of crisis and great suffering. But it is pointless to deny such times. They must be understood so that they can be ended: art and men will then be freer."[25] Presented in this way, art and artists don't just have a moral interest in political struggle. Anyone who is interested in art has an interest in struggling for a more equal world because equality is a condition for creativity to realize its full potential in our lives. At this point, however, we begin to transcend the question of artists as a professional group. In fact, we begin to see that making the distinction between art in its narrow sense and art in its broad sense is already political, in that it forces us to interrogate the conditions that create this separation, which confines our aspirations for our creative selves to one particular niche career.

Like Berger, I am a Marxist. What does this term mean to me? Not the strange form of vaguely concerned liberalism mixed with a radically complex vocabulary that it means in the academy. Even less the bizarro-world Cold War beliefs of those who still hold up the former Soviet Union or Cuba or China as paragons of workers' power.[26] Instead, I believe in three propositions that seem so ordinary that it astounds me to know that many people will want to debate them: that class struggle is real and has shaped society; that our present-day reality is deformed by the profit-seeking and greed that characterize the particular form of economic reality that dominates our lives, capitalism; and, finally, that we are clever enough as a species to come up with something better, and that the crazy idea of letting the people who actually do most of the work have a democratic say in how it is done and how its profits are distributed seems a good candidate.[27] Nothing in our genetic code says that every generation or so must have its dreams laid to waste by the trauma of recurrent economic crisis or that humanity will commit ecological seppuku; these unfortunate circumstances are a consequence of a balance of forces that puts power at the disposal of the masters of capital at the expense of the vast majority of the human race.

Where does art—in both the narrow and the broad sense—fit into this picture? In one sense, for all its inequalities, contemporary capitalism has given us more art than ever before. Visual artists are touted as quasi-celebrities and role models. The art schools overflow with hopeful young people. Meanwhile, our

everyday environment is more highly designed than it has ever been. We swim in tides of highly seductive images. Our gadget-fascinated, hyper-technological society has put the means for creative self-expression at the hands of vastly more people than at any previous time in history.

There are, however, obvious ways that the significance of all this creative potential is cramped by the more uncomfortable facts of contemporary life. Visual art is degraded when it has to ingratiate itself to patrons who are oil oligarchs, arms dealers, and financial sharks (that is, the people most directly responsible for environmental devastation, war, and economic injustice). The case against the still-more-omnipresent mass media is even clearer, since commercialism very clearly clouds its ability to stand as a full representation of human creative possibility. As for vernacular artistic expression, whether in the form of basement hobbyists and Sunday painters or of some wild and woolly Internet subculture, it is not to be dismissed—but even here creativity bears the stamp of the isolation, inanity, and fragmentation that characterize much of our existence today. Vernacular culture asks a question rather than providing an answer: given all the ingenuity ordinary people are capable of with very little prospect for reward or recognition, and in the face of all the demands of survival, what might they create if they had the raw material of a better society to work with?

For me, an analogy to sexual liberation renders art's stake in social transformation particularly clear. As Sherry Wolf recounts in her book *Sexuality and Socialism*, the modern LGBT (lesbian, gay, bisexual, transgender) movement has definitively altered the sexual landscape, making forms of desire available that would have been unnamable just a few short generations ago. Just as art has slipped the bounds of any conventional form since the 1960s, we now feel that there is no exact cookie-cutter correct way to love. Yet, Wolf continues, aside from us putting an end to the tenacious inheritance of bigotry and ignorance, real sexual liberation also requires real material liberation. How can you say that you truly know what you are capable of as a desiring being when you have to work until you are tired, when you are implanted with all the insecurities and neuroses of a pitiless consumer culture, and so on? We can be enthusiastic about the freedoms that have been won and still see that they are only a taste of what might be.

"In our society it is hardly surprising that people harbor jealousies when a lover has sex with another person or that they desire a soul mate to ward off loneliness and insecurity," Wolf writes, challenging those prophets of polyamory who think that all we need to do is flip the right mental switch to change society over into a world of free-form sexual plenty. "These emotions and desires cannot simply be willed out of existence because they are human responses to real conditions in our society."[28] Our creative lives, like

our love lives, bear the burden of representing the good part of our existence, of standing in for the richness of an unalienated world we lack; without the prospect of companionship or of creative fulfillment there's just the unending abyss of working for someone else in return for being able to survive another day to do it again. But the result of this fatal disequilibrium is that it puts a tremendous pressure on these aspects of our existence to deliver the goods, thereby lending a shrill and exaggerated intensity to everything about them, tingeing art and love alike with querulousness and obsession that might not be there if we didn't have so very much of our self-worth bound up in them. We can do our best, of course, to love wisely and create freely in the world we have, but it is not the best we could do.

Nevertheless, whatever its deformations, in a crucial sense the promise of art remains an important component of struggle. Because, despite it all, the rewards of creative expression that we do manage to experience give a small taste of a world worth fighting for. As the literary critic Terry Eagleton has emphasized, for Marx it was artistic activity that best emblematized what life might look like in a world that had transcended capitalism—"art" meant here not in a strictly professionalized sense, but in the sense of the free exploration of one's interests and potentials, of labor pursued for pleasure and intellectual reward rather than out of the need to sustain oneself. "In [Marx's] view, men and women only genuinely produce when they do so freely and for its own sake," writes Eagleton. "Only under communism will this be fully possible; but meanwhile we can gain a foretaste of such creativity in the specialized form of production we know as art."[29] The image of socialism is not some gray workers' state where everyone wears a Mao suit; its style would be much more polyphonic, because the foundational principle of such a community would be that "the free development of each is the condition of the free development of all," that we look to taking care of our common needs so that we can explore our individual desires. Full of pageantry and passionate debate, it would likely look much more like an artists' commune than a massive factory.

Here, at last, we enter into a kind of theoretical wormhole. Art, we've said, has often gained from its encounter with politics, where the urgency of the present finds an outlet in refracted forms of creative expression. "We live in a world of suffering in which evil is rampant, a world whose events do not confirm our Being, a world that has to be resisted," John Berger has written. "It is in this situation that the aesthetic moment offers hope."[30] Artistic pleasure, in this way of framing the problem, is determined in its very condition, in our unhappy world, by its rarity. Accepting the point, does this mean that in a future where humanity ceases to be so hard pressed and class-divided, where the resources to survive come much more easily and the time that goes into creating art is in much more widespread supply, we would

also lose our ability to appreciate the aesthetic as we know it now? Does the future negate the best of the present?

It is impossible to know. A wall of fire separates our present from any such future. Trotsky, the great thinker of revolutionary literature, was very clear that a better culture would be built not by junking the bourgeois past but by learning from its artistic accomplishments.[31] But a socialist society would not view those accomplishments quite as we do now. We would likely receive the enduring works of art produced under capitalism in much the same way that secular art historians contemplate religious works of art today. We can appreciate how for thousands of years the drama of religion was a primary vehicle for expressing compassion, suffering, and the aspiration for a redeemed world, and still feel that this art is confined to a framework that is narrower than the one from within which we now operate.

Or perhaps there's an example that's closer to hand: we can appreciate the simple heroism of a man carrying a sign expressing solidarity with the homeless into a playground for the wealthy before being threatened and hustled away, but also imagine remembering this incident from a world where it seemed strange that it all had to happen—not just because the petty cruelty that would lead organizers to banish him had been put in check, but because homelessness itself was a concept rendered alien by a more equitable distribution of society's resources.

So it might be with the significant art of the present as seen from a better future. We will still be able to love and appreciate it. But the ideas that made up its essence—that great art was something by definition rare and precious, a triumph that had to be scratched out against all odds, a privilege that needed to be defended with boundless righteousness and walled off in its own specific professional sphere—will likely seem strange. And our own present, transformed, will be more interesting than anything we can now even imagine.

Further Reading

Literally hundreds of books could be recommended for those looking for more information on the issues touched on in the preceding pages. Here, I will simply suggest a few texts that might serve as accessible or particularly useful entry points.

As introductions to the subject of how radical thought has shaped our views of art in the recent past, two can be recommended. The Andrew Hemingway–edited collection *Marxism and the History of Art* recovers the stories of how Marxism has affected some of the key figures in art history, from William Morris to Meyer Schapiro. Joan Day's *Dialectical Passions* offers a sharp, critical assessment of the political engagements of a more recent constellation of figures who have had a decisive influence on contemporary thinking about art, including Benjamin H. D. Buchloh, T. J. Clark, Hal Foster, and Fredric Jameson.

For his pure spirit of passion and political engagement, John Berger is always worth returning to. Start with his famous critique of Western art, *Ways of Seeing*, then go to his *Selected Essays* to get a sense of the scope and evolution of his thought. In a similar spirit, Lucy Lippard's corpus is one of the most inspiring examples of engaged art criticism—her socialist-feminist activism has directly shaped the course of recent art. Her collection *The Pink Glass Swan: Selected Essays on Feminist Art* has been a tremendous inspiration.

Raymond Williams's *The Sociology of Culture* offers a dazzlingly down-to-earth approach to the analysis of art in society. Almost everything Terry Eagleton has written has value for the way it cuts through the obscurantism of much cultural theory, offering a Marxist take on the subject that is both engaging and unsparing. I'd begin with his *The Ideology of the Aesthetic*, which provides an important history of how aesthetic thought has been shaped by capitalism.

Arnold Hauser's textbook introduction to Western art history through a Marxist lens, *The Social History of Art*, is out of fashion. However, I personally find this enormous opus a tremendously suggestive, if dense and at times

debatable, attempt to give a materialist account of some of the canonical developments of art. At any rate, it is a better starting point than much of what has come after to refute it.

Walter Benjamin was one of the first thinkers to try to think through how capitalism was altering the way we experience visual art. The collection *The Work of Art in the Age of Its Technological Reproducibility and Other Writings on Media* has all his best stuff. From the revolutionary tradition, Italian socialist Antonio Gramsci wrote extensively on problems of art and politics, and the most important nuggets are gathered in *Selections from Cultural Writings*.

Leon Trotsky's reflections on art never cease to startle on account of their ability to explode received wisdom about how radicals should approach art. *Literature and Revolution* is his classic treatise on the debates about popular art and the avant-garde in postrevolutionary Russia; *Problems of Everyday Life* contains invaluable reflections on what a revolutionary approach to art looks like in practice during truly revolutionary times; and *Art and Revolution* collects a variety of his interventions on cultural questions, mainly from his exile, including his classic manifesto "Towards a Free Revolutionary Art."

Finally, for those who seek primary sources, if you can find it, the slim volume *On Literature and Art* rounds up all of Marx and Engels's sporadic reflections on the subject of culture and is a useful reference.

Acknowledgments

This book brings together so many different parts of my life that it is difficult even to begin to pull it all apart again and think of the people I need to thank specifically. I will try though.

Thanks, first of all, to William Powhida and Jennifer Dalton for helping to inspire the work in the first place—and to all the other artists whom I have met, all over the world, whose anger at injustice and passion for what they do make me still believe in it all.

Andrew Goldstein (then of *Artinfo*) and Walter Robinson (of the now-defunct *Artnet*) were editors of the long-ago first versions of many of the texts here. They let me get away with a lot and helped make me into the writer I am. I also have to thank my coworkers at *Artinfo*, past and present, whose good spirits always kept my mood up, even through the most dispiriting periods.

Kiarina Kordela was my first mentor and remains my most demanding intellectual inspiration (my crack about "academic Marxists and postmodernists" is not about you, Kiarina!). Grant Mandarino, an old friend and valued colleague, has been a help in finding the straightest way through complex intellectual terrain.

I am grateful to all my friends and comrades in the Campaign to End the Death Penalty, the Campaign to End the New Jim Crow, and the International Socialist Organization for their patience at my absence as I made the long and solitary trip to the end of this project.

Thanks to Anthony Arnove, Julie Fain, and the Haymarket team for their interest, support, and patience. Thanks also to my editor Annie Zirin, who has spent too much of her life poring over my essays—on top of pursuing her own art! And thanks to Dao X. Tran and Sarah Grey for their vigilance in catching errors.

And, finally, because I could never say it too many times: Thanks to my parents and my sister, who have always believed in and supported me, even my craziest ideas.

Notes

Introduction

1. Terry Eagleton, *Why Marx Was Right* (New Haven, CT: Yale University, 2011), 98.

One: Art and Class

1. Damien Cave, "Tweaking the Big-Money Art World on Its Own Turf," *New York Times*, December 6, 2009, www.nytimes.com/2009/12/07/arts/design/07powhida.html.
2. Ibid.
3. Sarah Thornton, "Top 10 Reasons NOT to Write about the Art Market," *TAR Magazine* (Fall 2012): 82–83.
4. Quoted in Edward Helmore and Paul Gallagher, "Doyen of American Critics Turns His Back on the 'Nasty, Stupid' World of Modern Art," *Observer*, October 27, 2012, www.guardian.co.uk/artanddesign/2012/oct/28/art-critic-dave-hickey-quits-art-world.
5. Charles Saatchi, "The Hideousness of the Art World," *Guardian*, December 2, 2011, www.guardian.co.uk/commentisfree/2011/dec/02/saatchi-hideousness-art-world.
6. "The super-rich dominate the mainstream image of the art market, just as they do much to control the political agenda. Yet huge and diverse realms lie beyond the culture and the politics of this tiny elite. The years of the art boom were also those of social media, as millions started to show their photographs, videos, writings and art online. Many of them found that it is not so hard to make things that look like contemporary art. Another reflection—complex, contradictory, vulgar and popular, and in some respects less desolating—lies there." Julian Stallabrass, "A Sad Reflection on the Art World," *Art Newspaper*, December 2012, www.theartnewspaper.com/articles/A+sad+reflection+on+the+art+world/28099.
7. Jerry Saltz, "The 2006 Revue," *Artnet*, December 22, 2006, www.artnet.com/magazineus /reviews/robinson/robinson12–22–06.asp.
8. See Theodor W. Adorno and Max Horkheimer, *Dialectic of Enlightenment*, trans. John Cumming (New York: Continuum Publishing, 1972).
9. Theodor Adorno, *Prisms*, trans. Shierry and Samuel Weber (London: Neville Spearman, 1967), 32.
10. Martin Jay, *The Dialectical Imagination: A History of the Frankfurt School and the Institute of Social Research, 1923–1950* (Berkeley and Los Angeles: University of California Press, 1996), 44.
11. Michael Hardt, "Immaterial Labor and Artistic Production," *Rethinking Marxism* 17, no. 2 (April 2005): 176.

12. Michael Hardt, "Production and the Distribution of the Common," in *Being an Artist in Post-Fordist Times*, ed. Pascal Gielen and Paul De Bruyne (Rotterdam: NAi Publishers, 2009), 52.

13. See John Parker, "Burgeoning Bourgeoisie," *Economist*, February 12, 2009, www.economist.com/node/13063298?story_id=13063298&source=hptextfeature.

14. Michael Zweig, *The Working Class Majority: America's Best Kept Secret* (Ithaca and London: ILR Press, 2000), 11.

15. Ibid., 4.

16. To my knowledge, however, there has not been much work done systematically using the Marxist theory of class to understand the position of visual artists. John Molyneux mentions the theory briefly in a footnote to his fine pamphlet *Rembrandt and Revolution* (London: Redwords, 2001), 55: "Impressionistic evidence suggests that in the capitalist epoch most artists came from a middle to lower middle class background (though in the 20th century there has been a significant working class minority coming through the art colleges), but it is important to understand that the objective class position of the large majority of artists, whatever their background, is petty bourgeois in that predominantly they are self-employed or small employers selling, not their labour power, but the products of their labour where possible to the rich."

17. Zweig, *Working Class Majority*, 16.

18. "As the conscious representative of this movement, the possessor of money becomes a capitalist. His person, or rather his pocket, is the point from which the money starts and to which it returns. The expansion of value, which is the objective basis or main-spring of the circulation M-C-M, becomes his subjective aim, and it is only in so far as the appropriation of ever more and more wealth in the abstract becomes the sole motive of his operations, that he functions as a capitalist, that is, as capital personified and endowed with consciousness and a will. Use-values must therefore never be looked upon as the real aim of the capitalist; neither must the profit on any single transaction. The restless never-ending process of profit-making alone is what he aims at. This boundless greed after riches, this passionate chase after exchange-value, is common to the capitalist and the miser; but while the miser is merely a capitalist gone mad, the capitalist is a rational miser. The never-ending augmentation of exchange-value, which the miser strives after, by seeking to save his money from circulation, is attained by the more acute capitalist, by constantly throwing it afresh into circulation." Karl Marx, *Capital*, Volume 1, trans. Ben Fowkes (London: Penguin, 1976), 254.

19. Marx, *Capital*, Volume 1, 257.

20. Erik Hurst and Benjamin Wild Pugsley, *What Do Small Businesses Do?* (Washington, DC: Brookings Institution, August 2011), www.brookings.edu/~/media/Files/Programs/ES/BPEA/2011_fall_bpea_papers/2011_fall_bpea_conference_hurst.pdf.

21. Zweig, *Working Class Majority*, 37.

22. "Self-employed artists' careers display most of the attributes of the entrepreneurial career form: the capacity to create valued output through the production of works for sale; the motivation for deep commitment and high productivity associated with their occupational independence (deriving from the capacity to control their own work, a strong sense of personal achievement through the production of tangible outputs and the ability to set their own pace); and a high degree of risk-taking, as shown by the highly skewed distribution and high variability of earnings." Pierre-Michel Menger, "Artistic Labor Markets," in *The Handbook of the Economics of Art and Culture*, ed. Victor A. Ginsburgh and David Throsby (Amsterdam: North-Holland, 2006), 774.

23. The exact total of people who make their living as visual artists is unclear, since the "fine

artist" category lumps together "art directors" and "animators" with "painters" and "sculptors." National Endowment for the Arts, "NEA Research Note #105: Artists and Arts Workers in the United States," October 2011, www.nea.gov/research/Notes/105.pdf.

24. Some 212,236 workers were identified as belonging to the vague category that includes "art directors; craft artists; painters, sculptors, and illustrators; multimedia artists; animators," ibid., 4–5.

25. Norman Potter, "Is a Designer an Artist?," in *Design and Art*, ed. Alex Coles (London and Cambridge: Whitechapel and MIT Press, 2007), 32.

26. John Schmitt and Nathan Lane, "An International Comparison of Small Business Employment," Center for Economic and Policy Research, August 2009, www.cepr.net/documents/publications/small-business-2009–08.pdf.

27. "Ostensibly founded to take aggressive action in 'meeting outside attacks that are unjust,' to 'promote harmony and solidarity among the membership,' and a host of other vague, lofty goals, the Academy [of Motion Picture Arts and Sciences] managed and effectively postponed the impending unionization of Hollywood actors, writers, and directors. Stagehands, electricians, and other crewmembers had been unionized several months earlier in the Studio Basic Agreement. The Academy's members arbitrated labor contracts, but that was only the most direct manifestation of their management role. In order to defer the unionization of the Hollywood workforce, the Academy took several steps to define film industry jobs as skilled artistry rather than labor. The ultimate goal of the Academy was to oversee the Hollywood workforce from training to retirement, and the most public and disarming sign of this process was the establishment of the Academy Awards in 1929." Peter Decherney, *Hollywood and the Culture Elite: How the Movies Became American* (New York: Columbia University Press, 2006), 69.

28. Hollis Frampton, "Letter to Donald Richie," January 7, 1973, www.wageforwork.com/media/files/d663e7877e02c5506c6833ddabb49c19.pdf.

29. Ibid.

30. W.A.G.E., "W.A.G.E. Survey Report Summary," April 2012, www.wageforwork.com/resources/4/w.a.g.e.-survey-report-summary.

31. "It looks like larger organizations and museums were 10 percent more likely not to pay an artist fee than small- to medium-sized organizations. While 10 percent isn't a significant difference, the fact that larger organizations were not more likely to pay is significant, because we assume that larger institutions have greater means than smaller ones, and would therefore be more able to pay fees. The conclusion one might draw from this is that it's not a matter of being able but is instead a matter of being willing." W.A.G.E., interviewed by Kyle Chayka, "Advocacy Group W.A.G.E. on What Its First Survey Tells Us about How Artists Are Treated in NYC," *Artinfo*, April 27, 2012, www.artinfo.com/news/story/801870/advocacy-group-wage-on-what-its-first-survey-tells-us-about-how-artists-are-treated-in-nyc.

32. Frampton, "Letter to Donald Richie."

33. Dana Melamed, quoted in Rachel Corbett, "Can a Beefed Up Law Protect New York Artists from Deadbeat Dealers?," *Artinfo*, October 17, 2012, www.artinfo.com/news/story/834308/can-a-beefed-up-law-protect-new-york-artists-from-deadbeat.

34. See Anny Shaw, "Why Artists Must Put Pen to Paper," *Art Newspaper: Art Basel Miami Beach Daily Edition*, June 14, 2012, www.theartnewspaper.com/fairs/Art-Basel/2012/3.pdf.

35. The coalition was formed in 1969 when kinetic artist Takis challenged the Museum of Modern Art's right to show an example of his art without his approval. For a capsule history,

see Julia Bryan-Wilson, *Art Workers: Radical Practice in the Vietnam War Era* (Berkeley and Los Angeles: University of California Press, 2009).

36. Shane Ferro, "As Congress Ponders a Resale Royalties Act, a Blow by Blow of the Fight So Far," *Artinfo*, October 2, 2012, www.artinfo.com/news/story/830335/as-congress-ponders-a-resale-royalties-act-a-blow-by-blow-of.

37. Karl Marx, "Estranged Labour?," in *Economic and Philosophical Manuscripts of 1844*, trans. Martin Mulligan (Moscow: Progress Publishers, 1959), www.marxists.org/archive/marx/works/1844/manuscripts/labour.htm.

38. It is, in fact, a part of Maurizio Lazzarato's original definition of the concept: "The production of software is an explicit example of so-called 'immaterial production' and is a good case study for the ways in which manual and intellectual labour are entwined—combined technical and creative skills." Maurizio Lazzarato, "Immaterial Labour," in *Radical Thought in Italy*, trans. Paul Colilli and Ed Emory, ed. Paolo Virno and Michael Hardt (Minneapolis: University of Minnesota Press), 132–46.

39. Tom Chatfield, "Videogames Now Outperform Hollywood Movies," *Guardian*, September 26, 2009, www.guardian.co.uk/technology/gamesblog/2009/sep/27/videogames-hollywood.

40. Anonymous, "EA: The Human Story," ea_spouse, LiveJournal, November 10, 2004, http://ea-spouse.livejournal.com/274.html.

41. Tim Surette, "EA Settles OT Dispute, Disgruntled 'Spouse' Outed," *Gamespot*, April 26, 2006, www.gamespot.com/news/6148369.html.

42. Artists of SpiUnion, interviewed by Amid Amidi, "Exclusive: Interview with the Artists Who Demand Better Working Conditions at Sony Pictures Imageworks," *CartoonBrew*, April 11, 2012, www.cartoonbrew.com/ideas-commentary/exclusive-interview-with-the-artists-who-demand-better-working-conditions-at-sony-pictures-imageworks-60860.html.

43. "Dare to Know: Michelle Raimo Kouyate Works Hard, Plays Hard," *Women Working*, May 15, 2012, www.womenworking.com/dare-know-michelle-raimo-kouyate-works-hard-plays-hard.

44. Anonymous, "Family Time?," *SPIUnion Blog*, May 16, 2012, http://spiunion.wordpress.com/2012/05/16/family-time/.

45. Adam Turl, "Is the U.S. Becoming Post-Industrial?," *International Socialist Review*, March–April 2007, www.isreview.org/issues/52/postindustrial.shtml.

46. Karl Marx and Friedrich Engels, "Manifesto of the Communist Party," in *The Marx & Engels Reader*, ed. Robert C. Tucker (New York and London: W.W. Norton & Co.), 482.

47. Karl Marx, "The Labour of Handicraftsmen and Peasants in Capitalist Society," in *Theories of Surplus Value*, trans. Renate Simpson, ed. S. Ryazanskaya (Moscow: Progress Publishers), www.marxists.org/archive/marx/works/1863/theories-surplus-value/add1.htm.

48. "Ironically enough, although most of the artists and professionals in the cultural sector are ideologically left-oriented and prone to advocate egalitarianism in society, art worlds have developed an insuperable engine to rank artists by quality level and market value, to select and signal the best works out of an ocean of products through winner-take-all tournaments and endless competitive comparisons, to let the whirl of fads and fashions promote or eliminate aspiring superstars, to celebrate skyrocketing and ephemeral celebrity as well as to provide civilization with Pantheons of eternal values." Pierre-Michel Menger, "Artistic Labor Markets," in *Handbook of the Economics of Art and Culture*, 804.

49. Lucy Lippard, "The Pink Glass Swan: Upward and Downward Mobility in the Art World," in *The Pink Glass Swan: Selected Feminist Essays on Art* (New York: New Press, 1995), 117–18.

50. Karl Marx, *The Eighteenth Brumaire of Louis Bonaparte* (New York: International Publishers, 1963), 124.

51. Quoted in Bryan-Wilson, *Art Workers*, 217.

52. See Lucy Lippard, "The Art Workers' Coalition: Not a History," *Studio International*, November 1970, 171–74.

53. "In 1971, riding the coattails of the AWC, the Professional and Administrative Staff Association of MoMA was born. Art Strike and AWC veterans gave them organizational tips when they decided to go on strike." Bryan-Wilson, *Art Workers*, 218.

Three: What Good Is Political Art in These Times?

1. "We must still put off all large-scale construction. The originators of gigantic projects, men like Tatlin, are given involuntarily a respite for more thought, for revision, and for radical reexamination. But one must not imagine that we are planning to repair old pavements and houses for decades to come. As soon as a surplus will come after the most urgent and acute needs of life are covered, the Soviet state will take up the problem of gigantic constructions that will suitably express the monumental spirit of our epoch." Leon Trotsky, *Literature and Revolution*, trans. Rose Strunsky, ed. William Keach (Chicago: Haymarket Books, 2005), 200.

2. Gijs Van Hensbergen, *Guernica: The Biography of a Twentieth-Century Icon* (New York: Bloomsburg, 2005), 95.

3. Hélio Oiticica, "Position and Program," in *Conceptual Art: A Critical Anthology*, ed. Alexander Alberro and Blake Stimson (Cambridge: MIT Press, 2000), 6.

4. Quoted in Carlos Basualdo, "Tropicália: Avant-garde, Popular Culture, and the Culture Industry in Brazil (1967–1972)," http://tropicalia.com.br/en/eubioticamente-atraidos/visoes-estrangeiras/tropicalia-vanguard.

5. In a 1968 letter to Guy Brett, shortly after the phenomenal ascent of *Tropicália*, Oiticica wrote: "One thing, crazy but in a sense very important to me, is that my ideal of 'Tropicália' (the project I made last year in the MAM, and that will be going to London in July, that was a kind of ludic garden, with that anthropophagic penetrable, and all) became the most talked about thing here, giving 'Tropicalism' an origin in all Brazilian culture. But really what influenced it to be as it is (Tropicália is a word here, today, that most often means 'psychedelic' or 'hippie,' and I think it will soon be all over the world to characterize a 'Brazilian thing'), was that a very well known popular composer (today an idol here) Caetano Veloso, wrote a song called 'Tropicália.'" Quoted in Basualdo, "Tropicália."

6. Quoted in Carlos Basualdo, "Tropicália."

7. Basualdo, "Tropicália."

8. Peter Schjeldahl, "Festivalism," *New Yorker*, July 5, 1999.

9. Gergana Koleva, "First Prize: A Chance to Stay," *New York Times*, April 23, 2006, www.nytimes.com/2006/04/23/arts/design/23koleva.html.

10. For my review of *AsylumNYC*, see Ben Davis, "Inane Asylum," *Artnet*, May 4, 2006, www.artnet.com/magazineus/reviews/davis/davis5-4-06.asp.

11. Gladstone Gallery, "Thomas Hirshhorn, 'Superficial Engagement,'" press release, January 2006, www.gladstonegallery.com/release_hirschhorn_2006.htm.

12. Susan Sontag, *Regarding the Pain of Others* (New York: Picador, 2003), 13.

13. Victor Burgin, interviewed by Hilde Van Gelder, "Art and Politics: A Reappraisal," *Eurozine*, www.eurozine.com/articles/2010–07–30-burgin-en.html.

14. Martha Rosler, Reply to Questionnaire on the Iraq War, *October* 123 (Winter 2008), 130.

Four: Collective Delusions

1. See David Graeber, *Debt: The First 5,000 Years* (New York: Melville House, 2011).

2. See Yates McKee, "The Arts of Occupation," *Nation*, December 11, 2011, www .thenation.com/article/165094/arts-occupation#.

3. Anthony Iles and Marina Vishmidt, "Work, Work Your Thoughts, and Therein See a Siege," in *Communization and Its Discontents: Contestation, Critique, and Contemporary Struggles*, ed. Benjamin Noys (London: Minor Compositions, 2011), 133.

4. Blake Stimson and Gregory Sholette, "Introduction: Periodizing Collectivism," in *Collectivism After Modernism: The Art of Social Imagination After 1945*, ed. Blake Stimson and Gregory Sholette (Minneapolis: University of Minnesota Press, 2007), 1.

5. Jelena Stojanović, "Internationaleries: Collectivism, the Grotesque, and Cold War Functionalism," in Stimson and Sholette, *Collectivism After Modernism*, 18.

6. Jesse Drew, "The Collective Camcorder in Art and Activism," in Stimson and Sholette, *Collectivism After Modernism*, 97.

7. Okwui Enwezor, "The Production of Social Space as Artwork: Protocols of Community in the World of Le Groupe Amos and Huit Facettes," in Stimson and Sholette, *Collectivism After Modernism*, 224.

8. On some level Stimson and Sholette seem to know this, beginning their account by denouncing a number of contemporary art collectives like Dearraindrop, Gelatin, and the Royal Art Lodge—none of them particularly political—as perverting the radical claims of collectivism. The more obvious conclusion is that artistic collectivism has no specific radical claim. Blake Stimson and Gregory Sholette, "Preface," in Stimson and Sholette, *Collectivism After Modernism*, xii–xiii.

9. Martin Puchner, *Poetry of the Revolution: Marx, Manifestos, and the Avant-Gardes* (Princeton, NJ: Princeton University Press, 2006), 4.

10. Stimson and Sholette, "Introduction," 4–5.

11. Iles and Vishmidt, "Work, Work Your Thoughts," 134.

12. Sarah Ganz Blythe and Edward D. Powers, *Looking at Dada* (New York: Museum of Modern Art, 2006), 5.

13. Barry Bergdoll and Leah Dickerman, *Bauhaus 1919–1933: Workshops for Modernity* (New York: Museum of Modern Art, 2009), 50.

14. Vladimir Tatlin, "The Work Ahead of Us," *The Craft Reader*, ed. Glenn Adamson (London: Berg Publishers, 2010), 165.

15. As a general rule, radical Russian artists tailed public consciousness rather than led it: "The avant-garde had volunteered their professional skills to address the war when it seemed a positive experience, and they matched the public face of war in a different way once attitudes shift towards a more sober, 'real' understanding of the war in 1915." Aaron J. Cohen, *Imagining the Unimaginable: World War, Modern Art, and the Politics of Public Culture in Russia, 1914–1917* (Lincoln: University of Nebraska Press, 2008), 142.

16. Stimson and Sholette, "Introduction," 6.

17. See Karl Marx, "After the Revolution: Marx Debates Bakunin," in *Marx-Engels Reader*, ed. Tucker, 542–48.

18. Eric Kerl charts the evolution of anarchist thought over the twentieth century ("If classical anarchism called for the abolition of the capitalist state, contemporary anarchism attempts to resolve the problem of state power by going around it"), as well as providing a semi-comprehensive assessment of the strengths and weaknesses of a variety of contemporary

forms of anarchism (insurrectionary anarchism, post-leftism, social movement anarchism, class-struggle anarchism/anarcho-syndicalism, platformism). Eric Kerl, "Contemporary Anarchism," *International Socialist Review* 72 (July–August 2010), www.isreview.org/issues /72/feat-anarchism.shtml.

19. Hal Draper, *The Two Souls of Socialism*, 1966, www.marxists.org/archive/draper/1966/ twosouls/index.htm.

20. The full quote about modernist art practices is as follows: "Their task as artists was either to envision a radically new society, often in terms that resembled a monumental social design problem, or to represent the psychical consequence of the loss of a premodern collective human bond caused by the emergence of mass culture and new technologies." The former seems to be the interest of their political reading of modernist collectivism; how the latter—something like the antisocial tendencies of radical Dada—fits into their redemptive scheme of modernism is unexplored in the text. Stimson and Sholette, "Preface," 5.

21. Ibid., xii.

22. Leon Trotsky, *Literature and Revolution*, 34.

23. Stimson and Sholette, "Preface," xv.

24. Stimson and Sholette, "Introduction," 4.

25. Ibid., 13.

26. Speaking on the split in the Communist League, which came over whether or not to put faith in "determined bands of revolutionaries" or the masses, Marx said, "The minority . . . makes mere will the motive force of the revolution, instead of actual relations. Whereas we say to the workers: 'You will have to go through fifteen or twenty years of civil wars and international wars, not only in order to change extant conditions, but also in order to change yourselves and to render yourselves fit for political dominion,' you, on the other hand, say to the workers: 'We must attain to power at once, or else we may just as well go to sleep.'" Quoted in Draper, *Two Souls of Socialism*.

27. René Viénet, "The Situationists and the New Forms of Action Against Politics and Art," *Situationist International Anthology*, ed. and trans. Ken Knaab (Berkeley: Bureau of Public Secrets, 1989), 213–16.

28. McKenzie Wark, *The Beach Beneath the Street* (New York: Verso, 2011), 17.

29. Simon Ford, *The Situationist International: A User's Guide* (London: Black Dog Publishing, 2005), 157.

30. Brian Holmes, "Do-It-Yourself Geopolitics: Cartographies of Art in the World," in Stimson and Sholette, *Collectivism After Modernism*, 273.

31. Ibid., 290.

32. Stephen Duncombe, *Notes from Underground: Zines and the Politics of Alternative Culture* (Portland, OR: Microcosm Publishing, 2008), 203.

33. Holmes, "Do-It-Yourself Geopolitics," 279.

Five: How Political Are Aesthetic Politics?

1. Karen Beckman, "Telescopes, Transparency, and Torture: Trevor Paglen and the Politics of Exposure," *Art Journal* (Fall 2007), 62–67.

2. Ibid., 62.

3. Ben Davis, "Black Site Specific," *Artnet*, December 7, 2006, www.artnet.com/magazineus /reviews/davis/davis12-7-06.asp.

4. Beckman, "Telescopes, Transparency, and Torture," 67.

5. From an account by Paglen about his trip to Afghanistan to uncover the location of CIA torture sites: "There have been at least three or four black sites in and around Kabul, Afghanistan. The one we definitely knew the location of was the Salt Pit. We found a driver who would take us out there. When you drive out to the Salt Pit, you have these wide plains; it's very isolated. We were driving up and there was a traffic jam, which was a goat herder with a bunch of goats on the road. As we're waiting, he turns around and he's wearing a hat that says KBR—Kellogg Brown and Root (a subsidiary of Halliburton). As we drove farther, we saw a huge complex with a big wall around it. There are signs in English saying this is an Afghan military facility, no entrance. There's then a checkpoint. We were stopped. We told the guards we were turning around and going back to Kabul. We asked what goes on there and the guard said he didn't know exactly. Then we asked if there were Americans there. And he said, 'Oh yes, there's lots of Americans here.' And we saw some Americans sitting on a Humvee." Trevor Paglen, interviewed by Onnesha Roychoudhuri, "Secret CIA Prisons in Your Backyard," *Alternet*, www.alternet.org/story/41923.

6. See A. C. Thompson, "Spying on the Government," *San Francisco Bay Guardian*, May 4, 2005, www.sfbg.com/39/31/cover_spying_on_the_government.html.

7. Beckman, "Telescopes, Transparency, and Torture," 66.

8. A scant one page into their introduction, editors Benjamin Buchloh and Rachel Churner offer the following gem: US students, they declared ominously, had "adopted, by and large, a pervasive Untertan mentality." In a footnote, they helpfully explain, "We are using this untranslatable German term because of its historical precision in identifying the authoritarian personality of the fully subjected subject and its servility to the authority of the State, as Heinrich Mann portrayed it in his 1914 novel of that title." If you really want popular relevance, you might want to cut back on the use of untranslatable German terms. *October* 123 (Winter 2008), 4.

9. Christopher Bedford, Reply to Questionnaire on the Iraq War, *October* 123 (Winter 2008), 22.

10. Retort, "Afflicted Powers: The State, the Spectacle and September 11," *New Left Review* 27 (May–June 2004), http://newleftreview.org/A2506.

11. Bedford, Reply to Questionnaire, 20.

12. Beckman, "Telescopes, Transparency, and Torture," 65.

13. Trevor Paglen, *Blank Spots on the Map: The Dark Geography of the Pentagon's Secret World* (New York: Penguin, 2009).

14. Francesco Bonami, "For the Moment," *T Magazine*, June 8, 2009, http://tmagazine.blogs.nytimes.com/2009/06/08/for-the-moment-francesco-bonami-2/.

15. Guillermo Calzadilla, interviewed by Andrew Goldstein, "Bound for Glory: Cavorting Athletes and Oblique Politics at the Debut of Allora & Calzadilla's U.S. Pavilion in Venice," *Artinfo*, June 2, 2011, www.artinfo.com/news/story/37799/bound-for-glory-cavorting-athletes-and-oblique-politics-at-the-debut-of-allora-calzadillas-us-pavilion-in-venice/.

16. Jennifer Allora, interviewed by Ben Davis, "Striking Political Notes: A Q&A with Performance Artist Duo Allora & Calzadilla," *Artinfo*, May 27, 2011, www.artinfo.com/news/story/36584/striking-political-tones-a-qa-with-performance-artist-duo-allora-calzadilla.

17. Ibid.

18. David Mees, quoted in Christopher Livesay, "Art as 'Smart Power' at the Venice Biennale," *All Things Considered*, National Public Radio, June 2, 2011, www.npr.org/2011/06/02/136897424/a-tank-an-organ-and-smart-power-at-the-venice-biennale.

19. "But the development and expansion of the particular group are conceived of, and presented, as being the motor force of a universal expansion, of a development of all the 'na-

tional' energies. In other words, the dominant group is coordinated concretely with the general interests of the subordinate groups, and the life of the State is conceived of as a continuous process of formation and superceding of unstable equilibria (on the juridical plane) between the interests of the fundamental group and those of the subordinate groups—equilibria in which the interests of the dominant group prevail, but only up to a certain point, i.e., stopping short of narrowly corporate economic interest." Antonio Gramcsi, *Selections from the Prison Notebooks*, ed. and trans. by Quintin Hoare and Geoffrey Nowell Smith (New York: International Publishers, 1971), 182.

20. Jacques Rancière, interviewed by Fulvia Carnevale and John Kelsey, "Art of the Possible," *Artforum*, March 2007, 258–59.

21. Bill Horrigan, "Some Other Time," *Chris Marker: Staring Back* (Columbus, OH: Wexner Center for the Arts, 2007), 137–50.

22. Rancière, "Art of the Possible," 266.

23. Other aspects of Marker's Blum show only reconfirmed the overall effect. Alongside the montage of protest stills, another section paired images drawn from various documentary works, mainly faces of people staring soulfully at the camera. The accompanying texts make it clear that the individual images have an often-overwhelming historical weight for Marker, but are here paired according to abstract formal rhymes or personal associations instead of context. For instance, a figure identified by the text as a worker in an occupied factory in Allende's Chile, proudly brandishing a tool—an image haunted by the knowledge that the man may well have been killed or tortured shortly after by Pinochet's goon squad—is paired with a Korean archer, holding his bow, identified as having just won a contest. The nonlinear, free-associative installation strategy is thus a device serving as a painkiller, dulling the trauma of historical knowledge.

Six: Art and Inequality

1. Isabelle Graw, *High Price: Art Between the Market and Celebrity Culture* (Berlin: Sternberg Press, 2011), 10.

2. Diana Crane, *The Transformation of the Avant-Garde: The New York Art World, 1840–1985* (Chicago: University of Chicago Press, 1987), 2.

3. "Louvre in Paris Tops Most Visited Art Venue Poll," *British Broadcasting Service*, March 22, 2012, www.bbc.co.uk/news/entertainment-arts-17472587.

4. According to an analysis of data by economists Roberto Cellini and Tiziana Cuccia, museums, however, are not the drivers of increased tourism, but have merely benefited from it: "The available literature on specific successful cases (generally superstar museums, which represent a minority among museums) has perhaps generated the misleading idea that museums can be primary engines for tourism and hence for growth." Roberto Cellini and Tiziana Cuccia, "Museum & Monument Attendance and Tourism Flow: A Time Series Analysis Approach," Munich Personal RePEc Archive, November 28, 2009, http://mpra.ub.uni-muenchen.de/18908.

5. Crane, *Transformation of the Avant-Garde*, 127.

6. "It appears that a substantial share of the total attendance increase at museums between 1992 and 2002 was due to the popularity of blockbuster exhibits. Indeed, since the total fraction of the population attending museums hardly increased during this period, these data suggest that a large share of those visiting blockbuster exhibits were, in fact, return attendees." Kevin F. McCarthy, Elizabeth H. Ondaatje, Arthur Brooks, and András Szántó, *A Portrait of the Visual Arts: Meeting the Challenges of a New Era* (Santa Monica: RAND Corporation, 2005), 32.

7. See "Met Hits Record Attendance, While MoMA's Drops," *Bloomberg News*, January 12, 2012, www.bloomberg.com/news/2012-01-12/moma-attendance-falls-met-museum-rises-driven-by-blockbusters.html.

8. Attendance at the Brooklyn Museum was 585,000 in 1998, but just 326,000 in 2009. Robin Pogrebin, "Brooklyn Museum's Populism Hasn't Lured Crowds," *New York Times*, June 14, 2010, www.nytimes.com/2010/06/15/arts/design/15museum.html.

9. Growth between 1982 and 2002 was due to a rising population and higher education levels, while "holding education and population constant, the overall rate at which individuals of different levels attended museums actually declined—primarily because of slightly lower rates of participation among the less educated." Kevin F. McCarthy et al, A *Portrait of the Visual Arts*, 33–34.

10. The exact estimated figures for art attendance in metropolitan areas show a decline from 33 million visitors to 26.7 million in this period. Roland J. Kushner and Randy Cohen, *National Arts Index 2010: An Annual Measure of the Vitality of Arts and Culture in the United States: 1998–2009* (New York: Americans for the Arts, 2010), 54, 74, www.americansforthearts.org/pdf/information_services/art_index/NAI_report_w_cover_opt.pdf.

11. An article in *Pacific Standard* cites the research of Mark J. Stern on the decline of both so-called "cultural omnivores," arts lovers who sample a wide and diverse variety of events, and "highbrows," who limit themselves to traditionally elite cultural offerings like opera and ballet: "The percentage of population classified as omnivores has dropped dramatically, from 15 percent in 1982 to 10 percent in 2008. The highbrow population has also declined, from just over 7 percent in 1982 to 5 percent in 2008. These numbers matter enormously, since together, the two groups make up 'more than half of all respondents that reported any type of arts attendance,' he writes." Tom Jacobs, "Dip in Arts Attendance Tied to Decline of the Omnivore," *Pacific Standard*, March 14, 2011, www.psmag.com/culture-society/dip-in-arts-attendance-tied-to-decline-of-the-omnivore-29046/.

12. Betty Farrell, *Demographic Transformation and the Future of Museums* (Washington, DC: The AAM Press, 2010), 12, http://culturalpolicy.uchicago.edu/publications/Demographic-Transformation.pdf.

13. Clare McAndrew, "An Introduction to Art and Finance," in *Fine Art and High Finance: Expert Advice on the Economics of Ownership* (New York: Bloomberg Press, 2010), 5.

14. The original figures are $43 billion total, with $21.9 billion to dealers and $21.1 billion to auction houses. I am using the currency conversion from the time the report was issued. Clare McAndrew, *The Role of the Art and Antiques Dealer: An Added Value* (Paris: CINOA, 2011), 15, www.cinoa.org/page/2862.

15. "The idea, luxury executives explained, was to 'democratize' luxury, to make luxury 'accessible.' It all sounded so noble. Heck, it sounded almost communist. But it wasn't. It was as capitalist as could be: the goal, plain and simple, was to make as much money as heavenly possible." Dana Thomas, *Deluxe: How Luxury Lost Its Luster* (New York: Penguin, 2007), 9.

16. "The combination of a surging stock market and the proliferation of digital millionaires, real estate tycoons, and entertainment stars (whose incomes are in the top one percent of all households) created an unprecedented increase in the number of potential art buyers." McCarthy et al., *A Portrait of the Visual Arts*, 39.

17. William N. Goetzmann, Luc Renneboog, and Christophe Spaenjers, "Art and Money," Yale ICF Working Paper 09–26; TILEC Discussion Paper 2010–002; CentER Discussion Paper Series 2010–08 (April 28, 2013), http://papers.ssrn.com/s013/papers.cfm?abstract_id=1501171.

18. See Molyneux, *Rembrandt and Revolution*, 47–52.

19. "Value is concentrated in a small number of high-value transactions, and in recent years, the majority of these are in the fine art sector. There are a very large number of low-value transactions that take place in the market, and although individually less significant, these make up a substantial portion of the market's overall turnover." McAndrew, "Introduction to Art and Finance," 10.

20. Thierry Hoeltgen, Adriano Picinati di Torcello, and Anders Petterson, "Art and Finance Report 2011," *Deloitte Luxembourg and ArtTactic*, December 13, 2011, 8, http://www.deloittelux-library.com/artandfinance/2011/lu_en_wp_artfinancereport_29112011.pdf.

21. "49% of the art advisors said their clients were driven by the potential investment returns, 39% said portfolio diversification and 29% said art as a hedge against inflation. The emotional value associated with buying art was still the primary motivation given by 84% of the art advisors." Hoeltgen, di Torcello, and Petterson, "Art and Finance Report 2011," 26.

22. "Collectors are bulk-buying so many contemporary works that their various mansions are inadequate to house them all. But rather than leave extensive surpluses unseen in storage, they are choosing to share their hoards with the public. As the ultimate status symbol for the super-rich, the private museums even have a new label—'ego-seums.'" Dalya Alberge, "Art Collectors Build Museums to Let Public See Private Hoards," *Guardian*, July 10, 2010, www.guardian.co.uk/artanddesign/2010/jul/11/modern-art-collectors-private-museum.

23. McAndrew, "Introduction to Art and Finance," 5.

24. Jennifer Fishbein, "Contemporary Art Tops the Auction Charts," *Businessweek*, April 8, 2008, www.businessweek.com/globalbiz/content/apr2008/gb2008048_515555.htm.

25. Myrna M. Breitbart and Cathy Stanton, "Touring Templates: Cultural Workers and Regeneration in Small New England Cities," *Tourism, Culture and Regeneration* (Oxfordshire: CABI, 2006), 115.

26. Bruno S. Frey and Stephan Meier, "The Economics of Museums," in *Handbook of the Economics of Art and Culture*, ed. Victor A. Ginsburgh and David Throsby (Amsterdam: North-Holland, 2006), 1024.

27. Judith H. Dobrzynski, "If You Build It, Will They Come?," *Art+Auction*, July 2007, 67.

28. Ibid.

29. Quoted in ibid., 69.

30. Quoted in ibid., 70.

31. See also Robin Pogrebin, "In the Arts, Bigger Buildings Might Not Be Better," *New York Times*, December 11, 2009, www.nytimes.com/2009/12/12/arts/design/12build.html.

32. See Dave Zirin, *Bad Sports: How Owners Are Ruining the Games We Love* (New York: New Press, 2012).

33. McCarthy et al., *Portrait of the Visual Arts*, 41.

34. Frey and Meier list five characteristics that determine whether institutions are "superstars": they are a "must" for tourists; have a large number of visitors; feature world-famous works of art; have an iconic building; and are commercialized via their gift shops and restaurants and by being woven into the local economy. "Superstar museums are able to exploit economies of scale by reaching out to a large number of people. They are not only featured in newspapers, on the radio and TV, but can raise enough money to produce their own videos and virtual museums. These sorts of costs are essentially independent of the number of consumers and therefore favour the major museums, because the set-up costs are normally too high for smaller museums." Frey and Meier, "Economics of Museums," 1036–37.

35. McCarthy et al., *Portrait of the Visual Arts*, 97.

36. "Museum budgets totaled some $4 billion at the end of the first decade of the twenty-first century, but this money was not evenly dispersed. For example, in the late years of the first decade of the 2000s, just 8 percent of museums had annual budgets of $1 million or more, 57 percent operated with $100,000 or less, and 38 percent had $50,000 or less to spend. Using budget size as an indicator, most museums in the United States are generally small institutions. When budget size is adjusted to the differing operation costs of museum types (e.g., a science museum needs a $5 million budget to be considered large, but a nature center requires only $800,000), 80 percent of museums could be described as small." "Museums and Art Galleries," Highbeam Research, accessed February 3, 2013, http://business.highbeam.com/industry-reports/business/museums-art-galleries.

37. McCarthy et al., *Portrait of the Visual Arts*, 99.

38. Ibid., 100.

39. Kushner and Cohen, *National Arts Index 2010*, 8.

40. Ibid., 11.

41. "Art sales internationally are split between the two main types of traders in the market: dealers and auction houses. Although the relative market shares of these two sides of the trade varies over time, it has not shifted significantly from a fifty-fifty split (by value) in the last decade, although it does vary more dramatically in national markets." McAndrew, "Introduction to Art and Finance," 10.

42. Graw, *High Price*, 20.

43. McAndrew, "Role of the Art and Antiques Dealer," 15.

44. Conversation with the author.

45. McAndrew, "Role of the Art and Antiques Dealer," 53.

46. Ibid., 41.

47. Quoted in Peter Schjeldahl, "The Temptations of the Fair," *New Yorker*, December 25, 2006, www.newyorker.com/archive/2006/12/25/061225craw_artworld.

48. McAndrew, "Role of the Art and Antiques Dealer," 18.

49. Noah Horowitz, *Art of the Deal: Contemporary Art in a Global Financial Market* (Princeton, NJ: Princeton University Press, 2011), 15.

50. McAndrew, "Role of the Art and Antiques Dealer," 30.

51. Ibid.

52. Pierre-Michel Menger, "Artistic Labor Markets: Contingent Work, Excess Supply and Occupational Risk Management," in *Handbook of the Economics of Art and Culture*, 769.

53. "Evidence of sustained growth in artistic employment over recent decades is amply documented by several surveys and Census sources, and trends are quite similar in most advanced countries. For instance, in France, over the period 1982–1999 the number of artists grew at a rate of 98 percent; in the USA, from 1980 to 2000, the rate of increase was 78 percent. In both cases, the growth in numbers of artists was much higher than for the civilian labor force." Menger, "Artistic Labor Markets," 767.

54. McCarthy et al., *Portrait of the Visual Arts*, xvi.

55. Dan Thomson, *The $12 Million Stuffed Shark: The Curious Economics of Contemporary Art* (London: Aurum Press, 2008), 59.

56. "Numerous studies have shown that an increase in the number of artists may be far from corresponding to a similar increase in the level of activity. If there is more work but an ever more rapidly growing number of individuals, a fiercer competition takes place that implies higher inequalities in access to employment, more variability in the level and schedule of activity and on the whole work rationing for those who share the labor pie

and cycle more often from work to unemployment or from arts work to arts-related or non-arts work." Menger, "Artistic Labor Markets," 768.

57. "Aspiring artists are now highly likely to ascend through the art school and university art department route, gaining both artistic training and a support network upon graduation. Emerging visual artists now pass through the early steps in their careers of training and developing a body of work at a much faster pace than previous eras, cycling through the world of discourse at a higher rate. For some artists, this newly accelerated pace means much earlier financial success than prior generations of visual artists. For others it means they may ascend and descend based on a few years of studio experience and a limited body of work." McCarthy et al., *Portrait of the Visual Arts*, 51–52.

58. The Savannah College of Arts and Design alone grew from enrolling five hundred students in the early 1980s to more than ten thousand in 2010. "Savannah College of Art and Design," *New Georgia Encyclopedia*, www.georgiaencyclopedia.org/nge/Article.jsp?id=h-1055.

59. Analyzing the successive art movements between 1940 and 1985, Diana Crane notes, "Virtually all artists in the study had attended college, university, or art school, but among the older cohorts fewer artists had either the funds or the inclination to meet the requirements for degrees." Crane, *Transformation of the Avant-Garde*, 10.

60. "Now, at the start of the twenty-first century, MFAs are ubiquitous and effectively devalued. A recent job search for a plum position at the University of North Carolina at Chapel Hill attracted almost 700 candidates, the vast majority of whom would have had MFAs. The degree, by itself, has come to be little more than a requirement for competition on the job market, somewhat akin to the requirement of a high school or college diploma. To compete, job candidates need to have the MFA and something else, such as an exhibition record or a second field of expertise." James Elkins, *Artists with PhDs: Debates about the New Studio Art Doctoral Degree* (Washington, DC: New Academia Publishing, 2009), iv.

61. On the claim that Occupy Wall Street was "started by artists," see Martha Schwendener, "What Does Occupy Wall Street Mean for Art?," *Village Voice*, October 19, 2011, www.villagevoice.com/2011–10–19/art/what-does-occupy-wall-street-mean-for-art/.

62. Neil De Marchi and Hans J. Van Miegroet, "The History of Art Markets," in *Handbook of the Economics of Art and Culture*, 103.

63. Ibid., 115.

64. For a demonstration of this theory in the period of art between 1940 and 1985, see Crane, *Transformation of the Avant-Garde*.

65. Bruce Altshuler, "Introduction," in *Salon to Biennial—Exhibitions That Made Art History: Volume I, 1863–1959* (New York: Phaidon, 2008), 12.

Seven: The Agony of the Interloper

1. Rirkrit Tiravanija's *Untitled 1992 (Free)* (1992).

2. Martin Creed's *Work No. 227: The Lights Going On and Off* (2000).

3. Jorge Pardo's *Untitled (Pleasure Boat)* (2005).

4. The rising importance of the MFA for success in the contemporary art world has been widely noted. Among New York artists, Diana Crane tracked the rising number of degrees among the representatives of successive movements. Crane, *Transformation of the Avant-Garde*, 10–11.

5. This, to its credit, is the explicitly argued point of Arthur Danto's famous "end of art" theory, which seeks to theorize the pluralism of contemporary art by saying that its precondition is that discourse and context have become absolutely determinate. I view this state of affairs as involving art being confined to its professional sphere rather than having

achieved absolute liberation. See Arthur Danto, "The End of Art," in *The Philosophical Disenfranchisement of Art* (New York: Columbia University Press, 1986), 115.

6. Images of *Marilyn*, complete with details, are available at Pappas's website, www.billypappas.com.

7. For an account of the development of the outsider art market, see Richard Polsky, *The Art Prophets: The Artists, Dealers, and Tastemakers Who Shook the World* (New York: Other Press, 2011), 81–102.

8. John Anderson, "Art Imitating Life, and Obsessively So," *New York Times*, July 24, 2005, www.nytimes.com/2005/07/24/movies/24ande.html.

9. Gregory Sholette, *Dark Matter: Art and Politics in the Age of Enterprise Culture* (London: Pluto Press, 2011), 1.

10. Ibid., 3.

11. Ibid., 5.

12. Ibid., 4.

13. Trotsky, *Literature and Revolution*, 196.

Eight: Beneath Street Art: The Beach

1. Steve Grody, *Graffiti L.A.: Street Styles and Art* (New York: Abrams, 2007), 251.

2. "Street art in museums and commercial art galleries loses much of its rebellious nature. I would be shocked if Art in the Streets reaches beyond anything but a gala celebration of the genre. An ominous sign is the name itself that ideally should have been titled 'Street Art in a Museum.'" Nicolas Lampert, "Street Art Blu's," JustSeeds.org, www.justseeds.org/blog/2011/01/street_art_blus_1.html.

3. Ben Davis, "To Mark Opening of 'Art in the Streets,' MOCA Director Jeffrey Deitch Pledges to Eradicate Actual Street Art," *Artinfo*, April 15, 2011, www.artinfo.com/news/story/37478/to-mark-opening-of-art-in-the-street-moca-director-jeffrey-deitch-pledges-to-eradicate-actual-street-art.

4. Richard Winton, "Graffiti Artist's Past Is Tagging Behind Him," *Los Angeles Times*, March 11, 2011, http://articles.latimes.com/2011/mar/15/local/la-me-0315-smear-20110315.

5. Roger Gastman and Caleb Neelon, *The History of American Graffiti* (New York: Harper Design, 2010), 380.

6. *Beautiful Losers*, DVD, dir. Aaron Rose and Joshua Leonard (Sidetrack Films, 2008).

7. "Revs and Cost had mass-produced stickers and Xeroxed flyers on almost every crosswalk box in the city between 1991 and 1995. Their level of coverage was unprecedented, and their irritation to the city changed clean-up policies, insuring that such domination could never be achieved again. Revs and Cost approached promoting themselves through stickers seemingly less as typical graffiti than as a brand. They used bold, readable, no-frills type. The technique may not have been that stylish, but it was very effective, earning Revs and Cost the distinction of being two of the only writers whose names were well known outside of the graffiti community. My approach definitely takes cues from Revs and Cost, as well as the worlds of advertising and propaganda." Shepard Fairey, "Sticker Art," ObeyGiant.com, www.obeygiant.com/essays/sticker-art.

8. "Every time I think I've painted something slightly original, I find out that Blek le Rat has done it, too, only Blek did it 20 years earlier." Quoted in Lee Coan, "Breaking the Banksy: The First Interview with the World's Most Elusive Artist," *Daily Mail*, June 13, 2008, www.dailymail.co.uk/home/moslive/article-1024130/Breaking-Banksy-The-interview-worlds-elusive-artist.html#ixzz2CGOxx60z.

9. Quoted in Jeff Chang, *Can't Stop Won't Stop: A History of the Hip-Hop Generation* (New York, St. Martin's Press, 2005), 162.

10. Gastman and Neelon, *History of American Graffiti*, 34–41.

11. *¡Palante Siempre Palante! The Young Lords*, DVD, dir. Iris Morales (P.O.V., 1996).

12. Chang, *Can't Stop Won't Stop*, 73.

13. Ibid.

14. See Norman Mailer, *The Faith of Graffiti* (New York: Harper Collins, 2009).

15. A similar dynamic of dialogue and distinction prevailed in the later-breaking scene in sprawling L.A., where an even more robust tradition of preexisting "cholo" gang graffiti reigned as a way to mark turf; the more artistically minded distinguished themselves by an ambition to go "all-city." Grody, *Graffiti L.A.*, 18.

16. Gastman and Neelon, *History of American Graffiti*, 23.

17. Grody, *Graffiti L.A.*, 259.

18. Randy Kennedy, "Early Graffiti Artist, TAKI 183, Still Lives," *New York Times*, July 22, 2011, www.nytimes.com/2011/07/23/arts/design/early-graffiti-artist-taki-183-still-lives.html.

19. Gastman and Neelon, *History of American Graffiti*, 73.

20. Chang, *Can't Stop Won't Stop*, 142–52.

21. Gastman and Neelon, *History of American Graffiti*, 23.

22. See Mike Davis, *Planet of Slums* (New York: Verso, 2006).

23. Marc Schiller, interviewed by Scott Chappell, "Street Art and Outsider Art," *DesignMentor Training*, accessed February 3, 2013, http://training.sessions.edu/resources/interviews/interviews/marc_schiller.asp.

24. See Kathryn Branch, "The KAWS Effect." *T Magazine*, June 7, 2011, http://tmagazine.blogs.nytimes.com/2011/06/07/the-kaws-effect/.

Nine: White Walls, Glass Ceiling

1. Press Release, "International Survey of Contemporary Art to Open at the Museum of Modern Art," accessed February 3, 2013, www.moma.org/docs/press_archives/6069/releases/MOMA_1984_0005_5.pdf?2010.

2. For the poster, see the Guerrilla Girls website, www.guerrillagirls.com/posters/getnaked.shtml.

3. For an archive of articles about and publications by this group, see http://www.brainstormersreport.net.

4. For the Brainstormers report, see their website: www.brainstormersreport.net. One website scanned more than 3,400 gallery press releases from 2006 and 2007: "In the press releases sent out by Chelsea galleries in 2006, the words 'his' and 'he' were 48% more common than 'her' and 'she.' The following year, 2007, the gap had grown to 64%. The same trend holds for the more specific word combination 'his/her work.' In 2006 'his work' beat 'her work' with 38%, in 2007 the difference was 56%." "Gender Equality—Not in Chelsea!," *OneArtWorld*, February 1, 2008, http://oneartworld.com/index.php?pg=Notes¬e=0.

5. See Christian Viveros-Faune, "P.S.1's 'Greater New York 2010' Is Worse than the Biennial," *Village Voice*, June 1, 2010, www.villagevoice.com/2010-06-01/art/ps-1-s-greater-new-york-2010/.

6. Laura McLean-Ferris, "Totally Wack: What Happened to the Feminist Surge?," *ArtReview*, September 3, 2008, www.artreview.com/profiles/blog/show?id=1474022%3ABlogPost%3A438676.

7. East London Fawcett Group, "Audit Results: Frieze Art Fair 2012," accessed February 3, 2013, http://elf-audit.com/the-results/.

8. Linda Nochlin, "Why Have There Been No Great Women Artists?," in *Women, Art, and Power and Other Essays* (Boulder, CO: Westview Press, 1989), 152.

9. There are, of course, still critics who take a defiantly sexist view of the matter. In 2008, Brian Sewell could wisely assure the *Independent*, "The art market is not sexist. The likes of Bridget Riley and Louise Bourgeois are of the second and third rank. There has never been a first-rank woman artist. Only men are capable of aesthetic greatness." Quoted in "'There's Never Been a Great Woman Artist,'" *Independent*, July 6, 2008, www.independent.co.uk/arts-entertainment/art/features/theres-never-been-a-great-woman-artist-860865.html.

10. Jerry Saltz, "Lesser New York," *Artnet*, March 29, 2005, www.artnet.com/Magazine/features/jsaltz/saltz3-29-05.asp.

11. Mariko Lin Chang, "Women May Make 78% of What Men Make, But They Own Only 36% as Much Wealth," in *Shortchanged: Why Women Have Less Wealth and What Can Be Done About It* (Oxford: Oxford University Press, 2010), 2.

12. Only about 45 percent of the names on *ARTnews*'s list of the top 200 art collectors of 2011 are women, counting all the members of couples listed together individually. Of those listed solo, close to 80 percent are male. See "The *ARTnews* Top 200 Art Collectors," *ARTnews*, Summer 2011, www.artnews.com/2011/08/15/the-artnews-200-top-collectors-2011/.

13. As the exception that proves the rule, the one person among the *ARTnews* 2011 "Top 200 Collectors" whose collecting area specifically mentions "contemporary art by women" is Barbara Lee (whose fortune comes from her 1996 divorce settlement with Boston-based leveraged-buyout king Thomas Lee).

14. The exact totals are a bit unclear, given that the NEA inexplicably lumps "fine artists" together with "art directors" and "animators" rather than giving them their own category. See "Women Artists: 1990 to 2005," NEA Research Note #96, December 2008, www.nea.gov/research/Notes/96.pdf.

15. For her artwork *How Do Artists Live?* (2006), Jennifer Dalton polled 856 artists via an anonymous online survey and postcards. The (admittedly unscientific) results showed that, among artists with gallery representation, men with children were more likely to be represented, while women with children were less likely than those without: approximately 26 percent of women with kids reported having gallery representation; approximately 28 percent of women without kids reported having gallery representation; approximately 49 percent of men with kids reported having gallery representation; approximately 27 percent of men without kids reported having gallery representation. In other words, as the text accompanying the graphic put it, "Will having children hurt my art career? Not if you're a man." See www.howdoartistslive.com.

16. That total is for all creative laborers across categories. See "Women Artists: 1990 to 2005," 8.

17. "But it's not just work/life policies and crusty old office environments that are cramping women's career styles. It's unfashionable to admit this, but the truth is that women still have a confidence problem. As Mary Pipher first argued in her bestselling 1995 book *Reviving Ophelia*, when girls turn 13, societal and familial forces compel too many of them to exchange their healthy egos for a whole world of hurt and humility." Courtney E. Martin, "Why Smart Women Still Don't Make It Up the Career Ladder," *Christian Science Monitor*, May 24, 2011, www.csmonitor.com/Commentary/Opinion/2011/0524/Why-smart-women-still-don-t-make-it-up-the-career-ladder.

18. Kathy Grayson, "Live Through This: New York 2005," in *Live Through This: New York in the*

Year 2005 (New York: Deitch Projects, 2005), 78.

19. Lucy Lippard, quoted in Phoebe Hoban, *Alice Neel: The Art of Not Being Pretty* (New York: St. Martin Press, 2010), 284

20. Quoted in *Artnet*, March 15, 2005, www.artnet.com/Magazine/news/artnetnews2/ artnetnews3–15–05.asp.

21. Eleanor Heartney, Helaine Posner, and Nancy Princenthal, *After the Revolution: Women Who Transformed Contemporary Art* (New York: Prestel Publishing, 2007), 23.

22. Michael Brenson, "That Was Then: The Curator and the Collector in 2000," *Witness to Her Art: Art and Writings by Adrian Piper, Mona Hatoum, Cady Noland, Jenny Holzer, Kara Walker, Daniela Rossell, and Eau de Cologne*, ed. Rhea Anastas with Michael Brenson (Annandale-on-Hudson, NY: Center for Curatorial Studies, 2006), 49.

23. Brenson, "That Was Then."

24. See Stephanie Coontz, "The Myth of Male Decline," *New York Times*, September 29, 2012, www.nytimes.com/2012/09/30/opinion/sunday/the-myth-of-male-decline.html.

25. "There was a sharp decline in occupational segregation during the 1960s, 1970s, and 1980s. Here too, however, the pace of change slowed considerably in the 1990s and all but stopped in the period from 2000 to 2010. For instance, among managers, female representation increased by approximately one percentage point per year in the 1970s and 1980s, but by a total of only three percentage points for the entire decade of the 1990s and just two in first decade of the twenty-first century. Most of the decline in occupational segregation, moreover, was confined to middle-class jobs. Working-class occupations are nearly as segregated today as they were in 1950 and have become more segregated since 1990." David A. Cotter, Joan M. Hermsen, and Reeve Vanneman, "Is the Gender Revolution Over?," *Council on Contemporary Families*, March 6, 2012, http://contemporaryfamilies.org/ gender-sexuality/gender-revolution-symposium-keynote.html.

26. Quoted in Alison Perlberg, "Shortchanged: Women and the Wealth Gap," *Gender News*, April 4, 2011, http://gender.stanford.edu/news/2011/shortchanged-women-and-wealth-gap.

27. See Sharon Smith, "What Ever Happened to Feminism?," *Women and Socialism: Essays on Women's Liberation* (Chicago: Haymarket Books, 2005), 93–110.

28. See Sharon Smith, "Mistaken Identity—or Can Identity Politics Liberate the Oppressed?," *International Socialism* (Spring 1994), www.marxists.org/history/etol/newspape/isj2/1994/ isj2–062/smith.htm.

Ten: Hipster Aesthetics

1. Robin Marantz Henig, "What Is It About 20-Somethings?," *New York Times Magazine*, August 18, 2010, www.nytimes.com/2010/08/22/magazine/22Adulthood-t.html.

2. Dan Check, "What's the Matter with Twentysomething Kids Today?," *Slate*, August 20, 2010, www.slate.com/articles/news_and_politics/im/2010/08/whats_the_matter_with _twentysomething_kids_today.single.html.

3. Donald Kuspit, "The Trouble with Youth," *Artnet*, August 17, 2007, www.artnet.com/ magazineus/features/kuspit/kuspit8–17–07.asp.

4. Jeffrey Jensen Arnett, *Emerging Adulthood: The Winding Road from the Late Teens through the Twenties* (Oxford: Oxford University Press, 2004), 3.

5. Ibid., 4.

6. "U.S. Census Bureau Reports Men and Women Wait Longer to Marry," November 10, 2010, accessed on February 3, 2013, www.census.gov/newsroom/releases/archives/ families_households/cb10–174.html.

7. D'Vera Cohn, Jeffrey Passel, Wendy Wang, and Gretchen Livingston, "Barely Half of U.S. Adults Are Married—a Record Low," Pew Research Center, December 14, 2011, www .pewsocialtrends.org/2011/12/14/barely-half-of-u-s-adults-are-married-a-record-low/.

8. "The young people of today . . . see adulthood and its obligations in quite a different light. In their late teens and early twenties, marriage, home, and children are seen by most of them not as achievements to be pursued but as perils to be avoided. It is not that they do not want marriage, a home, and (one or two) children—eventually. Most of them do want to take on all of these adult obligations, and most of them will have done so by the time they reach age 30. It is just that, in their late teens and early twenties, they ponder these obligations and think, 'Yes, but not yet.' Adulthood and its obligations offer security and stability, but they also represent a closing of doors—the end of independence, the end of spontaneity, the end of a sense of wide-open possibilities." Arnett, Emerging Adulthood, 6.

9. Ibid., 8.

10. Hal Foster, "Precarious: Hal Foster on the Art of the Decade," Artforum, December 2009.

11. Sameer Reddy, "The Nifty 50: David Benjamin Sherry, Photographer," T Magazine, February 1, 2010, http://tmagazine.blogs.nytimes.com/2010/02/01/the-nifty-50-david-benjamin -sherry-photographer/.

12. Dominick Nurre, interviewed by Lauren O'Neill-Butler, "500 Words: Dominick Nurre," Artforum, May 22, 2010, http://artforum.com/words/id=25653.

13. Adam Kleinman, "DI Why, Not? A Review and an Application of the Das Institut Method," Texte Zur Kunst, November 12, 2009, www.textezurkunst.de/daily/2009/nov/12/di -why-not-review-and-application-das-institut-met/.

14. See October 130 (Fall 2009).

15. Mark Greif, "Epitaph for the White Hipster," in What Was the Hipster? A Sociological Investigation, ed. Mark Greif, Kathleen Ross, and Dayna Tortorici (New York: n+1 Foundation, 2010), 149.

16. Mark Greif, "Positions," in What Was the Hipster?, 5.

17. Greif, "Epitaph," 151.

18. Ibid., 161.

19. Ibid., 162.

20. Ibid., 4.

21. Paul Craig Roberts, "A Nation of Waitresses and Bartenders," Counterpunch, May 8, 2006, www.counterpunch.org/2006/05/08/a-nation-of-waitresses-and-bartenders/.

22. David Segal, "Is Law School a Losing Game?" New York Times, January 8, 2011, www.nytimes .com/2011/01/09/business/09law.html.

23. "Between 1947 and 1973, the typical American family's income roughly doubled in real terms. Between 1973 and 2007, however, it grew by only 22%—and this thanks to the rise of two-worker households. In 2004 men in their 30s earned 12% less in real terms than their fathers did at a similar age, according to Pew's Economic Mobility Project." "Upper Bound," Economist, April 15, 2010, www.economist.com/node/15908469.

24. Jason DeParle, "Harder for Americans to Rise from Lower Rungs," New York Times, January 4, 2012, www.nytimes.com/2012/01/05/us/harder-for-americans-to-rise-from-lower -rungs.html.

25. Reflecting a contradictory state of affairs, young people themselves, however, still reflected general optimism. Elizabeth Mendes, "In U.S., Optimism About Future for Youth Reaches All-Time Low," Gallup Politics, May 2, 2011, www.gallup.com/poll/147350/Optimism- Future-Youth-Reaches-Time-Low.aspx.

26. Christine Slocum, "Polls Indicate Declining Optimism for Gen Y," The Next Great Gen-

eration (blog), May 5, 2011, www.thenextgreatgeneration.com/2011/05/polls-indicate
-declining-optimism-for-gen-y/.

27. Arnett, *Emerging Adulthood*, 7.

28. According to a study by Hector R. Cordero-Guzman, visitors to the Occupy Wall Street
website (more than 90 percent of whom supported the protests) were 81.3 percent white;
62.4 percent were under thirty-four; 92.1 percent had some college, a college degree, or
beyond; 47.5 percent earned less than $24,999 a year; and 33.5 percent were unemployed
or part-time employed. Hector R. Cordero-Guzman, "Mainstream Support for a Main-
stream Movement," School of Public Affairs, Baruch College, October 19, 2011, http://
occupywallst.org/media/pdf/OWS-profile1-10-18-11-sent-v2-HRCG.pdf.

29. For a fine critique of this aspect of Occupy, articulated by sympathetic artists, see Not an Al-
ternative, "Occupy: The Name in Common," November 15, 2012, http://creativetimereports
.org/2012/11/15/occupy-the-name-in-common.

30. And, indeed, it is worth noting that *n+1* did not do so, putting out a regular paper aimed
at presenting theoretical analysis of the movement by various intellectuals and participants,
the *Occupy Gazette*.

31. The *Onion* is itself a classic hipster publication, of course. "Two Hipsters Angrily Call
Each Other 'Hipster,'" *Onion*, March 29, 2006, www.theonion.com/articles/two-hipsters
-angrily-call-each-other-hipster,5230/.

Eleven: Commerce and Consciousness

1. "We really didn't need a faux boutique. I felt that the experience could only be achieved
by having an operational one, rather than a fixed, embalmed replication. The fact that there
is a new product that is only available here is very dynamic and represents that kind of re-
lationship between the viewer and the consumer." Quoted in Diane Haithman, "MOCA
Show Asks: Is It Business or Art?," *Los Angeles Times*, August 9, 2007, http://articles
.latimes.com/2007/aug/09/entertainment/et-moca9.

2. This reading is canonical when it comes to the early Koons. To take one example,
"Themes in Contemporary Art"—a work that features Koons's Pink Panther on the
cover—contextualizes his work as being "about" the state of cultural entropy described
by Fredric Jameson and Jean Baudrillard. See Paul Wood, "Inside the Whale: An Intro-
duction to Postmodern Art," in *Themes in Contemporary Art*, ed. Gill Perry and Paul Wood
(New Haven, CT: Yale University Press, 2004), 30.

3. Quoted in Lauren A. E. Schuker, "The Artist and the Director," *Wall Street Journal*, October
2, 2009, http://online.wsj.com/article/SB10001424052748704471504574445603670923492
.html.

4. Johanna Drucker, *Sweet Dreams: Contemporary Art and Complicity* (Chicago: University of
Chicago Press, 2006), 16.

5. Quoted in "Vanessa Beecroft: VB LV," Amazon.com, accessed February 3, 2013, www.amazon
.com/Vanessa-Beecroft-VB-Alexandra-Polier/dp/8881586150.

6. It might be worth emphasizing that even the limit case of Beecroft cannot be considered
completely "complicit" in Drucker's sense. She has felt the need to secure her critical cre-
dentials by making a political claim on her audience, as with the freakish 2007 performance
"VB61: Still Death! Darfur Still Deaf?" at the Venice Biennale, for which she had thirty
naked Sudanese models lay face down on a white sheet splashed with a blood-like liquid.

7. Drucker, *Sweet Dreams*, 48.

8. Dave Hickey, *Air Guitar* (Santa Monica, CA: Art Issues Press, 1997), 202.

9. Lawrence Alloway, "The Arts and the Mass Media," in *Imaging the Present: Context, Content, and the Role of the Critic*, ed. Richard Kalina (London: Routledge, 2006), 55.

10. Lawrence Alloway, "Personal Statement," in *Imaging the Present*, 52.

11. Jim Cullen, *The Art of Democracy: A Concise History of Popular Culture in the United States* (New York: Monthly Review Press, 2002), 10–13.

12. "Speaking generally, the decisive development of twentieth-century culture, the rise of a revolutionary popular entertainment industry geared to the mass market, reduced the traditional forms of high art to elite ghettoes, and from the middle of the century their inhabitants were essentially people who had enjoyed a higher education." Eric Hobsbawm, *The Age of Extremes: A History of the World, 1914–1991* (New York: Vintage, 1994), 509.

13. "What 'Pixar' does demonstrate, with good humor and élan, are the considerable artistic gifts of its animators and sculptors. . . . At the same time, the show makes it crystal clear that commercial art of this sort, however accomplished, lacks the kind of questioning relationship with modern life and its institutions that we generally expect from fine art, at least the avant-garde kind. . . . In fact, since the art is 'work for hire,' Pixar owns it all. Incredibly, these gemlike drawings and paintings are not ordinarily exhibited, collected or traded. The artists don't own any of their work, at least not the works made for Pixar." Walter Robinson, *Artnet*, December 13, 2005, www.artnet.com/magazineus/news/artnetnews/artnetnews12–13–05.asp.

14. For my own review of Bell-Smith's 2006 show at Foxy Productions, see Ben Davis, "Retro Activities," *Artnet*, May 31, 2006, www.artnet.com/magazineus/reviews/davis/davis5–31–06.asp.

15. Michael Bell-Smith, interviewed by Rebecca Gordon, "Michael Bell-Smith talks to Rebecca Gordon," *New York Arts*, January–February 2008, www.nyartsmagazine.com/conversations/michael-bell-smith-talks-to-rebecca-gordon.

16. Gordon, "Michael Bell-Smith."

17. Bourdieu uses the term "class," but I am using "social group" here for clarity's sake. He uses "class" in the more conventional sociological sense of educational and income groupings, rather than the Marxist terms of relation to means of production.

18. "The different social classes can subject photographic practice to different norms, but these at least share the fact that they differ (in different ways) from the norm which governs the most ordinary practice." Pierre Bourdieu, *Photography: A Middle-Brow Art* (Stanford, CA: Stanford University Press, 1996), 47.

19. In seventeenth-century Antwerp, for instance, a painter's originals could be considered "capital assets," that is, investments that could generate a string of reproductions, rather than being valued as unique objects. Neil De Marchi and Hans J. Van Miegroet, "The History of Art Markets," *Handbook of the Economics of Art and Culture*, 98

20. Thomas, *Deluxe*, 41.

21. "It is so new and unique you want to buy it. You feel as if you must buy it, or else you won't be in the moment. You will be left behind." Bernard Arnault, quoted in Thomas, *Deluxe*, 41–42.

22. Michael Petry, *The Art of Not Making: The New Artist/Artisan Relationship* (London: Thames & Hudson, 2011), 6, 61, 109.

23. Ibid., 21.

24. "These days in Beijing he employs anywhere from four to ten workers, depending on the urgency, plus a studio manager, the American artist Ain Cocke." Christopher Beam, "The New Art World Rule Book: Outsource to China," *New York Magazine*, April 22, 2012,

http://nymag.com/arts/art/rules/kehinde-wiley-2012–4/.

27. Quoted in the wall text for the Watermill Center's "Mike Kelley: 1954–2012," July 28–September 16, 2012.

28. Ben Davis, "The Rise of the Superartists," *Artnet*, July 16, 2008, www.artnet.com/magazineus/reviews/davis/davis7–16–08.asp.

29. "Hirst Unveils £50m Diamond Skull," *BBC News*, June 1, 2007, news.bbc.co.uk/2/hi/entertainment/6712015.stm.

30. "The six major studios rarely, if ever, green-light a project unless it is certified as 'marketable' in America. What makes a movie 'marketable' is that the marketing arm finds that it contains the action, stars, visual effects or other elements that it needs to put in 30-second television ads to activate millions of people on a particular weekend to go to the opening of a movie at thousands of screens across the country. This operation is extremely costly. The average ad budget was $32 million for wide-released movie in 2010." Jay Epstein, "How Hollywood Reads the Latest Numbers," *Hollywood Economist*, April 8, 2011, http://thehollywoodeconomist.blogspot.com/2011_04_01_archive.html.

31. Alexandra Peers, "Head Case: The Mystery of the Very Well-Timed Sale of Damien Hirst's $100 Million Skull," *New York*, September 10, 2007, http://nymag.com/news/intelligencer/37270/.

32. Quoted in "Works by Damien Hirst Lose 30 Per Cent of Their Value, While One Third Fail to Sell at All," *Telegraph*, November 27, 2012, www.telegraph.co.uk/culture/art/art-news/9705338/Works-by-Damien-Hirst-lose-30-per-cent-of-their-value-while-one-third-fail-to-sell-at-all.html.

Twelve: Crisis and Criticism

1. "At almost every international art fair over the past few years, there has been a panel discussion about the crisis in art criticism. I have found myself talking about the topic in London, Madrid, Berlin, and Miami. Wherever critics are paid to gather (you wouldn't catch us in the same room otherwise), they go on about the crisis." Adrian Searle, "Critical Condition," *Guardian*, March 17, 2008, www.guardian.co.uk/artanddesign/2008/mar/18/art.

2. Thomas McEvilley, "The Tomb of the Zombie," in *Critical Mess: Art Critics on the State of Their Practice*, ed. Raphael Rubinstein (Stockbridge, MA: Hard Press Editions, 2006), 17.

3. Michael Duncan, "Buggy-making in Tulip Time," in *Critical Mess*, 111–12.

4. James Elkins, "What Ever Happened to Art Criticism?," in *Critical Mess*, 5.

5. Carter Ratcliff, "Ion's Tears," in *Critical Mess*, 98.

6. Benjamin H. D. Buchloh, "The Present Conditions of Art Criticism," *October* 100 (Spring 2002), 200–28.

7. Katy Siegel, "Everyone's a Critic," in *Critical Mess*, 43.

8. Amy Newman, *Challenging Art: Artforum 1962–1974* (New York: Soho Press, 2003).

9. Quoted in Amy Newman, *Challenging Art*, 59.

10. Ibid., 455. See also chapter three of Chris Harman, *The Fire Last Time: 1968 and After* (London: Bookmarks, 1988).

11. Michael Brenson, *Visionaries and Outcasts: The NEA, Congress, and the Place of the Visual Artist in America* (New York: New Press, 2001), 15.

12. Hal Foster, *The Return of the Real: The Avant-Garde at the End of the Century* (Cambridge, MA: MIT Press, 1996), xiv.

13. Ana Finel Honigman, "Overwhelming Life," *Artnet*, March 29, 2006, www.artnet.com/magazineus/features/honigman/honigman3–29–06.asp.

14. Sally Renfro and Allison Armour-Garb, *Open Admissions and Remedial Education at the City University of New York* (The Mayor's Advisory Taskforce on the City University of New York, Archives of Rudolph W. Giuliani, June 1999), www.nyc.gov/html/records/rwg/cuny/.

15. Roger Geiger and Donald E. Heller, *Financial Trends in Higher Education: The United States* (New York: Center for the Study of Higher Education, January 2011), www.ed.psu.edu/educ/cshe/working-papers/WP%236.

16. "The issue was not that the work of Mapplethorpe, Serrano, and the NEA Four did not deserve support. They did. The issue was rather that their work did not fit within the agency's shifting rhetorical framework during the last years of the Cold War. That always precarious balance between the language of free expression, experimentation, and risk, and the language of balance, civilization, universality, and wholesomeness was essentially gone. The ennobling, transcendent language had essentially taken over, and it was largely in the hands of the NEA's opponents, who felt far more comfortable with it, and for whom key claims of the Endowment legislation, including supporting artists experimentation, risk, process, and progress, were worthless." Brenson, *Visionaries and Outcasts*, 102.

17. Jack Bankowsky, "What Was I Thinking?," *Artforum* (September 2012).

18. This standoff is, in effect, an updated version of Immanuel Kant's "Antinomy of Taste," the core paradox outlined in the Enlightenment philosopher's classic treatise on aesthetics, the *Critique of Judgment*. On the one hand, Kant says, "the judgment of taste is not based on concepts," because it is by nature subjective and not provable by any law that can definitively tell you something is good. Yet on the other, "the judgment of art is based on concepts," because otherwise there would be nothing to argue about at all; it would be enough to simply say that everyone has their own taste. Kant solves his antinomy by returning the question back on the subject doing the judging. When we argue about art, he thinks, we are not arguing about the actual object but about how we perceive something in relationship to a hypothesis of how others also perceive the world—we are arguing about what principles of perception we hold in common. Immanuel Kant, *Critique of Judgment*, trans. James Creed Meredith (Oxford: Oxford University Press, 2007), 166.

19. Leon Trotsky, "Manifesto: Towards a Free Revolutionary Art," in *Art and Revolution: Writing on Literature, Politics, and Culture* (Atlanta: Pathfinder Press, 1970), 122.

20. For a theory of art and class, the following passage from "Towards a Free Revolutionary Art" is tremendously suggestive, seeming to indicate that Trotsky sees present-day art as flowing from a class position very different from that of the working class—in fact one that flows from middle-class "anarchistic" tendencies: "If, for the better development of the forces of material production, the revolution must build a socialist regime with centralized control, to develop intellectual creation an anarchist regime of individual liberty should from the first be established. No authority, no dictation, not the least trace of orders from above! Only on a base of friendly cooperation, without constraint from the outside, will it be possible for scholars and artists to carry out their tasks, which will be more far-reaching than ever before in history." Leon Trotsky, "Manifesto," 127.

21. Ibid.

22. Leon Trotsky, "The Independence of the Artist: A Letter to Andre Breton," in *Art and Revolution*, 132.

23. Ibid.

Thirteen: In Defense of Concepts

1. Lucy Lippard, *Six Years: The Dematerialization of the Art Object* (Berkeley and Los Angeles: University of California Press, 1973/2001), xxi.

2. Adrian Searle, "Notes on an Art Crisis," *Guardian*, November 9, 2009, www.guardian .co.uk/artanddesign/2009/nov/09/art-world-crisis.

3. Denis Dutton, "Has Contemporary Art Jumped the Shark Tank?," *New York Times*, October 15, 2009, www.nytimes.com/2009/10/16/opinion/16dutton.html.

4. You can, if you like, get the full dose of his argument in his book of the same name. Denis Dutton, *The Art Instinct: Beauty, Pleasure, and Human Evolution* (London: Bloomsbury Press, 2009).

5. At New York's Metropolitan Museum of Art, "the mean time spent viewing a work of art was found to be 27.2 seconds, with a median time of 17.0 seconds." Jeffrey K. Smith and Lisa F. Smith, "Spending Time on Art," *Empirical Studies of the Arts*, no. 2 (2001): 229–36.

Fourteen: The Semi-Post-Postmodern Condition

1. Terry Eagleton, *Literary Theory: An Introduction* (Minneapolis: University of Minnesota Press, 1996), 200.

2. "Postmodernism Panel Texts," Victoria and Albert Museum, accessed on February 3, 2013, www.vam.ac.uk/content/exhibitions/postmodernism/download-postmodernism-panel-text/.

3. Nicolas Bourriaud, "Altermodern Manifesto," Tate Modern, accessed on February 3, 2013, www.tate.org.uk/britain/exhibitions/altermodern/manifesto.shtm.

4. "Off modern is a contemporary worldview that took shape in the 'zero' decade of the twenty-first century that allows us to recapture different, often eccentric aspects of earlier modernities, to 'brush history against the grain'—to use Walter Benjamin's expression— in order to understand the preposterous aspects of our present. In other words, off modern is not an 'ism' but a prism of vision and a mode of acting and creating in the world that tries to remap the contemporary landscape filled with the ruins of spectacular real estate development and the construction sites of the newly rediscovered national heritage." Svetlana Boym, "The Off-Modern Mirror," *E-Flux Journal* (October 2010), www.e-flux .com/journal/the-off-modern-mirror.

5. "The problem is that this dismemberment then became a kind of official position (the pervasiveness of installation art is one sign of this state of affairs), and now it's a commonplace among artists and critics alike; it's understood as given. And if I as a critic have any responsibility now, it is to disassociate myself from this attack on the medium, and to speak for its importance, which is to say for the continuance of modernism. I don't know if poststructuralism will help me do this, and thus I don't know if I can maintain my earlier commitment to this methodological position." Rosalind Krauss, in conversation with Benjamin Buchloh, Hal Foster, and Yves-Alain Bois, "The Predicament of Contemporary Art," in *Art Since 1900: Modernism, Antimodernism, Postmodernism* (London: Thames and Hudson, 2004), 674.

6. Hal Foster, "Questionnaire on the Contemporary," *October* (Fall 2009): 3.

7. Craig Owens, "The Allegorical Impulse: Towards a Theory of Postmodernism," in *Beyond Recognition: Representation, Power, and Culture* (Berkeley and Los Angeles: University of California Press, 1994), 58.

8. The answer is that Owens construes all site-specific works as being about a "mythical" reading of their site (implying a second-order level of meaning) or as being about their own condition of impermanence (making them an allegory for the fleetingness of all

things). This is obviously reductive both to the category of site-specificity in general and to the specific works in question. Owens, "Allegorical Impulse," 55–58.

9. Joe Scanlan, "The Uses of Disorder," *Artforum* (February 2010).

10. Ibid.

11. The inventor of modern camouflage, the painter Lucien-Victor Guirand de Scévola, stated the connection clearly: "In order to deform totally the aspect of an object, I had to employ the means that cubists use to represent it." Spencer Tucker, *European Powers in the First World War: An Encyclopedia* (London: Routledge, 1999), 160.

12. Fredric Jameson, "Postmodernism and Consumer Culture," in *The Cultural Turn: Selected Writings on the Postmodern, 1983–1998* (New York: Verso, 1998), 3.

13. Perry Anderson, *Origins of Postmodernity* (New York: Verso, 1998), 72.

14. "In late capitalism the share of the underdeveloped countries in world trade is declining, so that they are becoming poorer in comparison with the imperialist nations. As Mandel explains it, the imperialist countries depend on the raw materials of the underdeveloped countries and on the decline in their prices, which leads to a relative decline in the value of those raw materials. But since, according to Mandel, the share of the underdeveloped countries in world trade is diminishing, this must express imperialism's decreasing dependence on the raw materials of the poor nations, which leads to the drop in their prices." Paul Mattick, "Ernst Mandel's Late Capitalism," 1972, www.marxists.org/archive/mattick-paul/1972/mandel.htm.

15. Alex Callinicos, *Against Postmodernism: A Marxist Critique* (Cambridge: Polity Press, 1989), 133.

16. David Harvey, *The Condition of Postmodernity: An Enquiry into the Origins of Cultural Change* (Hoboken, NJ: Wiley-Blackwell, 1990).

17. "Saatchi & Saatchi was appointed by the Conservatives at the prompting of Gordon Reece, the party's head of communications and the man who is often credited with honing Mrs. Thatcher's steely image. As a sizeable British-owned agency that had developed a reputation for creativity, Saatchi & Saatchi met all the party's requirements." Mark Tungate, *Adland: A Global History of Advertising* (London: Kogan Page Limited, 2007), 96.

18. "By the end of 1986 Saatchi & Saatchi PLC had spent US $1 billion acquiring 37 companies. It had 18,000 employees in 500 offices across 65 countries." Tungate, *Adland*, 101.

19. Jean-François Lyotard, *The Postmodern Condition: A Report on Knowledge*, trans. Geoff Bennington and Brian Massumi (Minneapolis: University of Minnesota, 1984), 6.

20. Josephine Meckseper, interviewed by Liam Gillick, *Interview* (November 2008), www.interviewmagazine.com/art/josephine-meckseper/.

21. Sylvère Lotringer, "Josephine Meckseper," *Vitamin 3-D: New Perspectives in Sculpture and Installation* (London: Phaidon Press, 2009), 194.

22. In the wake of the UK riots of 2011, critic Jonathan T. D. Neil reassessed Meckseper's remarks that her vitrines were meant to resemble store windows about to be smashed: "Faced with the rioters' stones, acts of avant-gardist subversion, or hyperbolic mirroring, or arm's-length irony can appear as nothing more than manifestations of impotence. The riots, on the other hand, were 'a demonstration of the material force of ideology,' the perfect marriage of destructive consumption, or consumptive destruction. This is not to idealize or fetishize them, the acts or their perpetrators; it's only to note that the art which comes in their wake needs to imagine what a more just world might be like, or to carve out a space where such an imagination might be possible, not to continue to hint at the injustices of the present." Jonathan T. D. Neil, "Josephine Meckseper," *Artreview*, October 2011.

23. Boris Groys, "Comrades of Time," *E-Flux Journal* (December 2009), www.e-flux.com/journal/comrades-of-time/.

24. For a Marxist critique of this constellation of theorists, see Alex Callinicos, *The Resources of Critique* (Cambridge: Polity, 2006).

25. Bourriaud, "Altermodern Manifesto."

26. To get a sense of the limits of the debate, see Hal Foster, "Contemporary Extracts," *E-Flux Journal*, January 2010, www.e-flux.com/journal/contemporary-extracts/.

27. Chris Giles, Ralph Atkins, and Krishna Guha, "The Undeniable Shift to Keynes," *Financial Times*, December 29, 2008, www.ft.com/intl/cms/s/0/8a3d8122-d5da-11dd-a9cc-000077b07658.html#axzz2JsgbaQ8s; Holland Cotter, "The Boom Is Over. Long Live the Art!," *New York Times*, February 12, 2009, www.nytimes.com/2009/02/15/arts/design/15cott.html.

28. David Harvey, "Enigma of Capital Lecture at LSE," London, April 26, 2010, http://davidharvey.org/2010/04/enigma-of-capital-lecture-at-lse/.

Fifteen: Beyond the Art World

1. Arnold Hauser, *The Social History of Art: Volume III, Rococo, Classicism, and Romanticism* (London and New York: Routledge, 1951), 48.

2. Ben Davis, "The Bauhaus in History," *Artnet*, January 28, 2010, www.artnet.com/magazineus/reviews/davis/bauhaus1-28-10.asp.

Sixteen: To the Future

1. Cyril Josh Barker, "Homelessness Rises among Children in NYC," *Amsterdam News*, November 29, 2012, www.amsterdamnews.com/news/local/homelessness-rises-among-children-in-nyc/article_1c056b1c-3a61-11e2-a74e-0019bb2963f4.html.

2. Aaron Edwards, "New York Acts Quickly Amid Sharp Rise in Homelessness," *New York Times*, August 10, 2012, www.nytimes.com/2012/08/11/nyregion/nyc-homeless-shelters-in-record-demand-new-facilities-planned.html.

3. Johnson's personal website states his mission: "As a visual artist and poet, I mine stories that have been buried or left to die. I raise questions that need attention. I shine light on shadows and attempt to bring voice to the voiceless.

 I am constantly exploring new means of expressing the 'smells I see.' By repurposing e-waste and other objects in my assemblage artworks, that may have found their way into landfills and toxic dumps, both nationally and internationally and among our world's poorest citizens, these elements now may find their way into museums to be viewed by some of our world's wealthiest citizens." F. Geoffrey Johnson, "Artist Statement," www.SmellsISee.com.

4. "The bottom 20 percent of the U.S. population has never done so poorly, relative to the median, during the whole postwar period. Low-earning households have become, during the course of the Great Recession, more vulnerable due to large losses in wealth." Fabrizio Perri and Joe Steinberg, quoted in Aki Ito, "Fed Says U.S. Inequality Rose to Record Even with Redistribution," *Bloomberg.com*, February 21, 2012, www.bloomberg.com/news/2012-02-21/fed-s-u-s-inequality-rose-to-record-in-10.html.

5. "America has the least equality of opportunity of any of the advanced industrial economies." Quoted in Aaron Task, "The 'American Dream' Is a Myth: Joseph Stiglitz on 'The Price of Inequality,'" *Yahoo Finance*, June 8, 2012, http://finance.yahoo.com/blogs/

daily-ticker/american-dream-myth-joseph-stiglitz-price-inequality-124338674.html.

6. "Mass incarceration on a scale almost unexampled in human history is a fundamental fact of our country today—perhaps the fundamental fact, as slavery was the fundamental fact of 1850. In truth, there are more black men in the grip of the criminal-justice system—in prison, on probation, or on parole—than were in slavery then. Over all, there are now more people under 'correctional supervision' in America—more than six million—than were in the Gulag Archipelago under Stalin at its height. That city of the confined and the controlled, Lockuptown, is now the second largest in the United States." Adam Gopnik, "The Caging of America," *New Yorker*, January 30, 2012, www.newyorker.com/arts/critics/atlarge/2012/01/30/120130crat_atlarge_gopnik.

7. John Bellamy Foster and Brett Clark, "The Planetary Emergency," *Monthly Review* (December 2012), http://monthlyreview.org/2012/12/01/the-planetary-emergency.

8. "Once the rules of the game called art had been revised in Florence to include the demand for a 'contribution,' a problem-solution, no other conception of art had much chance against it. Thus, when Vasari identified the history of art almost entirely with the history of art in Florence (allowing for such tangible contributions from the North as the 'invention' of oil painting), he was not only prompted by parochial patriotism. He was writing the history of the new game that had actually sprung up in Florence. And this new conception acted like a vortex with ever widening ranged and momentum." E. H. Gombrich, "The Renaissance Conception of Artistic Progress," in *Norm and Form: Studies in the Art of the Renaissance* (London: Phaidon, 1966), 9.

9. William Morris, "Art and Labour," www.marxists.org/archive/morris/works/1884/art-lab.htm.

10. In *The Lives of the Artists*, Vasari approvingly quotes a story about Giotto by Franco Sacchetti to illustrate his greatness of the artist who, in many ways, stands as the grandfather of the tradition of the Renaissance. A "common workman" comes to Giotto, having heard of his talent, and asks that he paint him a coat of arms. Giotto responds by painting a travesty, and the workman is naturally offended. "What are your arms?" Giotto replies to the man, with memorable spite. "Where do you come from? Who are your ancestors? Aren't you ashamed of yourself? You'll have to make people aware that you exist before you start talking about your coat-of-arms, as if you were the duke of Bavaria himself. I've painted all of your arms for you on your buckler. If there's more, tell me and I'll put it in." Clearly, one of the things that Vasari admires in Giotto is not just his superior skill, but how his superior skill puts normal laborers in their place. Similar anecdotes are found throughout this, the foundational work of Western art history. Giorgio Vasari, *The Lives of the Artists*, trans. George Bull (New York: Penguin Classics, 1980), 80.

11. "The lower middle class, the small manufacturer, the shopkeeper, the artisan, the peasant, all these fight against the bourgeoisie, to save from extinction their existence as fractions of the middle class." Marx and Engels, "Manifesto of the Communist Party," 482.

12. "The images that became the icons of such societies were those of mass entertainment and mass consumption: stars and cans. It is not surprising that in the 1950s, in the heartland of consumer democracy, the leading school of painters abdicated before image-makers so much more powerful than old-fashioned art." Hobsbawm, *Age of Extremes*, 513.

13. Julian Stallabrass, *Contemporary Art: A Very Short Introduction* (Oxford: Oxford University Press, 2004), 3.

14. Leopold II, "The King of the Belgians to Queen Victoria," in the Project Gutenberg E-book of *The Letters of Queen Victoria*, vol. 2 (of 3), 1844–1853, www.gutenberg.org/files/

24780/24780-h/24780-h.htm.

15. "The Artists' Union and the National Maritime Union (NMU) were two of the most active participants in aiding striking picket lines anywhere in New York City. If the salesgirls went out on strike at May's department store in Brooklyn, a grouping from the above-mentioned unions was bound to swell the picket line." Joseph Solman, "The Easel Division of the WPA Federal Art Project," in *The New Deal Art Projects: An Anthology of Memoirs*, ed. Francis V. O'Connor (Washington, DC: Smithsonian Institute Press, 1972), 120.

16. "Call for an American Artist's Congress," quoted in Lincoln Rothschild, "Artists' Organizations of the Depression Decade," in *New Deal Art Projects*, 208.

17. "The future of painting is clear, is historically determined and . . . built on the solid foundation of modern art. . . . [It] looks toward improving the lives of the workers by giving them more money, more leisure, more education, and more culture. Such a program can only be conceived in view of modern technological development through the materialism of science." Quoted in Lowery Stokes Sims, *Stuart Davis: American Painter* (New York: Metropolitan Museum of Art, 1991), 67.

18. Rosalind Bengelsdorf Browne, "The American Abstract Artists and the WPA Art Project," in *New Deal Art Projects*, 240.

19. "It was just about '69, '70. The Berkeley students were decrying the loss of personal contact, any possibility of intimacy in teaching. And what was happening with Judy and her group is that she was reinstating all of that." Miriam Schapiro, interviewed by Ruth Bowman, "Oral History Interview with Miriam Schapiro, Sept. 10, 1989," Archives of American Art, www.aaa.si.edu/collections/interviews/oral-history-interview-miriam-schapiro-11695.

20. Mira Schor, *A Decade of Negative Thinking: Essays on Art, Politics, and Daily Life* (Durham, NC: Duke University Press, 2010), 73.

21. Holland Cotter, "Feminist Art Finally Takes Center Stage," *New York Times*, January 29, 2007, www.nytimes.com/2007/01/29/arts/design/29femi.html.

22. "AIDS changed everything. The people I feel knew me the best, who understood me, the people who carried my history, the people I grew up with and I was planning to get old with are gone. . . . I don't believe photography stops time. . . . I still believe pictures can preserve life rather than kill life. The pictures in the Ballad haven't changed. But Cookie is dead, Kenny is dead, Mark is dead, Max is dead, Vittorio is dead. So for me, the book is now a volume of loss, while still a ballad of love." Nan Goldin, quoted in Janna Ireland, "The Ballad of Sexual Dependency," *Slow Century*, March 27, 2012, http://visualarts .slowcentury.com/post/86796415/the-ballad-of-sexual-dependency.

23. Quoted in Hal Foster et al., *Art Since 1900: Modernism, Antimodernism, Postmodernism* (London: Thames and Hudson, 2004), 607.

24. Government art support has from its beginnings been designed to turn artists into a political interest group. Roosevelt's WPA and Johnson's National Endowment for the Arts were both frequent targets of attack by Republicans looking for an easy face for government waste. On the other hand, both in different ways were conceived of as tools for a Democratic president to shore up the support of an influential constituency. In my opinion, while government art support is something to fight for, artists have to see beyond it: "As the old protest slogan goes, we should be able to demand bread and roses, essential services and healthy funding for arts. But to make that case, one must think beyond slogans like 'Save the Arts,' and frame the question in terms of a battle over wider priorities. Is it really so outrageous to think of cutting a bloated military budget, or taxing the smooth-talking cabal of bankers who got us into this crisis in the first place, rather than letting ourselves

be pitted against each other fighting for their scraps? The conservative art-slashers have their bigger agenda. Why shouldn't we push ours back?" Ben Davis, "Bread, Roses, and the Republican Anti-Art Agenda," *Artinfo*, February 3, 2011, www.artinfo.com/ news/story/36874/bread-roses-and-the-republican-anti-art-agenda.

25. John Berger, *The Success and Failure of Picasso* (New York: Vintage, 1993), Kindle edition.

26. For the curious, I hold to the "state capitalist" theory of socialism in the Soviet Union— essentially that after an early period of substantial workers' power, conditions of scarcity forced the return of a form of capitalism to Russia in the guise of state-owned enterprise. The capitalist norms of exploitation and disenfranchisement of workers remained the same, despite the lack of private property. The debate is complex—but some theory of the phenomenon would save left-wing art critics the embarrassment of repeating statements about how "really existing socialism" is an example of what Marxism looks like in power. For a good summary of the theoretical debates about the nature of the Soviet Union, see Marcel van der Linden, *Western Marxism and the Soviet Union* (Chicago: Haymarket Books, 2007).

27. For inspiration on what this would look like in practice, see Richard Wolff, *Democracy at Work: A Cure for Capitalism* (Chicago: Haymarket Books, 2012); *Ours to Master and to Own: Workers' Control from the Commune to the Present*, ed. Immanuel Ness and Dario Azzellini (Chicago: Haymarket Books, 2011); and *Sin Patrón: Stories from Argentina's Worker-Run Factories*, the lavaca collective (Chicago: Haymarket Books, 2007).

28. Sherry Wolf, *Sexuality and Socialism: History, Politics, and Theory of LGBT Liberation* (Chicago: Haymarket Books, 2009), 276.

29. Terry Eagleton, *Why Marx Was Right*, Kindle edition.

30. John Berger, "The White Bird," in *Selected Essays*, ed. Geoff Dyer (New York: Vintage, 2001), 364.

31. "It is childish to think that bourgeois belles-lettres can make a breach in class solidarity. What the workers will take from Shakespeare, Goethe, Pushkin, or Dostoyevsky will be a more complex idea of human personality, or its passions and feelings. . . . In the final analysis, the worker will become richer." Trotsky, *Literature and Revolution*, 184.

Index

About Haymarket Books

Haymarket Books is a nonprofit, progressive book distributor and publisher, a project of the Center for Economic Research and Social Change. We believe that activists need to take ideas, history, and politics into the many struggles for social justice today. Learning the lessons of past victories, as well as defeats, can arm a new generation of fighters for a better world. As Karl Marx said, "The philosophers have merely interpreted the world; the point, however, is to change it."

We take inspiration and courage from our namesakes, the Haymarket Martyrs, who gave their lives fighting for a better world. Their 1886 struggle for the eight-hour day reminds workers around the world that ordinary people can organize and struggle for their own liberation.

For more information and to shop our complete catalog of titles, visit us online at www.haymarketbooks.org.

Also from Haymarket Books

Literature and Revolution • Leon Trotsky, edited by William Keach

Bury My Clothes • Roger Bonair-Agard

Essays • Wallace Shawn

L-vis Lives!: Racemusic Poems • Kevin Coval

Boots Riley: Lyrics in Context, 1993–2012 • Boots Riley, Introduction by Adam Mansbach

Poetry and Protest: A Dennis Brutus Reader • Dennis Brutus, edited by Lee Sustar

Exile: Conversations with Pramoedya Ananta Toer André Vltchek and Rossie Indira Vltchek, edited by Nagesh Rao

Is Just a Movie • Earl Lovelace

About the Author

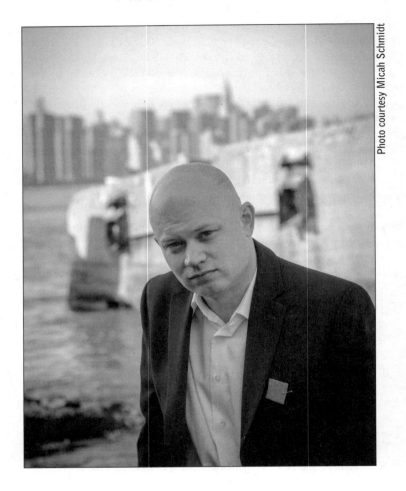

Ben Davis is an art critic living and working in New York City. His writings have appeared in *Adbusters*, the *Brooklyn Rail*, *Slate*, the *Village Voice*, and many other publications. He is currently executive editor of *Artinfo.com*.